ARTISTIC THEORY
IN ITALY

1450–1600

ANTHONY BLUNT

OXFORD NEW YORK
OXFORD UNIVERSITY PRESS

Oxford University Press, Walton Street, Oxford OX2 6DP

*London Glasgow New York Toronto
Delhi Bombay Calcutta Madras Karachi
Kuala Lumpur Singapore Hong Kong Tokyo
Nairobi Dar es Salaam Cape Town
Melbourne Auckland*

*and associates in
Beirut Berlin Ibadan Mexico City Nicosia*

ISBN 0 19 881050 4

*First published by the Clarendon Press 1940
First issued as an Oxford University Press paperback 1962
Sixth impression 1982*

*Printed in Great Britain
at the University Press, Oxford
by Eric Buckley
Printer to the University*

PREFACE TO SECOND IMPRESSION

THIS second impression is, except for the corrections of minor mistakes and small additions to the bibliography, an exact reprint of the first edition. This does not imply that there is nothing in the book which I think should be altered; in fact, it implies exactly the opposite. Now I should not dare to write such a book at all. The capacity to make broad generalizations, to concentrate a number of ideas into a small compass in the hope that they will convey more of truth than of falsehood, is the result either of the rashness of youth or the wisdom of age. In the intervening period caution takes control, and if I were now to attempt a revision of this book, I should want to qualify every sentence with so many dependent clauses and parentheses that the book would lose whatever utility it has, which is, I hope, to provide an introduction to the subject which may stimulate the reader to pursue it further.

PREFACE TO THE FOURTH IMPRESSION

THE arguments stated in the preface to the second impression still apply, and I have made no attempt to revise the text of this book systematically. I have corrected a few mistakes which had survived into the second edition and have removed a few references to out-of-date literature. The Bibliography has, however, been completely revised and extended to include the large number of new and often well annotated editions of texts which have appeared in the last ten or fifteen years.

1978.

PREFACE TO FIRST EDITION

THIS book is not meant to be an exhaustive treatise on the aesthetics of the Italian Renaissance. It is intended for the student of Italian painting who may feel that it is not enough to study the concrete works of art left by the painters of that period, but that a fuller comprehension can be gained of these works, and of the different movements in the arts, if we also know what the artists were consciously aiming at. Such knowledge can serve two main purposes: it can often give us a clue to the meaning of tendencies in a form of art which might otherwise be puzzling; and it can be used as a check on the theories which it is only too easy for us to read into the works of art which we have to interpret. If we see a feature in a painting, and then find that it is also set up as an ideal by the theoretical writers of the time, then we are doubly, and even more than doubly, sure that the feature really exists in the painting and is not the creation of our imagination.

The exact scope of the book should perhaps be defined. It deals with the artistic theory of the Italian Renaissance in its fully developed form, and is therefore primarily concerned with the sixteenth century. No attempt has been made to trace the relation between the theory of the early Quattro-cento and that of the Middle Ages, as this subject is one of great complexity and could only be dealt with adequately if a disproportionate amount of space was allowed it. Even the first writers of the Early Renaissance are hardly mentioned, though in some ways they foreshadow theories which later become of importance. Instead Alberti has been chosen as the starting-point, since it is in his writings that a full Humanist doctrine is formulated for the first time, and they are the source from which later ideas mainly derive.

The last three chapters of the book lead us beyond the Renaissance, in the strictest sense, since they deal with the

theories associated with the movement of Mannerism, which in Italy succeeded the Humanist art of the High Renaissance. But the doctrines of Mannerism form a logical sequel to those of the Renaissance and can conveniently be treated with them. The approximate date of 1600 has been chosen for the upper limit of the book, since after that time the whole character of artistic theory in Italy changes, and an account of it would demand an entirely different treatment, on a far larger scale.

The obligations incurred in the writing of this book are legion. First to the Master and Fellows of Trinity College, Cambridge, for giving me the means, in the form of scholarships and fellowship, to carry out the necessary research; and to the Courtauld Institute of Art, London University, my appointment at which allowed me to finish the work. To the Warburg Institute I also owe practical assistance, but it is overshadowed by a debt of a more spiritual kind. In the process of working with the members of this Institute I have had the inestimable advantage of seeing a really scientific method consistently applied, and any features of this book which are not wholly amateur are due to this example.

To individuals my debts are too wide to be acknowledged adequately. To Mr. A. Gow I owe encouragement and advice at a vital period; to Dr. F. Antal I am indebted for instruction in a method which has, I fear, been applied in an only too slipshod manner in this book and for many ideas on individual points; to Mr. Guy Burgess the stimulus of constant discussion and suggestions on all the more basic points at issue. Dr. Saxl, Dr. Wittkower, Dr. Wind, and Professor Boase have all earned my gratitude by reading either manuscript or proofs and making valuable emendations. Finally I would thank my mother, Miss Margaret Whinney, and Miss Ida Herz for help in the preparation and copying of the manuscript, and my brother and sister-in-law for providing shelter and quiet during the actual writing of the book.

A. B.

28 January 1940

CONTENTS

LIST OF PLATES

Chapter I

ALBERTI[1]

WITH the generation of Brunelleschi, Masaccio, and Donatello in Florence a new ideal of art was realized, which expressed the aspirations of the most progressive minds in Florence at a moment when the city-republic reached a high point in its development. As the last remains of Gothic disappear, a style emerges which expresses men's new approach to the world, their Humanist confidence, and their reliance on the methods of reason. In painting and sculpture naturalism flourished, but a naturalism based on the scientific study of the outside world by means of the new weapons of perspective and anatomy. In architecture the revival of Roman forms was used to create a style which answered to the demands of human reason rather than to the more mystical needs of medieval Catholicism.

Such a change in the practice of the arts was, of course, accompanied by a similar change in the theories which were held about them. Medieval writers on painting had been predominantly theological in their approach. For them the arts were entirely subject to the direction of the Church; they accepted its general scale of values, which emphasized the spiritual and had no interest in the material; and for this reason they made no demand that artists should imitate the outside world. Their duty was rather to evolve the appropriate symbol to convey the moral and religious lessons of the Church. The painter was a craftsman who performed a practical function under the direction of the Church, and

[1] For details of the various texts referred to in this and later chapters and for books and articles dealing with the subjects treated, see the Bibliography on pp. 160 ff.

through the organization of the Guilds, like any other kind
of craftsman.

The generation of 1420 regarded the arts in a very different
spirit. For them painting consisted first and foremost in the
rendering of the outside world according to the principles
of human reason. Therefore they could no longer acknow-
ledge a theory of the arts which did not allow any place to
naturalism or to the scientific study of the material world.
The new ideas which they formulated are most fully expressed
in the writings of Leon Battista Alberti, whose universal
intelligence particularly suited him for expounding a doctrine
which affected all branches of human activity—political life,
and philosophy, just as much as literature and the arts.

Alberti did not, of course, leap into a wholly unprepared
world with a ready-made theory. There had been men
before him who had hinted at the doctrines which he was to
enunciate with such clarity and completeness. In Cennino
Cennini, for instance, we find traces of the new naturalism
which was already growing up in the Trecento, and in
Lorenzo Ghiberti the new feeling for antiquity makes its
appearance.[1] But these and the other points of detail which
can be traced in writers before Alberti's time are only indica-
tions of what is to come. Their real significance only be-
comes clear when we consider them in connexion with the
whole new view of the arts and of the world as we find it set
forth in Alberti.

Alberti was the illegitimate son of a Florentine merchant.
He was born in 1404 in Genoa, where his father had moved
after the decree of exile which had been passed on the whole

[1] For the predecessors of Alberti cf. the following works: for Cennini,
Il Libro dell' Arte, ed. by D. V. Thompson (1933); for Ghiberti, *I Com-
mentarii*, ed. by Schlosser (1912); for the Trecento and early Quattro-
cento in general, J. von Schlosser, *Präludien*, and the following articles
by L. Venturi: 'La Critica d'arte e Francesco Petrarca', *L'Arte*, xxv;
'La Critica d'arte nel Trecento e nel Quattrocento', *L'Arte*, xx; 'La
Critica d'arte al fine del Trecento', *L'Arte*, xxviii.

Alberti family, one of the richest and most powerful in Florence. He was educated in the north of Italy, principally in Bologna, where he studied Law. He seems to have gone to Florence in 1428, when the ban on his family had been lifted, and the next few years, which must have been of vital importance in his formation, coincided with the end of that period when Florence was dominated by the big merchants, who had achieved a greater power than they had held for nearly a century.

The rest of Alberti's life was spent for the most part either in Florence or following the Papal Court, in which he held a secretarial post from 1432 to 1464. Papal policy was at this period increasingly concentrated on central Italy, and relied largely on the merchant class and its support. The outlook, too, in Papal circles was Humanist in character, so that Alberti found there a similar atmosphere to that of his own city, Florence.

In his width of knowledge, as well as in his rational and scientific approach, Alberti was typical of the early Humanists. He worked apparently with equal ease in the fields of philosophy, science, classical learning, and the arts. He wrote pamphlets or treatises on ethics, love, religion, sociology, law, mathematics, and different branches of the natural sciences. He also wrote verses, and his intimacy with the Classics was so great that two of his own works, a comedy and a dialogue in the manner of Lucian, were accepted as newly discovered writings of the ancients. In the arts, he practised and wrote about painting, sculpture, and architecture. Indeed, his grasp of all forms of learning was so encyclopaedic that he well deserved the praise written by a contemporary copyist in a manuscript of the *Trivi*: 'Dic quid tandem nesciverit hic vir?'

Alberti's views about the arts are so closely dependent on his general philosophical attitude that it is worth while analysing the latter in some detail. His outlook on life was

precisely that of the Humanists of the first half of the fifteenth
century, and corresponds to the conception of the city-state
as it existed in Florence before the final triumph of Cosimo
de' Medici.

For Alberti the highest good is the public interest. To
this princes and individual citizens are equally bound. The
prince must govern in the interests of the citizens, preserve
their liberties, and obey the laws of the city, or he becomes
a tyrant. Above all the peace of the city must be preserved,
and Alberti strongly condemns the factions which arouse
civil strife and from which his own family had suffered so
much. Those who hold office under the prince must equally
seek the general good. The judge, for instance, whose func-
tions Alberti discusses at length, must administer the law
with firmness but with moderation and humanity, so that
public and private interest may be protected, but so that no
greater suffering than is necessary may be inflicted on those
who infringe the law. Some of his views on punishment are
strangely modern; for though he admits the use of torture
as a means of arriving at the truth, he attacks the bad prisons
of his time and sets down the principle that prisons are
intended to reform, not to destroy, the criminal.

Alberti is not a strict republican. In the fifth book of the
treatise on architecture he discusses the different forms of
government, and though he approves strongly of the republic-
city he does not exclude the idea of government by a prince,
provided that he governs in the interests of the city. But
when Alberti speaks of the public good, he does not mean
the good of some abstract entity, 'the State', he means
the good of all the individual citizens who make up the
State. And he is therefore as much interested in the in-
dividual citizen as in the prince or those who govern for
the prince.

The first aim of the individual is to be a good citizen, that
is to say, to serve his fellow-citizens as far as possible. He

can only attain this end by the pursuit of virtue, and it is to methods of acquiring virtue that Alberti devotes most of his purely ethical writings. His rules can be summarized as follows. The individual must seek virtue by the application of the will, by the use of reason, and by following nature. Will supplies the driving force. A man, he says, can achieve as much as he wishes to achieve. But it is only through reason that he can know what he should aim at, and what he should avoid. Finally man must follow nature in the sense that he must know the end for which he was created, and try to attain it; he must discover why nature gave him certain faculties, and develop them, unless he is sure that they are bad. So, for instance, Alberti believes that man must aim at spiritual good and not be bound by the senses and the passions; he must be superior to material things and so be independent of fate. Yet he is strongly opposed to the extreme of Stoicism as represented by the Cynicism of Diogenes, since he finds it contrary to nature. It is inhuman not to be moved by any emotions at all. What man needs is to be moderate in his feelings, and to enjoy the things of this world without being tied to them. In fact, the moderation which is one of the results of following reason is the most significant and often recurring feature of Alberti's doctrine. It leads to the calm of mind which is for him a necessary condition for the right conduct of life.

The outstanding characteristic of Alberti's view of life is this rationalism, based more on ancient philosophy than on the teachings of Catholicism. But this does not imply that he was opposed to Christianity. On the contrary he constantly pays his respects to it, but it is before a curious form of Christianity that he bows, a typical Humanist religion in which elements of pagan and classical philosophy blend without any difficulty with Christian dogmas, in which churches are referred to as 'Temples' and in which sometimes 'the gods', in the plural, seem to receive as much

honour as the Christian God.[1] With this humanized religion Alberti feels himself entirely at home, but he will not give up his right to individual judgement on every matter. Even the ancients, for whom he has a deeper reverence than for any other persons, human or divine, he treats on a level and does not feel himself obliged to follow either their precept or their example if his own judgement tells him otherwise.

We shall find many of Alberti's ideas on these general philosophical and political subjects reflected in his theoretical writings in the aesthetic field, but before we go on to them we must consider the actual works which he left behind him in the arts. In painting and sculpture nothing survives from his hand, but in architecture his contribution is considerable. His position is that of a younger member of the group which, under the leadership of Brunelleschi, dominated Florence at the time of his return there in 1428. He carried on their work and developed many of their principles a stage further.

Alberti was a more fully self-conscious classicist than Brunelleschi and his contemporaries. He was more learned in the study of antiquity than they, more scientific in his application of the archaeological knowledge which he had acquired. In architecture he eliminates the last traces of Gothic, which were still so evident in Brunelleschi, especially in the dome of the cathedral. He was far more scrupulous in his treatment of the orders (cf. Plate 1); and in the Palazzo Rucellai he adapted them for use on a facade of more than one story, by using a single order for each—a method which was later universally adopted. In other ways he carried on the tradition of clear design which was an essential feature of Brunelleschi's work. His design for S. Sebastiano at Mantua is perhaps the most mature centralized church plan of the time, and his S. Andrea, in the same town, was the last word in lucid spacing of the Latin Cross church. The

[1] Cf. *De Re Aed.*, bk. vii, ch. 3.

PLATE 1

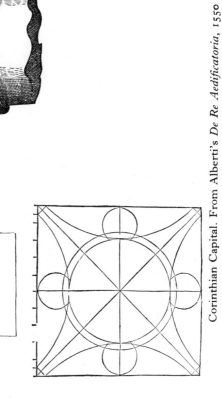

Corinthian Capital. From Alberti's *De Re Aedificatoria*, 1550

latter was of dominant importance in church design for several centuries.

His theoretical ideas on the arts are to be found principally in three works. The earliest is the treatise on painting, *Della Pittura di Leon Battista Alberti Libri tre*, written in 1436 probably in Latin, but translated by Alberti himself for Brunelleschi's benefit into Italian. The second and the most considerable of the treatises consists of the ten books of architecture, *De Re Aedificatoria*, which Alberti began probably about 1450, but to which he went on making additions and alterations till the time of his death in 1472. The last work is the pamphlet on sculpture, *De Statua*, written probably shortly before 1464.

Since architecture is the art most closely connected with the practical needs of man, it is in Alberti's architectural theories that his general social ideas are most visibly reflected. He thinks of architecture entirely as a civic activity. In the preface to his treatise, which is a sort of apologia for architecture, he speaks above all of the glory which it brings to the city, in utility and in ornament. Architecture serves commerce, of which, as we should expect, Alberti speaks in the highest terms; it enables the city to defend itself against its enemies, and, by inventing aggressive machines of war, even helps it to extend its dominion. From architecture the city derives its splendid public buildings, its private houses, and the monuments which keep alive the memory of its great men.

It is the principles of such a civil architecture that Alberti expounds in his treatise, not an architecture for private patrons or ecclesiastical purposes only, though, of course, the needs of both the individual and the Church are carefully considered. The novelty in his method is that he proposes a scheme for the building of an entire town, and every detail in his suggestions is made subordinate to the main design of the town as a whole.

The first three books of the treatise are given up to purely

technical matters; the first to the use of drawings in architecture, the second to the choice of materials, and the third to the principles of structure. After this preliminary Alberti attacks at once the problems which concern the town as a whole, first of all the question of its site. This must be healthy, in a temperate climate, conveniently placed for water-supply, easy to defend, and so on.[1] Next it must be clearly laid out, with good main streets conveniently connected with the bridges and gates of the town. The streets must be wide enough not to be congested but not so wide as to be too hot.[2] Moreover, Alberti proposes that if possible the streets shall be so designed that symmetry may reign between the houses on the two sides of the street, and that a standard design may be repeated for a whole street[3] (Plate 2). This is a piece of large-scale planning which reveals Alberti's astonishing civic-mindedness, for this suggestion was not put into general practice till the seventeenth and eighteenth centuries, when town life had reached a far more advanced stage of development.[4] It is in marked contrast to the medieval method of town planning, against which Alberti explicitly protests, according to which each family built a palace and a tower without any consideration of its neighbours, except one of rivalry.[5]

[1] *De Re Aed.*, bk. iv, ch. 2.
[2] Ibid., bk. iv, ch. 5.
[3] Ibid., bk. viii, ch. 6.
[4] In a sense he was only giving systematic form to a tendency already visible in Italian architecture of the fourteenth century. Many north Italian towns, such as Cremona and Piacenza, had central squares round which were grouped the principal public buildings. But it was not till the fifteenth century that we find a standard design repeated round a square, as in the Piazza of St. Mark's in Venice, or that in front of the Annunziata in Florence, both of which were in great part laid out in the Quattrocento. Pius II's plans for Pienza show something of the same spirit, and Nicholas V's idea for linking up St. Peter's with the Castel S. Angelo, in which Alberti was involved, is an even more ambitious scheme of the same kind.
[5] *De Re Aed.*, bk. viii, ch. 5.

PLATE 2

Design for a market-place. From Alberti's *De Re Aedificatoria*, 1550

Having thus settled the questions which affect the whole layout of the town, Alberti proceeds to consider the different kinds of buildings which are to be put up in it. He divides these into three groups: public buildings, the houses of the important citizens, and the houses of the people.[1] Over the first type he is very thorough and gives the fullest details about the planning and construction of squares, towers, bridges, halls of justice, churches, and theatres, which must all be carried out with the greatest possible splendour as befits the dignity of the city.[2] The houses of the leading citizens must also be dignified, but they must avoid all ostentation, and rely more on beauty of design and convenience of disposition than on size or ornament.[3] Otherwise they will arouse the envy of their neighbours, and the harmony of the whole design will be disturbed. The houses of the poorer citizens should be built on the same scheme as those of the richer, but in a smaller and more modest manner, so that the difference between the positions of the richer and poorer citizens will not be too strongly marked.[4] In each of these cases Alberti gives fairly complete rules for the buildings which he proposes, so that the same principles appear in each detail as in the whole scheme of the town.

In Alberti's other writings on the arts his social and ethical views are not so clearly reflected, but in all of them we find the spirit of rational Humanism which is characteristic of his philosophical works.

Certain of his predecessors, such as Cennini and Ghiberti,

[1] Ibid., bk. iv, ch. 1.
[2] Ibid., bk. viii, &c.
[3] Ibid., bk. ix, ch. 1. By leading citizens Alberti means those who are responsible for the government of the city; and the qualifications which he demands for this are highly typical: either wisdom, which will fit a man for making laws and for supervising the religious life of the town; or experience, which will give him a place in the executive; or wealth, which brings prosperity to the city, and alone makes it possible for the other two groups to perform their functions. (Cf. bk. iv, ch. 1.)
[4] Ibid., bk. ix, ch. 1.

had maintained that the artist was an independent individual, who needed to be acquainted with the liberal arts, and no one could have carried out this principle more thoroughly in practice than Alberti. His conception of the architect appears most clearly in the definition which he gives in the preface to the book on architecture:

'Before I go any further I think it will be convenient to say whom exactly I mean to call an architect; for I will not set up before you a carpenter and ask you to regard him as the equal of men deeply versed in the other sciences, though it is true that the man who works with his hands serves as an instrument for the architect. I will call an architect one who, with a sure and marvellous reason and rule, knows first how to divide things with his mind and intelligence, secondly how rightly to put together in the carrying out of the work all those materials which, by the movements of weights and the conjoining and heaping up of bodies, may serve successfully and with dignity the needs of man. And in the carrying out of this task he will have need of the best and most excellent knowledge.'

He is less elaborate in his definition of the painter, but here again he wishes him to be acquainted with all the forms of knowledge which are relevant to his art, particularly history, poetry, and mathematics.[1]

This is the most complete definition of the artist as a man engaged in a scientific occupation that can be found in the Early Renaissance; and this conception runs through the whole of Alberti's writings. Each of the treatises on the arts begins with a statement of the scientific basis of the art in question. In the case of architecture, for instance, the first book is mainly given up to the importance of drawings, which Alberti regards as the link between architecture and mathematics. The second deals with the knowledge of the materials necessary to building, and the third to methods of construc-

[1] 'Della Pittura', in *Leone Battista Albertis kleinere kunsttheoretische Schriften*, ed. Janitschek, p. 145.

tion. These three books cover the two aspects of the scientific study of architecture—first the purely theoretical and then the technical. In the treatise on painting the first book is devoted to mathematics and to the application of geometry to painting in the form of perspective.

On this solid foundation of science Alberti builds up a structure of the arts which is no less scientific. 'The arts', he says, 'are learnt by reason and method; they are mastered by practice,'[1] and this could almost be taken as the motto of the book. According to him the artist must grasp the fundamental principles of his art by means of reason; he must study the best works that have been produced by other artists before his time; and by this means he will be able to formulate precepts about the practice of the arts,[2] which, however, must always be combined with practical experience.

Alberti's scientific approach is only part of his general Humanism, for science is the finest fruit of the application of human reason to the study of the world. There is hardly a trace in him of the theological preoccupations which dominated the thought of medieval writers. His definitions of the arts do not include any reference to religion and are entirely framed in human terms. In the case of architecture he does not talk of its use in the service of the Church, except by the way. His basic proposition is that 'Buildings have been made because of men', and he develops this idea by saying that buildings are made either to satisfy the needs of life or for the convenience of men's occupations, or for their delight.[3] His attitude towards painting is the same. For him history painting, i.e. subject painting of any kind, as opposed to that of single figures, is the noblest kind of painting, partly because it is the most difficult genre and one which demands proficiency in all the others,[4] but also because

[1] 'De Statua', in Janitschek, op. cit., p. 189.
[2] *De Re Aed.*, bk. vi, ch. 3. [3] Ibid., bk. iv, ch. 1.
[4] 'Della Pittura', ed. cit., pp. 105, 117.

it gives a picture of the activities of man, like a written history. 'And I may well stand looking at a picture . . . with no less delight to my mind than if I was reading a good history; for both are painters, one painting with words and the other with the brush.'[1] A history painting affects the spectator deeply because the emotions which he sees represented in it will be stirred in him; he will laugh, cry, or shiver according as those in the painting show joy, sorrow, or fear.[2] For this reason Alberti attributes great importance to the ability of the painter to explain an action and to render the emotions by means of gesture and by the expression of the face.[3]

In the arts as in all other fields this Humanism is combined with a strong admiration for classical antiquity. Ghiberti had expressed his admiration for the ancients in general terms and quoted them often, but he had not the absolute cult for them which characterizes Alberti. It has already been said that in style Alberti's actual buildings are more strictly in accordance with the practice of ancient Roman architecture than any works of his predecessors, and in his theoretical writings we find the same spirit. The ancients appear at every turn. The picture which he gives of the ideal town is almost entirely made up of elements taken from antiquity. The models which he quotes for the buildings, public or private, are almost always those that he has seen in Rome or read about in ancient writers; and the authorities to whom he refers for any method which he recommends are the historians and philosophers of Greece and Rome.[4]

We can see from his descriptions that he had an intimate knowledge of the remains of ancient architecture in Italy,

[1] *De Re Aed.*, bk. vii, ch. 10.
[2] 'Della Pittura', ed. cit., p. 121. [3] Ibid.
[4] In general Alberti displays a greater admiration for Rome than for Greece. He maintains, for instance, that architecture reached its first maturity in Greece but its final perfection in Rome (cf. *De Re Aed.*, bk. vi, ch. 3).

and that he had studied them first of all from the point of view of structure and planning. He wished to understand the real principles of Roman architecture, not merely to be able to produce a building which looked classical on the outside but underneath was Gothic in design. This does not, however, mean that he neglected the question of ornament and decoration, and one of the most typical features of the treatise is that it contains the first exposition of the use of the Five Orders in Italy since classical times. Brunelleschi and his contemporaries had used them in their buildings, but always with great freedom, and there was evidently no recognized canon for the proportions of their different parts. Compared with later theoretical treatments of the orders Alberti's seems simple and cursory, but it gave a new foundation for their correct use.

But though Alberti was possessed of a really extensive and first-hand knowledge of ancient architecture, he was never either pedantic or slavish in his application of it. He considers the ancients as the best models, but he never encourages the modern architect to imitate them blindly. On the contrary, he advises him to try always to introduce into his designs something entirely of his own invention.[1] He says that he found the information supplied by Vitruvius of great use,[2] but he is far from setting him up as the final authority. In fact in one place he speaks of him with very little respect, complaining that his style is so obscure and confused that it is almost impossible to understand what he means.[3] In this as in all other matters, therefore, Alberti reserves the right to judge every problem which comes before him on its own merits.

The rational and scientific method which, as we have seen,

[1] Ibid., bk. ix, ch. 10.
[2] Though what he learnt from the study of surviving buildings was even more helpful (cf. ibid., bk. iii, ch. 16).
[3] Ibid., bk. vi, ch. 1.

Alberti pursues in architecture appears in connexion with painting and sculpture in the form of a new conception of realism. The core of his views about the representational arts is to be found in his theory of the imitation of nature, and it is here that his realism can be most clearly traced.

In certain contexts he defines painting in terms of an absolutely unqualified naturalism: 'The function of the painter is to render with lines and colours, on a given panel or wall, the visible surface of any body, so that at a certain distance and from a certain position it appears in relief and just like the body itself.'[1] But on other occasions he is more scientific and defines painting as the imitation of a section of the pyramid which any body subtends at the eye of an observer.[2] He even invented a device for recording the appearance of such a section, namely, a net which the painter held between himself and the object to be painted, and on which he could trace exactly the outlines which appeared through it.[3] This idea of the pyramid leading from the object seen to the eye is the foundation of linear perspective, so that Alberti's net is only a method for recording the correct view of an object according to linear perspective; it has, however, the disadvantage that it can only be applied to scenes which are visible to the eye. When the painter came to construct compositions of things which he had not actually seen, he had need of a more efficient device, and this was supplied by the full theory of perspective which Alberti expounds in the first two books of his treatise on painting.

[1] 'Della Pittura', ed. cit., p. 143. This naturalism is reflected in certain examples which Alberti gives; as, for instance, when he refers to Narcissus as the first painter, since his image reflected in the water was an exact likeness of himself on a flat surface (ibid., p. 91).

[2] Ibid., p. 69.

[3] Ibid., p. 101. In the 'De Statua' Alberti supplies the sculptor with an apparatus by means of which he, too, can attain the mathematical certainty which realism demanded. It consisted of a series of circles and plumb-lines which allowed the sculptor to measure in terms of height and projection the contour of any figure or three-dimensional object.

But though the exact imitation of nature is the first function of painting it has another and more important duty. The painter must make his work beautiful as well as accurate, and beauty does not necessarily follow from exactness of imitation as Alberti shows by the example of the ancient painter Demetrius, 'who failed to obtain the highest praise, because he paid much more attention to making paintings which were true to nature than to making them beautiful'.[1] Beauty, therefore, is a quality which is not necessarily inherent in all natural objects, though nature is the only source from which the artist can derive it. The artist, therefore, must not use nature indiscriminately: 'We must always take what we paint from nature and always choose from it the most beautiful things.'[2] This process of selection is essential because 'it is very rarely granted even to Nature herself to produce anything absolutely perfect in every part'.[3]

Alberti does not explicitly define and describe this beauty which is not attainable in art by mere imitation. In the treatise on painting he does not pursue the matter, but evidently assumes that his readers will know beauty when they see it. In the later and much more elaborate *De Re Aedificatoria* he gives two definitions of beauty which are roughly those to be found in Vitruvius. In one case he describes beauty as 'a certain regular harmony of all the parts of a thing of such a kind that nothing could be added or taken away or altered without making it less pleasing'.[4] In the second definition he says: 'Beauty is a kind of harmony and concord of all the parts to form a whole which is constructed according to a fixed number, and a certain relation and order, as symmetry, the highest and most perfect law of nature, demands.'[5] Perhaps more important is another

[1] Ibid., p. 151.
[2] Ibid., p. 153.
[3] *De Re Aed.*, bk. vi, ch. 2.
[4] Ibid.
[5] Ibid., bk. ix, ch. 5.

passage in the same treatise in which he expands the idea, again with reference to architecture:

'What pleases us in the most beautiful and lovely things springs either from a rational inspiration of the mind, or from the hand of the artist or is produced by nature from materials. The business of the mind is the choice, division, ordering and things of that kind, which give dignity to the work. The business of the human hand is the collecting, adding, taking away, outlining, careful working and things of that kind, which give grace to the work. From nature things acquire heaviness, lightness, thickness and purity.'[1]

We may suppose, I think, that Alberti would admit a parallel view of painting in which the mind controlled the disposition, the hand contributed skill in technique, and nature added richness of material; though from what he says elsewhere about those who waste their time using gold and rich colours in painting and pay little attention to skill in using them,[2] it seems probable that, unlike medieval artists, he attributed small importance to the part which nature plays in painting by supplying good materials.

Alberti considers that beauty gives pleasure to the eye,[3] and it is partly by this means that we can recognize it. But he does not identify the recognition of beauty with this feeling. In the treatise on architecture he explicitly distinguishes between the two processes of liking a thing and judging it to be beautiful. He is talking of people's tastes in women, how some prefer them fat, others thin, others medium:

'But, because you like one kind or another more, will you maintain that the others are not noble and beautiful in form? Certainly not. That you liked this particular woman depends on some cause, but what that cause is I will not try to discover. But when you judge about beauty, that does not depend on mere

[1] *De Re Aed.*, bk. vi, ch. 4.
[2] 'Della Pittura', ed. cit., p. 139; cf. also p. 91.
[3] *De Re Aed.*, bk. ix, ch. 8.

opinion but on a certain judgement innate in our minds' (*animis innata quaedam ratio*).[1]

And elsewhere he differentiates between personal taste and the judgement that a thing is beautiful:

'Many . . . say that our ideas of beauty and architecture are wholly false, maintaining that the forms of buildings are various and changeable according to the taste of each individual and not dependent on any rules of art. This is a common error of ignorance, to maintain that what it does not know does not exist.'[2]

All this can be summed up by saying that Alberti believes that man recognizes beauty not by mere taste, which is entirely personal and variable and judges of attractiveness, but by a rational faculty which is common to all men and leads to a general agreement about which works of art are beautiful. Beauty, in fact, is detected by a faculty of artistic judgement.

The artist must take pains to introduce as much of the beautiful and as little of the ugly as possible into his paintings. First of all he must cover up or leave out any imperfections in his model; and this concealing of flaws is said by Alberti to be the particular function of ornament.[3] In the next stage the artist must carefully select from the various models before him all the most beautiful parts in order to combine them into a single faultless whole: 'He must take from all the beautiful bodies those parts which are particularly praised . . . which will be difficult because perfect beauty is never to be found in any one body but is scattered and dispersed in many different bodies.'[4]

In the book on sculpture this theory is further developed. The book ends with a table of the proportions of a man, which is prefaced with the following passage:

'We have taken the trouble to set down the principal measure-

[1] Ibid., bk. ix, ch. 5. [2] Ibid., bk. vi, ch. 2.
[3] Cf. 'Della Pittura', ed. cit., p. 119, and *De Re Aed.*, bk. vi, ch. 2.
[4] 'Della Pittura', ed. cit., p. 151.

ments of a man. We did not, however, choose this or that single body, but as far as possible we have tried to note and set down in writing the highest beauty scattered, as if in calculated portions, among many bodies. . . . We have chosen a number of bodies considered by the skilful to be the most beautiful and have taken the dimensions of each of these. These we compared together, and leaving aside the extreme measurements which were below or above certain limits, we chose out those which the agreement of many cases showed to be the average.'[1]

This shows a new feature in Alberti's theory of imitation, namely, the desire to make his figures conform not only to the most beautiful in nature but to the most usual, the most general, or the most typical.

This identification of the beautiful with the typical in nature implies a belief in the Aristotelian view of nature as an artist striving towards perfection and always hindered from attaining it by accident.[2] According to this view the artist, by eliminating the imperfections in natural objects and combining their most typical parts, reveals what nature is always aiming at but is always frustrated from producing. Alberti has simplified Aristotle's views on this point, for he arrives at the type-beauty by a process of more or less arithmetical averaging, whereas in Aristotle some faculty nearer to the imagination is involved.

This very matter-of-fact averaging technique, however, is characteristic of Alberti and illustrates how far he was removed from any sort of idealistic or Neoplatonic conceptions. From what he says about choosing the best and the typical from nature it follows that the artist can create a work which is more beautiful than anything in nature. But with Alberti this can only be done by a series of processes all of which keep the artist in the closest touch with nature, and it is done without any appeal to the imagination. The impor-

[1] 'De Statua', p. 199.

[2] This conception of nature is related to Alberti's view that man should follow nature in his way of living. Cf. above, p. 5.

tance of this will appear when the development of aesthetics in the sixteenth century is considered. For the moment it is enough to notice how consistent Alberti is in his fidelity to nature. Towards the end of the treatise on painting, after he has been advising the artist only to select the best from nature, he is immediately frightened that he may have gone too far and puts in a warning to those who think they can neglect nature and rely on their own skill and imagination. They will fall into bad ways, he says, from which they will never be able to free themselves.[1]

Alberti varies a little in the meaning which he attaches to the word 'nature'. In the early treatise on painting he generally seems to mean by it simply the sum of all the material objects not made by man. In the later works on sculpture he seems to assume the vaguely Aristotelian view discussed above. One of the most curious results to which Alberti's acceptance of this definition of nature leads him is to describe architecture as an imitation of nature, just as much as the directly representational arts. The idea underlying this view is that nature acts according to certain general laws and on an orderly method. The aim of the architect is, therefore, to infuse into his works something of this order and method which is to be found in nature. Ancient architects, he says, 'rightly maintained that nature, the greatest of all artists in the invention of forms, was always their model. Therefore they collected the laws, according to which she works in her productions as far as was humanly possible, and introduced them into their method of building.'[2] The principles to which Alberti refers are defined by such qualities as harmony (*concinnitas*), proportion, symmetry.[3]

There is nothing startlingly original in this view, which is made up of ideas taken from Aristotle and Vitruvius, but Alberti was not primarily interested in abstract aesthetic

[1] 'Della Pittura', ed. cit., pp. 151 and 153.
[2] *De Re Aed.*, bk. ix, ch. 5. [3] Ibid.

speculation, and when he comes to discuss these very general qualities he often takes over traditional theories from the ancients. He himself distinguishes the laws governing the beauty of buildings as a whole which are derived from philosophy from those dealing with the parts of the building which, based on experience, are the proper business of the architect and the real foundation of architecture.[1]

When Alberti first evolved his philosophy he was in close agreement and sympathy with many of the best thinkers in Florence. But when he again came into contact with Florentine society in the last years of his life, between 1464 and 1472, he found that life and culture there had changed. The Medici were now in complete control of the city, and, under their autocratic rule, life had grown more luxurious. Men's philosophy, too, had changed. For Florentine culture of the later Quattrocento was dominated by the Neoplatonists led by Marsilio Ficino and Pico della Mirandola.

Alberti's relation to Platonism is somewhat complex. Many of the fundamental ideas in his philosophy are ultimately Platonic in origin, and Alberti very likely derived them from the Florentine followers of Plato in the fourteenth and early fifteenth centuries, such as Petrarch or Bruni. His faith in man and in the human will, his doctrine of following nature, his conception of the prince, and many others of his opinions are to be traced in the writings of the early Humanist admirers of Plato such as Salutati.[2] But by the end of the fifteenth century the philosophy of the Platonists in Florence had entirely changed. Under the influence of Cosimo and Lorenzo de' Medici the Platonic Academy had developed, but it had tended to pay even more attention to the writings of the Alexandrian exponents of Plato than to the philosopher himself. Ficino and Pico are soaked in mysticism, derived partly from Plotinus and partly from oriental origins. This

[1] *De Re Aed.* bk. vi, ch. 5.
[2] Cf. N. Robb, *Neoplatonism of the Italian Renaissance*, 1935, ch. 2.

mystical Neoplatonism was encouraged by Lorenzo de' Medici, perhaps to some extent for political reasons. At any rate it certainly served his ends; for the Neoplatonists at this time laid much more emphasis on the contemplative than on the active life; and it suits an autocrat to keep thinking men as far as possible out of active politics in order that he may enjoy his absolute power undisturbed.

Alberti seems to have felt little sympathy either with the methods of Lorenzo or with the mystical kind of Neoplatonism which he encouraged. He is sometimes claimed as a supporter of the Neoplatonists on the grounds that he was involved in many of their discussions. But his agreement with them appears to be limited to the doctrines which they held in common with earlier Platonists, and did not extend to those more mystical ideas which Ficino and Pico had added. Nothing could be less mystical than Alberti's way of thought. He believed above all in the importance of the active life, and thought that the citizen should contribute tangibly and materially to the good of the city.[1] Indeed, to the Florentines of the late 1460's Alberti must have seemed a relic of the heroic period of thirty years before. In his last work, the *De Iciarchia*, he condemns the luxury of the city, and attacks the Medici almost openly, saying that great power awakens vices in a man, and reminding them that the prince is subject to the laws of the city and must preserve its liberties.

Seen in relation to his predecessors, Alberti's most striking characteristics are his rationalism, his classicism, his scientific method, and his complete faith in nature. In relation to the Neoplatonists of the later Quattrocento, the feature which stands out most is the complete absence of the idea of

[1] A typical example of the difference between Alberti and the Neoplatonists appears in their views on love. Ficino and Pico had developed the mystical beliefs of the Alexandrian Platonists, and they regarded love as the contemplation of divine beauty. For Alberti love had above all a social function, and it is as the basis of family life that it appears most frequently in his writings.

imagination in his writings. Everything is attributed to reason, to method, to imitation, to measurement; nothing to the creative faculty. And this is quite logical. The artists of the early Quattrocento whose ideas he expresses were entirely occupied with exploring the visible universe which they had so recently discovered. What they needed was practical advice, not abstract speculation; and that is exactly what Alberti gave them. It was not till the next century that the doctrines of Neoplatonism came into real contact with the theory of painting, most notably in the person of Michelangelo, whose first training was received in the circle of Lorenzo de' Medici. With him the artist becomes for the first time 'the Divine', and Alberti's practical conception of the arts gives place to a loftier doctrine.

Chapter II

LEONARDO

APART from Michelangelo, Leonardo is the only great painter of the Italian Renaissance who has left in writing any quantity of material dealing with the arts, and we should expect that the opinions and ideas of such a man would throw more light on Renaissance art-theories than all the systematic and philosophical treatises of the laymen who wrote in the sixteenth century. Many of his theories do, of course, give us information about the methods and ideas of the period which we cannot derive from other sources, but the confusion of the surviving manuscripts and the lack of plan in the notes make it impossible to deduce a really coherent theory of the arts from Leonardo's written works.

Leonardo evidently intended to write a full-dress treatise on painting, and, according to Luca Pacioli, some sections of it at least were finished by 1498. If this is so, the parts in question are lost, but many schemes for the general plan of the treatise, not all of them consistent with each other, survive in the existing material. What we actually have left of Leonardo's writing is an enormous mass of notes, mostly jotted on the margins of sketch-books. These notes are either passages which Leonardo copied down from what he read, or original ideas embodying a personal theory or observation.

The datable manuscripts cover a period from 1489 to 1518. The originals are to be found in many public and private libraries, particularly in Paris and at Windsor, and most of them have been published.[1] Even more important, however,

[1] Principally by J. P. Richter in *The Literary Works of Leonardo da Vinci*, London, 1880–3, and 1939; by C. Ravaisson-Mollien in *Les Manuscrits de Léonard de Vinci*, Paris, 1881–91; in the edition of the Codex Atlanticus published by the Accademia dei Lincei, Rome, 1884–1904; and by Beltrami in *Il Codice di Leonardo da Vinci nella Biblioteca del*

for the present purpose is a copy of the originals, now in the Vatican Library, made by a sixteenth-century student, evidently with the idea of publication, in which the notes are to some extent arranged by subjects.[1] The first printed edition, based on two other manuscript copies,[2] was published in Paris by Dufresne in 1651. It is of little importance for the study of the text, since it is incomplete and inaccurate, and its chief interest lies in the engravings illustrating it, which were made after drawings executed by Poussin in order to explain points in Leonardo's writings.

Leonardo was born in 1452, and as he grew up in Florence the main intellectual influence in the city was that of the Neoplatonists who were discussed in the last chapter. But though they dominated the philosophical field, the old scientific method in the arts, which we have seen in the work of Alberti, survived in the form of a studio tradition, above all through painters such as Verrocchio, under whom Leonardo studied.

The basis of Leonardo's scientific observations, which covered every branch of the study of natural phenomena—zoology, anatomy, botany, geology, as well as mechanical and mathematical problems—was a profound belief in the value of experiment and of direct observation. It was by what he actually saw—in the human body, in plants, or in the formation of rocks—that he entirely outstripped his contemporaries, even the experts in the various sciences which he studied. His knowledge of human anatomy was not attained by members of the medical profession for half a

Principe Trivulzio in Milano, Milan, 1891. The Commissione Vinciana has begun a complete edition of the manuscripts.

[1] This manuscript formed the basis of the edition of Leonardo's writings prepared by H. Ludwig for Eitelberger's *Quellenschriften für Kunstgeschichte*, which is the most convenient edition, and that generally referred to here.

[2] The Codex Barberini and a manuscript in the Ambrosiana.

century after his death, and many of the facts which he observed had to wait still longer before they could be properly fitted into man's scheme of the universe.

He expresses his faith in experiment on many occasions. In one group of notes he attacks the abstract speculations of the Scholastics. He exactly reverses the medieval canon that a science is only certain if it is purely speculative and merely mechanical if it comes into contact with the material universe:

'They say that any knowledge is mechanical if it is the product of experiment, that it is scientific if it begins and ends in the mind, and that it is semi-mechanical if it springs from pure knowledge and ends in a manual activity. But it seems to me that those sciences are vain and full of error which do not spring from experiment, the source of all certainty, and which do not lead to experimental truth, of which, that is to say, neither the beginning, the middle nor the end is dependent on one of the five senses. And if we doubt the certainty of everything which comes to us through the senses, how much more should we doubt those things which cannot be tested by the senses, such as the nature of God and of the soul and such things.'[1]

Here Leonardo's faith in the material world and in the evidence of the senses has led him to opinions which in less secure times would have brought trouble from the Church authorities, but the passage shows how deeply he was opposed to speculation not based on experiment. His real feeling is summed up in the formula, borrowed from Aristotle, 'All our knowledge has its origin in our perceptions'.[2]

Leonardo applied the same argument to the principle of authority as to the method of abstract speculation: 'Many will think they may reasonably blame me by alleging that my proofs are opposed to the authority of certain men held in the highest reverence by their inexperienced judgements; not considering that my works are the issue of pure and simple

[1] Ludwig, op. cit., § 33. [2] Richter, op. cit., § 1147.

experiment, which is the one true mistress.'[1] This is an extension of the personal test for truth which Alberti and the early Humanists had already substituted for the test of authority. 'Any one who in an argument appeals to authority uses not his intelligence, but his memory.'[2]

In a sense Leonardo carried on the scientific principles which Alberti had applied to the arts; but there are important differences between their methods. Whereas Alberti applies the ordinary processes of deduction to the facts which he observes in order to arrive at general laws, Leonardo's strength lies in the actual observation of phenomena, and he is little given to deducing general laws from his observations. Moreover, such generalizations as he does make are usually closely based on the work of his predecessors, above all on the medieval philosophers.

For Leonardo, as for Alberti, painting is a science because of its foundation on mathematical perspective and on the study of nature. It is based on 'scientific and true principles';[3] but these principles are derived from observation, as appears when Leonardo, after putting down a series of practical hints for the painter, says that they are 'the issue of sound experience, the common mother of all the Sciences and Arts'.[4]

Considered as a kind of knowledge, the art of painting is to be judged by two standards: the certainty of its premisses and methods, and the completeness of the knowledge represented by its productions.

The certainty of painting depends on various facts: first it depends on the eye, which is the least easily deceived of all the senses;[5] secondly the painter does not rely wholly on the eye but checks its judgements by actual measurement;[6] and thirdly painting is based on the principles of geometry.[7]

[1] Richter, op. cit. § 12. [2] Ibid., § 1159.
[3] Ludwig, op. cit., § 33 [4] Richter, op. cit., § 18.
[5] Ludwig, op. cit., § 11. [6] Ibid., § 47 and cf. § 36.
[7] Ibid., § 3.

The importance which Leonardo attaches to the complete-ness with which an art represents nature, to the comprehen-siveness of its particular kind of truth, comes out most clearly in the disputes about the relative dignity of the various arts, the significance of which will be discussed later.[1] In arguing with the defenders of poetry Leonardo maintains that paint-ing is the finer art because 'it makes images of the works of nature with more truth than the poet',[2] and in other passages he expresses the same view in different ways. Painting is to poetry as reality to the shadow,[3] and elsewhere he says: 'Write up in one place the name of God, and put a figure representing him opposite, and see which will be the more deeply reverenced.'[4] The same idea comes out when Leonardo claims superiority for painting over sculpture because the latter cannot use colour, or aerial perspective, or depict luminous or transparent bodies, clouds, storms, and many other things.[5] All this suggests that the completeness with which an art represents nature is, after the certainty of its methods, one of the standards by which it is to be judged.

Since painting is a kind of science, its processes must be checked by rational judgement at each stage. 'He is a sorry master whose works are ahead of his judgement; but that master will go forward to the perfection of his art whose judgement exceeds his work.'[6] And the fact that judgement in art is a rational process is made even clearer in another section where Leonardo advises the artist to listen to the opinion of all his friends about his paintings: 'Be ready there-fore to hear with patience the opinions of others; and con-sider well and think carefully whether he that blames your work has cause or not to do so. If you find that he has, correct it; if not, pretend not to have understood him, or, if he is a man of merit, make him understand by reasoning (*per ragione*) that he is mistaken.'[7]

[1] Cf. below, Ch. IV. [2] Ludwig, op. cit., § 14. [3] Ibid., § 2.
[4] Ibid., § 19. [5] Ibid., § 38. [6] Ibid., § 57. [7] Ibid., § 75.

Painting, therefore, is a science, but it is different from other sciences because it involves the production of a material work of art. In an important passage Leonardo enumerates those elements, like perspective, which compose the science of painting and 'which exist in the mind of those that think about it. From this springs the execution (*operatione*), which is much nobler than the thinking or science'.[1] This is a remarkable inversion of the current idea, which Leonardo seems to accept on other occasions, that the actual execution was manual and for that reason despicable.

According to Leonardo, then, painting is a science having as its material product a work which is a reproduction of some part of nature. So we are back to the idea of painting as the scientific imitation of nature, though it will be seen later that Leonardo's ideas on this imitation are different from Alberti's.

Leonardo constantly emphasizes the fact that artistic imitation is a scientific act and not a mere mechanical process. He has particular scorn for those who ignore theory and think that by mere practice they can produce works of art: 'Those who devote themselves to practice without science are like sailors who put to sea without rudder or compass and who can never be certain where they are going. Practice must always be founded on sound theory.'[2] He also disapproves of those who rely on devices for exact imitation, like Alberti's net or the method of painting on a piece of glass held in front of the view. These should only be used as short-cuts and labour-saving tricks by those who have enough knowledge of theory, that is to say above all of perspective, to be able to check their work according to scientific standards.[3]

As with all Leonardo's ideas the originality of his conception of the imitation of nature can only be seen in his treatment of specific problems. A very large part of the notes is devoted to scientific observation of facts relevant to the

[1] Ludwig, op. cit., § 33. [2] Ibid., § 80. [3] Ibid., § 39.

painter. In some of them, for instance in those dealing with linear perspective, he is on ground which had already been covered by earlier authors, but in most of the subjects his observations are entirely original and of astonishing acuteness. In those sections in which he writes of the movements of a man and the attitudes which he will take up in performing different actions, he is perhaps only putting down what was to some extent the common property of Florentine painters, and following up the investigations of men like the Pollaiuolo brothers. His notes on botany, particularly on the growth of trees, are much more personal, for before his time men had paid little attention to the scientific study of inanimate nature for its own sake.

But the notes in which the exactness of his observation is most startlingly apparent are those dealing with light and shade and those on aerial perspective. To the former he attaches great importance because without the correct disposition of light and shade a painting will not have the appearance of relief. The details of his treatment of the subject are not relevant here, but one specimen will give an idea of how carefully he observed nature. He noticed that shadows cast by the sun on a white surface are blue,[1] an idea which was not taken up again till the second half of the nineteenth century, when it became one of the fundamental discoveries of Impressionism. Unfortunately, however, this did not lead Leonardo to experiment further with the theory of colours in which he was not particularly interested. In aerial perspective Leonardo appears as a complete innovator. Earlier writers, such as Alberti, were apparently quite unaware that the edges of objects become less clearly defined and the details on them less distinct as they get farther away. They seem not even to have noticed or not to have been interested in the fact that hills are blue in the distance, and, though some painters before Leonardo, or independent

[1] Ibid., §§ 196, 467.

contemporaries like Perugino, hint in their paintings at the possibilities of this kind of perspective, it is only in a very vague way. Leonardo was the first to carry out a really systematic study of the subject, the effects of which appear in his paintings and no less in his theoretical writings.

These examples of Leonardo's scientific observation illustrate the importance which he attached to the certainty of methods in painting, and the care with which he established this certainty in direct experiment with nature. Other details in his theory are relevant to his other standard, that painting must be as complete as possible in its representation of nature.

Leonardo's belief in the exact imitation of nature is even greater than Alberti's. He constantly sets up this exactness as the final test of painting, as, for instance, when he says: 'That painting is the most to be praised which agrees most exactly with the thing imitated';[1] and though in other passages his opinion on this seems to differ, he certainly considers it of great importance, since he recommends the painter always to carry with him a mirror and to see whether the reflection in it agrees exactly with his painting,[2] and elsewhere he refers to the reflection in a mirror as 'the true painting'.[3]

The artist, therefore, is to imitate nature exactly and he must not try to improve on it, for this will only lead him to be unnatural and mannered.[4] In this matter Leonardo is even more whole-heartedly opposed to any idealism than Alberti. In his practical advice to the painter there is no trace of it, and he never suggests that the artist must make nature conform to some idea which exists in his mind, though nature herself, of course, is subject to general laws.

Leonardo lays little emphasis on Alberti's process of selection of the most beautiful from nature. From passages

[1] Ludwig, op. cit., § 411.
[2] Ibid., § 408. [3] Ibid., § 410. [4] Ibid., § 411.

quoted above it is evident that he wishes the painter to copy
all that is in nature and not to limit himself by leaving out
certain classes of things; and in many other notes he talks
of the beauty of all the works of nature without making any
distinction of different degrees of beauty.[1] From other
sections, however, we can see that he is aware that all nature
is not equally beautiful, but he believes it to be all equally
worthy of imitation by the painter nevertheless. Both the
painter and the poet describe 'the beauty or ugliness of a
body',[2] and the introduction of ugliness even serves a definite
purpose because the contrast of beautiful and ugly parts
serves to show up each with greater intensity.[3] Contrast,
which is elsewhere recommended by Leonardo as a quality
always to be sought after,[4] is a very important element in his
theory and may be connected with one of the most general
features of his thought: that he is primarily interested not
in the beautiful but in the individual and the characteristic.
In this way he is entirely opposed to Alberti, who, with his
search after perfect proportion, the generalized type of human
figure and so on, was always in pursuit of the beautiful.
Leonardo seems to feel that, provided he can make his figures
real, individual, and living, it will not matter if they do not
conform to some absolute standard of harmony. In his
practice Leonardo consistently followed this principle, as
is shown by the extraordinary series of caricatures in the
sketch-books.[5]

Leonardo disagrees with Alberti's pursuit of only the
beautiful in nature and also of his pursuit of the typical and
the general which is closely associated with it. This follows
from what has just been said of his interest in the individual

[1] e.g. ibid., §§ 23, 24. [2] Ibid., § 32.
[3] Ibid., § 139. [4] Ibid., § 187.
[5] In one passage he seems to go back on this view. He says that it
adds 'no little grace' to a painting if the artist gives beautiful faces to his
figures and that this can be done by selecting the best features from faces of
accepted beauty; but this is an isolated example (ibid., § 137).

and the characteristic. It appears particularly when he discusses the proportions of the human figure. Alberti had tried to fix a single canon of proportion to apply to all human figures. Leonardo goes about it in exactly the opposite way. He concentrates on the infinite variety which nature shows in the human figure: 'A man can be well proportioned if he is thick and short, or tall and thin, or medium; and whoever does not observe this variety will always make his figures on a single model, so that they will all look like brothers, which is greatly to be condemned.'[1] Leonardo finds himself compelled to admit that the proportions of a man are fixed in height (presumably by a false deduction from the fixed length of the bones), but he urges the painter to make them vary as much as possible in breadth.[2] What is vitally important is not that the limbs of a figure should obey a fixed rule of proportion, but that they should be harmonious among themselves and that you should not see, for instance, a woman's hand on a muscular arm.[3]

The contrast between the views of Leonardo and Alberti on the subject of proportion corresponds to certain changes which had taken place in painting in the fifteenth century. In the time of Alberti, when artists were still working back to realism after the non-realistic style of the Middle Ages, it was necessary in the interests of realism to establish what were roughly the proportions of a man, this not having been in the Middle Ages a matter of importance to artists. Alberti's theories of proportion, therefore, were a weapon for establishing the first stage of realism. But in the time of Leonardo the situation was changed. Realism had been fully established, and artists knew the correct proportions of the human body only too well. Their tendency was to use them mechanically and to produce an academic uniformity, so that it was necessary to give the contrary advice to that which Alberti had rightly given. Therefore, in opposition to the stylization

[1] Ludwig, op. cit., § 78. [2] Ibid., § 270. [3] Ibid., § 272.

and monotony into which Florentine artists were threatening
to slip, Leonardo emphasized the importance of variety in
the proportion of the human figure.

Leonardo's whole-hearted faith in nature makes him dis-
approve of those who devote themselves to imitating the
style of other masters: 'Never imitate the manner of another
painter, or you will be called a grandson and not a son of
nature in your art.'[1] He makes an exception for the young
painter, who must study the work of the masters as a training
but must give up the practice as soon as possible.[2] The
danger of copying the style of another painter is that it leads
to mannerism, and that, in Leonardo's eyes, is one of the
worst sins, since mannerism excludes naturalism.[3] Manner-
ism in general springs from constantly repeating a trick of any
kind without referring back to nature, so that in the end an
unconscious habit is formed and the artist is unaware that
he is going against nature.[4] The same sort of fate is likely
to befall an artist who relies on his memory instead of
studying nature directly.[5]

One other small point illustrates Leonardo's views about
the imitation of nature, namely, the importance which he
attaches to relief in a painting. If a painting has not the
appearance of relief it has not satisfied the very first condition
necessary for likeness to the thing depicted. For Leonardo
this quality is of greater importance than beauty of colour,
or correctness of drawing: 'The first business of the painter
is to make a plane surface appear to be a body raised and
standing out from this surface, and whoever excels the others
in this matter deserves the highest praise. And this study, or
rather this summit of our learning, depends on lights and
shades.'[6] This is high praise for the mere appearance of
relief, but it is for Leonardo a quality so essential to any kind

[1] Ibid., § 81. [2] Ibid., § 47. [3] Ibid., § 58.
[4] Ibid., § 411. [5] Ibid., § 76.
[6] Ibid., § 412.

of good painting that nothing that he can say is too good for
it, and he comes back to it over and over again in his notes.[1]

Leonardo's view of the world is anthropocentric, but much
less narrowly so than Alberti's. The latter thinks of every-
thing in terms of man, whereas Leonardo was deeply inter-
ested in animals and plants for their own sake, and not merely
for their utility to man. When, therefore, Leonardo says that
painting imitates all nature he includes not only man but also
all other living creatures and inanimate nature as well. We
know that he devoted one section of his treatise to the pro-
portions of the horse, and a very large number of the sur-
viving fragments deal with trees and with the general aspects
of landscape. 'How to paint night', 'How to paint a storm'
are typical chapter headings, and all the notes dealing with
aerial perspective are directed towards a more complete
rendering of landscape. Without a knowledge of landscape
the artist would never be *universal*, and his imitation of
nature would be incomplete.

History painting, in which the artist is required to show
all the aspects of his talent, is the highest and noblest kind of
painting. It demands universal knowledge, though the most
important element in it is the painting of man. This, how-
ever, involves the painting not only of his body but also of
his mind: 'The good painter must paint principally two
things, which are man and the ideas in man's mind. The
first is easy, the second difficult, because they can only be
expressed by means of gestures and the movements of the
limbs.'[2] It is for this purpose that Leonardo develops his
whole theory of Expression, to which he devotes much space
and which was to be taken up and developed by almost all

[1] Alberti had also laid great stress on the importance of relief in
painting, but his method for obtaining it is that of the plastic tradition
of Florentine painting in the Quattrocento—hard outline and the careful
placing of shadows. Leonardo recommends a softened contour and
the blurring of shadows.

[2] Ludwig, op. cit., § 180.

later theorists, particularly in France. Leonardo repeats over and over again the importance of showing the emotions and the ideas in a person's mind by means of his gestures and facial expression, and he gives various indications how this can be done. It is typical of his reliance on nature that his chief advice is that the painter should study people as they argue, or grow angry or look sad, or show any other emotion to see by what gestures they express their feelings,[1] taking care at the same time that they do not know that they are being watched and do not therefore become self-conscious. He adds to this advice, however, by writing down the way in which certain emotions should be expressed,[2] and though, no doubt, these details are based on his own observation, this seems to be a beginning of that systematization of gesture and expression which was carried to its highest point by the French theorists of the seventeenth century. An even further step in the same direction, however, is marked by his suggestion that the appropriate gestures can be found by studying the dumb, who have only the language of gesture by which to express their feelings.[3]

Closely connected with Expression is another theory which had a great success later and which is to be found in Leonardo for the first time, the theory of Decorum. The gestures which a figure makes must not only show his feelings but must be appropriate to his age, rank, and position. So also must be his dress, the setting in which he moves, and all the other details of the composition.

'Observe Decorum, that is to say the suitability of action, dress, setting and circumstances to the dignity or lowliness of the things which you wish to present. Let a king be dignified in his beard, his mien and his dress; let the place be rich, and let the attendants stand with reverence and admiration, in clothes worthy of and appropriate to the dignity of a royal court. . . . Let the movements

[1] Ibid., § 173. [2] e.g. ibid., §§ 380–2.
[3] Ibid., § 115.

of an old man not be like those of a youth, nor those of a woman like those of a man, nor those of a man like those of a child.'[1]

In the hands of Leonardo decorum is simply an element in the complete rendering of the outside world, without which history painting would be incomplete and unconvincing. Later the theory was made to serve entirely different purposes.[2]

All the notes so far quoted from Leonardo bear on his conception of the artist as a scientist. But opposite to this figure stands that of the artist as creator and inventor. However great may be Leonardo's feeling that painting is a scientific activity, he realizes that it is not simply a science, and that certain faculties are needed by a good painter which are not necessary to the scientist. The young artist has need of a natural talent, whereas, according to Leonardo the student of mathematics can learn by sheer application.[3] The impossibility of producing works of art solely by scientific means is also implied when he says of geometry and arithmetic that 'these two sciences only extend to a knowledge of quantity . . . but they do not concern themselves with quality, which forms the beauty of the works of nature and the glory of the world'.[4] Painting, however, 'studies with philosophical and subtle speculation the qualities of every form'.[5] Moreover, the painter must 'by means of drawing show to the eye in visible form the idea and invention which exists first in his imagination (*nella sua immaginativa*)'.[6] And in another chapter he says more generally: 'in fact, whatever exists in essence, in material form or in imagination, all this the artist has first in his mind and then in the work of his hand.'[7] He even compares this inventive faculty in one case

[1] Ludwig, op. cit., § 377.　　[2] Cf. below, Ch. VIII.

[3] Painting 'can only be learnt by those to whom it has been granted by nature, unlike mathematics in which the pupil acquires as much as the master reads to him' (Ludwig, op. cit., § 8).

[4] Ibid., § 17.　　[5] Ibid., § 12.

[6] Ibid., § 76.　　[7] Ibid., § 13.

with the power of God in creating the world: 'that divine power, which lies in the knowledge of the painter, transforms the mind of the painter into the likeness of the divine mind, for with a free hand he can produce different beings, animals, plants, fruits, landscapes, open fields, abysses, terrifying and fearful places.'[1]

The painter is, therefore, not merely a scientist who copies nature, he is also a creator; he can draw 'not only the works of nature, but infinitely more than those which nature produces',[2] and he excels nature 'by the invention (*fintione*) of endless forms of animals and herbs, plants and landscapes'.[3] In another chapter Leonardo gives examples of the kinds of things which the artist can invent—monsters, unknown landscapes, mountains, plains, and so on.[4]

But Leonardo never encourages the artist to give free play to his imagination. What he invents must always have the most exact foundation and justification in nature. Even if it does not actually exist, it must appear to the spectator as if it could exist. If the imagined vision is not built up of material collected directly from nature it will be vague and incomplete because 'the imagination does not see such splendour as the eye sees',[5] and 'the imagination stands in the same relation to reality as the shadows to the body which casts it'.[6] Even if the artist wants to paint a purely fantastic monster he must build it up from limbs observed in different animals, or it will not be convincing.[7] Therefore Leonardo gives the following final advice to the artist on the method of stocking and stimulating his imagination:

'Knowing that you cannot be a good painter unless you are a universal master capable of imitating with your art all the qualities of the forms which nature produces, and that you will not be able to do this unless you see them in your mind and copy them from there, when you go through the fields turn your mind to different

[1] Ibid., § 68. [2] Ibid., § 133. [3] Ibid., § 28. [4] Ibid., § 13.
[5] Ibid., § 15. [6] Ibid., § 2. [7] Richter, op. cit., § 585.

objects, and study them one after another, making a bundle of selected and chosen things.'[1]

In this way the artist will fill his mind with images based on the exact knowledge of nature and his imagination will have a sure foundation for its inventions.

This double conception of the artist's function, as scientific observer and as imaginative creator, is found perfectly expressed in the paintings and, above all, in the drawings of Leonardo. Here the material collected by the minute study of natural phenomena seems to have been transmuted by the imagination by an almost magical process of which Leonardo gives no account in his writings.

[1] Ludwig, op. cit., § 56.

Chapter III

COLONNA: FILARETE: SAVONAROLA[1]

CERTAIN other works produced during the Quattrocento are relevant to the development of theory in Italy. The most important is the curious and celebrated romance attributed to Fra Francesco Colonna, entitled *Hypnerotomachia Poliphili*, first published by Aldus Manutius in 1499 in an edition principally famous for its woodcuts. Colonna, who was born in 1433, was a monk in the monastery of SS.Giovanni e Paolo in Venice and also for a time at his native Treviso. The *Hypnerotomachia* is dated 1467, but the author probably went on working at it till the date of its publication. This romance is of interest because it is the only work dealing with the Fine Arts produced in Venice during the Quattrocento, and therefore the only direct clue to the views which the Venetians held about aesthetics at that time.

A very large element of Gothic survives in the painting and architecture of Venice in the late fifteenth century; for the Gothic tradition was too deeply established to be completely dislodged by the cult of antiquity which spread to Venice from Florence and Rome. The classical style was taken up, but it was treated in a romantic and irrational spirit. Painters like Mantegna imitated ancient statues with enthusiasm, but they combined what they derived from them with a Gothic emotionalism. Architects such as the Lombardi used the classical orders, but in combination with Gothic structure and with an almost oriental use of rich marbles.

[1] The traditional attribution of the *Hypnerotomachia* to Colonna and its dating have been the subject of much discussion. The attribution is probably correct, but the book may have been composed at a date nearer to that of publication than 1467.

The same mixture of medieval and classical elements appears in the *Hypnerotomachia*. In form it is a Gothic romance, of the type of the *Roman de la Rose*, but taken more directly from the *Amorosa Visione* of Boccaccio. The wanderings of the unhappy lover Poliphilus in search of his Polia are accompanied by all the adventures and allegories traditional in the romances of the Middle Ages. But the author has used this medieval form to express above all his overwhelming passion for antiquity. Every episode, every allegory is dressed up in classical phraseology. The language and names are a bastard mixture of Italian, Latin, and Greek; the buildings described are in the ancient manner; the monuments are covered with Latin or Greek inscriptions, or with hieroglyphics which the author painstakingly transcribes and explains; every ceremony is dedicated to a classical god or goddess.

The author evidently set himself to recreate an atmosphere which he believed to be ancient. But his method and, indeed, his whole attitude to antiquity are fundamentally different from that of a Florentine Humanist like Alberti. Whereas the latter is rational and severely archaeological, Colonna interprets his knowledge of antiquity imaginatively, with no great regard for accuracy of detail. He is not interested in the philosophical and moral ideas of the ancients; he wishes only to take from antiquity those elements which will help him to build up a dream; and this dream, one feels, became for him more important than the ordinary conduct of life. His view is summed up in the sub-title of the book: 'Ubi humana omnia non nisi somnium esse ostendit'.

But the dream which he spun was a very sweet one, in which he could enjoy all those things which were unattainable to him in real life. Among these is the ideal of perfect love, which is expressed in a very strong erotic element throughout the book. This is usually discreetly clothed in allegory, but the covering is sometimes of the thinnest and the symbolism of the most direct kind.

PLATE 3

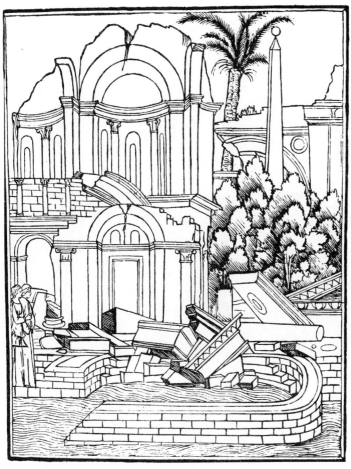

The Ruins of Polyandrion. From the *Hypnerotomachia
Poliphili*, 1499

The author's imaginative attitude also extends to matters of pure archaeology, in which he seems not to bother about either accuracy or consistency. When he describes the ritual which is performed in the various temples which Poliphilus visits, there is often a strong tinge of Christian usage; so that, for instance, the attendants in the temple of Venus say 'So be it', at the end of each prayer.[1] The architectural descriptions, which are the most important part of the book from the present point of view, do not contain the same mixture of non-classical elements, but, compared with Alberti's business-like analyses, they are fantastic and irrational. At first sight the author seems to be very precise in the giving of dimensions, which he piles up for every building that he describes. But these are apparently not supplied for the benefit of an architect who might wish to carry out the schemes, but merely to give the reader an impression of vast size and elaboration. The buildings are so fantastic that few have attempted to put Colonna's ideas into execution.[2]

One of the most remarkable of the buildings which he describes is the great monument crowned with an obelisk, illustrated on Plate 4. Colonna's description is evidently a free imaginative version of ancient accounts of the Mausoleum at Halicarnassus, but with many elements of his own invention. The base of the building was a block forty paces high on a square of 1,200 paces. On this was built a pyramid of 1,400 steps, crowned by a cube of stone on a side of four paces, which supported a huge obelisk, in a single shaft fourteen paces high. Finally the whole monu-

[1] *Hypnerotomachia*, fol. o viii r.
[2] Bernini seems to have had a description from the *Hypnerotomachia* in mind when he designed the fountain outside S. Maria sopra Minerva with the elephant carrying an obelisk on its back; and J. H. Mansart probably based the design for the Colonnade in the gardens at Versailles on some of the engravings.

ment was topped by a great statue of gilded bronze, repre-
senting Occasio, so arranged that it was turned on its axis by
the wind, with a terrifying noise. There is in this description
something of the fear which men of the Middle Ages felt
before the vast ruins of Roman times; but it is combined with
an intense desire to recreate their glories, though only in the
imagination.

In many other cases, however, Colonna shows a different
view about the remains of antiquity. Many of the buildings
which he describes are in a state of ruin, and in talking of
them he betrays a romantic feeling quite unlike the serious
archaeological approach of the early Quattrocento Floren-
tines. Brunelleschi and Alberti, for instance, spent much
time on the study of the remains of ancient Rome, but only
in order to find out what they had been like when they were
complete. For them the ruins were a school for the modern
builder. Colonna takes an actual delight in the fact that they
are ruins and not complete buildings. He describes their
decay with real feeling, and he makes them an excuse for
reflections on the frailty of human life and love, and on the
destructive passage of time. When Poliphilus comes upon
the ruins of Polyandrion (Plate 3), the ancient temple of
Pluto, Polia says to him: 'Look a while at this noble relic of
things great in the eyes of posterity, and see how it now lies
in ruins and has become a heap of fragments of rough and
humpy stones. In the first age of man it was a splendid and
magnificent temple. . . .'[1] Colonna is in fact here indulging
in that sentimental and melancholy delight in ruins as symbols
of the impermanence of things which became so fashion-
able at a later date, particularly in the eighteenth century.

The *Hypnerotomachia* was not of great use to architects
who wished to learn about the methods and structure of
ancient building, but to the painters, sculptors, engravers,
and maiolica painters it was an endless source of themes.

[1] *Hypnerotomachia*, fol. p ii*v*.

PLATE 4

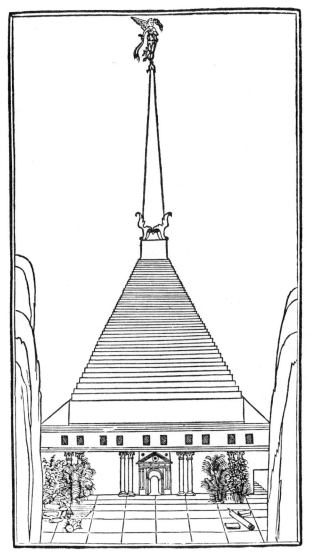

The Pyramid. From the *Hypnerotomachia Poliphili*, 1499

The hieroglyphics which Colonna describes were perhaps the most popular part of the book, and Aldus set the fashion by taking one representing a dolphin curled round an anchor as his printer's mark. Other parts were also borrowed. Some painters, for instance, copied the subjects on the reliefs which Poliphilus finds in his wanderings; others illustrated scenes from the story in paintings. In these various ways the novel could be of use to all those who felt that antiquity was a sort of ideal existence which could be reconstructed in imagination. For those whose approach was more sharply archaeological or more severely moralizing it was not of much service.

Some of the same elements that appear in the *Hypneroto-machia* are to be found in the treatise on architecture written by Antonio Averlino, called Filarete. The author was a Florentine sculptor and architect, born about 1400, who worked mainly in Rome and Milan, his best-known works being the bronze doors of Old St. Peter's. His treatise was written between 1460 and 1464 in Milan, where Filarete was attached to the court of Francesco Sforza. The author has given it a semi-romantic form, in which he describes the building of an imaginary city, 'Sforzinda'. The vastness of the conception, the descriptions of the pageantry accompanying the founding of the city, the time of which is chosen in accordance with astrological observation, the passionate but uncritical admiration for antiquity, are all elements which bring Filarete's work close to the *Hypnerotomachia*. On the other hand, underneath the dilettante surface there is more rationalism than is to be found in Colonna. Filarete was a serious defender of ancient architecture in a town where the Gothic continued to have a firm grip till well into the sixteenth century. His ideas on town planning, which recall Alberti (by whom they may have been partly inspired), are whole-heartedly anti-medieval, and the author lays great emphasis on regularity of disposition and on the importance of having large squares. The treatise ends with three books

on drawing in which, however, the author only repeats the mathematical and technical commonplaces of earlier writers.

In the same town as Filarete's *Trattato* there was produced in 1497 the curious work *De Divina Proportione* of the mathematician Fra Luca Pacioli. Pacioli was a pupil of Piero della Francesca, from whom he learnt mathematics and perspective. He was also a friend of Alberti and Leonardo, but his outlook was very different from theirs. Springing from a tradition of scientific artists who used mathematics as a weapon for studying nature, Pacioli absorbed their learning but applied it to wholly different purposes. He devoted his attention to the abstract side of mathematics, thinking entirely of theory and not at all of the foundation of his theory in nature. His attitude is almost Pythagorean, for to him numbers have a mystical significance, with which the idea of beauty is closely associated. There are passages in the *De Divina Proportione* which might almost have been written in the thirteenth century, and Pacioli's favourite authorities are not the Classics but St. Augustine or Duns Scotus. With the mystical play with numbers are intermingled certain ideas which are more closely Neoplatonic.

There is no need to analyse Pacioli's writings in detail. Their importance here depends on their being an example of the application to the theory of painting of the medieval and Neoplatonic ideas which gradually spread over Italy as the early city-republics broke up and were replaced by tyrannies. The earlier philosophers of this group had speculated on the nature of beauty, but Pacioli's treatise brings the doctrines closer to the arts. The significance of this movement, however, becomes clearer in the sixteenth century, and it will be discussed later.[1]

[1] To complete the list of Quattrocento writers directly concerned with the arts we must make two additions. First comes a group of writers on perspective and on architecture, such as Piero della Francesca and

Before going on to the sixteenth century something must be said of a writer not generally associated with the theory of the Fine Arts, namely, Fra Girolamo Savonarola. Historians often think that, when they have mentioned Savonarola's burning of those paintings and statues which he considered incitements to sin, they have given his whole view on the arts. But from passages in the *Sermons* it is clear that, though Savonarola feared the evil effects which might come from the wrong kind of art, he had the greatest faith in the good which could be done by the right kind.[1]

It is not surprising that Savonarola's views on art should be almost medieval. The whole basis of his work and teaching was a protest against the worldly and capitalist Papacy of Alexander VI, and an attempt to restore something of the purity which he associated with medieval life and doctrine. At the same time his preaching was directed towards the artisan classes and not to the feudal aristocracy, which, with the upper middle classes, opposed his efforts.

His conception of beauty is based on the assumption that the spiritual is superior to the material. Perfect beauty resides in God, and below Him in varying degrees come the beauty of the saints, the soul of man, and the body.[2] Some of Savonarola's definitions are like those of St. Thomas. Beauty lies in proportion, in the harmony of forms and colours.[3] Others are more Neoplatonic: the beauty of simple things consists in Light.[4] Since the forms of all created things proceed ultimately from God, beauty in the material world is a reflection of the divine. Therefore Socrates was

Francesco di Giorgio, whose works are entirely technical and contain no general ideas about painting or the other arts. Secondly there are certain artists, like Foppa and Bramante, who are known to have written on their arts, but whose works are lost. The accounts of them that survive are too general to provide any material for the present history.

[1] The relevant texts have been brought together by G. Gruyer in *Les Illustrations des écrits de Jérôme Savonarole*, Paris, 1879.

[2] Gruyer, op. cit., p. 185. [3] Ibid., pp. 183, 189.

[4] Ibid., p. 189.

able to contemplate the divine beauty through the beauty of young men. Savonarola does not entirely recommend this method, which is, he says, tempting God, but he quotes it as an example of how material beauty can be used for the perception of the divine.[1]

Savonarola's conception of beauty is, therefore, in agreement with medieval ideas. His view of the function of the arts is no less so. Painting is to be the Bible of the Illiterate. In one sermon Savonarola recommends his hearers to read the Scriptures, and adds: 'And you who cannot read, go to paintings and contemplate the life of Christ and of His Saints.'[2] And elsewhere he says that 'figures represented in churches are the books of women and children'.[3]

Though Savonarola was medieval in his outlook, he lived surrounded by the worldliness of the Renaissance, and he was therefore impelled, unlike the writers of the Middle Ages, to attack the sinful kinds of painting put into churches in his time. Since painting is such a powerful weapon for good or evil by its effects on the spectator, all indecent or mundane pictures must be taken from churches.[4] Savonarola makes, however, an interesting addition to this demand. He wishes all paintings to be removed which by their incompetence may arouse the laughter of those who see them. 'Indecent figures must first be taken away, and then no composition should be allowed which arouses laughter by its mediocrity. In churches only the greatest artists should be allowed to paint, and they should only paint decent subjects.'[5] Savonarola was therefore far from being indifferent to artistic qualities, and the view expressed in this passage is in almost exact agreement with the opinion of Michelangelo reported by Hollanda.[6]

But Savonarola does not always speak of the moral purpose

[1] Gruyer, op. cit., p. 184. [2] Ibid., p. 204. [3] Ibid., p. 207.
[4] Ibid p. 200. [5] Ibid., p. 207.
[6] See below, Ch. V.

of painting, or even of the skill of the artist. There is one passage in the *De Simplicitate Vitae Christianae* in which he talks in terms of the most naïve naturalism. 'Art prefers the works of nature to its own creations, for it seeks to imitate nature as closely as possible. . . . If works of art please men they do so in proportion as they imitate nature. And in praising a painting one says: "These animals seem to be alive, these flowers look real." '[1] This is a curious point of view to find among the Scholastic talk about beauty, but it can be explained by the popular basis of Savonarola's appeal. All through the later Middle Ages popular ideas expressed themselves in the arts by means of realism, but a naïve realism not at all like the scientific realism of the Renaissance, and a realism that is often found in conjunction with purely medieval elements of fantasy and symbolism; as, for instance, in the tradition of Diableries leading up to painters like Bosch or Grünewald. One would therefore expect in any expression of a popular late medieval view of art a mixture of idealist and simple naturalistic theories. And, though he preached almost at the height of the Renaissance, it is as a representative of the later Middle Ages that Savonarola speaks.

[1] Gruyer, op. cit., p. 192.

Chapter IV

THE SOCIAL POSITION OF THE ARTIST

MENTION has already been made in connexion with Leonardo of the struggle of painters, sculptors, and architects to attain recognition of their professions as liberal arts. With their new scientific methods they began to claim superiority over mere craftsmen, and tried to establish for themselves a better social position.

In practice the position of the artist was considerably higher in the fifteenth century than it had been before. Ghiberti and Brunelleschi both held important administrative posts in Florence, the latter being even a member of the Signoria. In general the public respect for artists had increased immeasurably and was to become even greater in the sixteenth century when the adjective *divine* was applied to Michelangelo. However, there continued to be theoretical opposition to the admission of painting and sculpture among the liberal arts. In the middle of the fifteenth century Lorenzo Valla excludes them from his list, and much later both Cardanus and Vossius class them as mechanical. Pinturicchio leaves them out in his frescoes of the liberal arts in the Borgia apartments of the Vatican, painted in the last decade of the fifteenth century. It is hard for us to realize the importance attached to these disputes about the liberal arts, but it is brought home to us by a story told by Baccio Bandinelli, who records in his *Memoriale* a duel fought between his cousin and the Vidame de Chartres because the latter accused the Florentine nobles of practising manual arts in that they took an active interest in painting and sculpture.[1]

The claims of artists to a better social position sometimes simply take the form of showing that in earlier times the

[1] See *Repertorium für Kunstwissenschaft*, xxviii, p. 434.

art of painting had been held in great respect. Theoretical writers on painting in the fifteenth century searched out every instance in antiquity and in more recent times of favour shown to painters by kings, princes, or popes. The greatest value was attributed to cases in which it could be found that a great man had actually practised painting. For the distinction between the liberal and mechanical arts was that the former were practised by free men, the latter by slaves; and an art acquired much reflected glory from being practised by a royal artist.[1]

In general, however, the principal aim of the artists in their claim to be regarded as liberal was to dissociate themselves from the craftsmen, and in their discussions on the subject they make it their business to bring out all the intellectual elements in their art. In later fifteenth-century theoretical writings it becomes a commonplace that painting depends on a knowledge of mathematics and of different branches of learning. The early critics argue this matter in quite general terms, but later their claims become more precise and exaggerated.

The part which mathematics played in the painting of the Early Renaissance has already been discussed. In the form of linear perspective it provided one of the most important scientific weapons for the study of nature, and it is as a learned science that the theorists appeal to it. Mathematics was included in the narrow circle of the liberal arts, and if the painters could show that their art involved a knowledge of it, this would be a strong argument for their own art to be considered liberal. Alberti and Ghiberti explain the kinds of mathematics of which a painter must be master, but they do not explicitly connect the matter with the question of the liberal arts. Leonardo is the earliest writer to do so. He first of all says in general terms: 'Practice must always be founded on sound theory, and to this perspective is the guide and gateway; and without this nothing can be done well in the

[1] Cf. Alberti, 'Della Pittura', bk. ii, ed. cit., pp. 91 ff.

matter of painting.'[1] But in another passage he alludes
directly to the ennobling qualities of mathematics in con-
nexion with perspective: 'Among all the studies of natural
causes and reasons light chiefly delights the beholders; and
among the great features of mathematics the certainty of its
demonstrations is what pre-eminently tends to elevate the
mind of the investigator. Perspective therefore must be pre-
ferred to all the discourses and systems of human learning.'[2]

The emphasis which Leonardo here lays on the certainty
of mathematical demonstration is typical of the use which
painters of the Quattrocento made of perspective. As has
already been said, it was by means of perspective that they
got beyond the naïve and tentative imitation of the natural
world and were able to reconstruct it with the sureness which
comes from reliance on absolute rules.[3]

In their claim to knowledge in other branches of science
the painters were probably urged on to greater audacity by
the rivalry which they felt with the architects. Vitruvius

[1] Richter, op cit. i, § 19.

[2] Ibid. i, § 13. It is typical of Leonardo's method that this should not
be an original passage, but should be copied from a medieval writer on
perspective, John Peckham (*Perspectiva Communis*, Milan, 1482, Intro-
duction). Peckham had not, of course, in mind any connexion between
perspective and painting, and was thinking of the former as a purely
optical study; but Leonardo almost certainly copied the passage for its
relevance in the quarrels about the liberal arts. For several notes
dealing with these quarrels he refers to the superiority of the eye over the
ear among the senses, which was a common Neoplatonic doctrine based
on the dignity of light of which Peckham speaks here.

[3] The dignity which architecture derives from its reliance on the
certainty of mathematics is alluded to at an early date, in a patent given
by Federigo da Montefeltro in 1468 in which he speaks of 'La virtù del-
l'Architettura fundata in l'arte dell' Aritmetica e Geometria, che sono
delle sette arti liberali e delle principali, perchè sono in primo gradu
certitudinis' (cf. Gaye, *Carteggio Inedito d'Artisti*, Florence, 1839–40, i,
p. 24). The writers of this time were able to point to an ancient example
for the connexion of painting with mathematics, and Equicola (*Institu-
zioni*, Milan, 1541) refers to the view of Eupompus, that painting could
not exist except on a basis of arithmetic and geometry (Pliny, *Nat. Hist.*
xxxv. 76, attributes this view to Pamphilus).

had claimed that the architect must be acquainted with many branches of knowledge,[1] and Renaissance writers from Ghiberti onwards repeat his demands. The painters could not allow themselves to be beaten by this claim, and they simply incorporate the sciences which Vitruvius mentions into their list of requirements for the painter. They do not evolve their full list till the end of the Mannerist period, but the tendency to exaggerate their claims appears earlier. Cellini, for instance, maintains that a sculptor must know about the art of war and must be himself a brave man if he is to make a successful statue of a brave soldier. In the same way he must know about music and rhetoric to represent a musician or an orator.[2] To this demand, which can be extended indefinitely, he was probably provoked by an opinion expressed by Plato, who argues that the painter is a mere illiterate imitator: 'The painter will paint a shoemaker, a carpenter, or any other craftsman, without knowing anything about their trades; and notwithstanding this ignorance on his part, let him be but a good painter, and if he paints a carpenter and displays his painting at a distance he will deceive children and silly people by making them think that it really is a carpenter.'[3] This scornful opinion clearly offers the painter an opportunity to retort in the way suggested by Cellini, whose view is otherwise hard to explain.

But the painters and sculptors did not content themselves with a general claim to learning; they explicitly demanded equality with the poets. Poetry and rhetoric were accepted as liberal arts, and the painters and sculptors evidently felt that, if they could show that their arts were as noble as that of the poets, they would have proved their claim to be liberal artists also. The first difficulty which they had to overcome was that painting and sculpture seemed to be more manual

[1] Writing, drawing, geometry, arithmetic, optics, philosophy, music, medicine, jurisprudence, astrology (bk. i, ch. 1).
[2] See Varchi, *Due Lezioni*, p. 153. [3] *Republic*, x. 598b.

than literature. Equicola, for instance, says: 'Therefore, however worthy of praise painting, modelling and sculpture may be, nevertheless they must be considered far inferior to poetry in dignity and authority. Painting is a work and a labour more of the body than of the mind, and is, more often than not, exercised by the ignorant.'[1] Leonardo, however, has a reply ready for this kind of argument; and in defence of painting he says: 'If you call it mechanical because it is, in the first place, manual, and that it is the hand which produces what is to be found in the imagination, you writers also set down manually with the pen what is devised in your mind.'[2]

Having dealt with this attack, Leonardo goes on to claim that the painter can achieve no less than the poet. Painting can represent an action as completely, more completely even, than poetry; and, in particular, painting can attain the same moral ends on which poetry prides itself:

> 'And if a poet should say: "I will invent a fiction with a great purpose", the painter can do the same, as Apelles painted Calumny. . . . If poetry deals with moral philosophy, painting deals with natural philosophy. Poetry describes the action of the mind, painting considers what the mind may effect by the motions [of the body]. If poetry can terrify people by hideous fictions, painting can do as much by depicting the same things in action.'[3]

Painting, that is to say, can attain its moral end by showing human action through the use of gesture and facial expression, and Leonardo is therefore able to press his favourite theory of expression into the defence of his art. But his argument was not always accepted. Equicola still decides against painting on the grounds that it cannot go beyond the simple imitation of nature: 'Painting has no other concern

[1] Op. cit. Equicola was writing after Leonardo's death, but he seems to be repeating the kind of argument to which the artist was replying.
[2] Richter, op. cit. i, § 654. [3] Ibid.

except with copying nature with various appropriately chosen colours.'[1] And Castelvetro later repeats the same argument: 'That which in poetry is first and of most account, the imitation of a human action, as it ought to be, is the last in painting and of no account, namely, that which painters call *history*.'[2] It was, we may imagine, against arguments of this type that Leonardo was directing one of his notes which refers to the phrase traced back to Simonides which describes painting as *muta poesis* and poetry as *pictura loquens*: 'If you call painting dumb poetry, the painter may call poetry blind painting. Now which is the worse defect? to be blind or dumb?'[3]

As soon, however, as the visual arts became generally accepted as liberal,[4] the protagonists began to quarrel among themselves about which of them was the noblest and most liberal. Leonardo, in particular, was much concerned with defending painting from the attacks of the sculptors, and many of his notes deal with this question. In these Leonardo first argues, as he did with the poets, that painting can give a more complete description of nature than the rival art. To this the sculptors reply that their art actually creates objects in three dimensions, whereas painting merely gives the illusion of the third dimension. Leonardo, however, turns this argument to his advantage by showing that this illusion is created by intellectual means, whereas the three-dimensional quality of sculpture depends simply on the

[1] Op. cit.

[2] Cf. H. B. Charlton, *Castelvetro's Theory of Poetry*, 1903, pp. 62 ff. It is curious to find a sculptor, Baccio Bandinelli, as late as the middle of the sixteenth century, who still regards writing as a nobler art than sculpture. He states in his *Memoriale* that he nearly devoted his life to writing, because, he says, I felt 'much more inclined, rather than working with the chisel, to immortalize myself with the pen, in a really intellectual and liberal study' (cf. *Repertorium für Kunstwissenschaft*, xxviii, p. 430).

[3] Richter, op. cit., § 653.

[4] They seem to have been generally so accepted by the Humanists by about 1500. Castiglione, for instance, allows them to be liberal (cf. *Cortegiano*, bk. i).

material: 'Sculpture shows with little labour what in painting appears a miraculous thing to do; to make what is impalpable appear palpable, flat objects appear in relief, and near objects seem distant,'[1] all this being achieved by means of linear and aerial perspective.

An argument of the same kind occurs later in one of the *Lezioni* of Benedetto Varchi, who tried to settle the rivalry between the painters and sculptors by collecting the opinions of a selected group of masters[2] and combining them into a single discourse of his own. He succeeded in showing that painting and sculpture are equally noble arts, because fundamentally their aims and methods are the same. During his exposition, however, he mentions the argument put forward by the sculptors that their art is more difficult. But, following a suggestion of Bronzino, Varchi distinguishes between two kinds of difficulty: manual and intellectual. He admits that the sculptor has more manual or technical difficulties to deal with, by reason of the material in which he works, but he regards this as an ignoble kind of difficulty. The only noble difficulties are intellectual problems, such as those which confront the painter when he has to deal with proportion or with the two perspectives.

Implicit in these arguments is a belief in the superiority of the intellectual over the manual or mechanical, which corresponds to the desire of artists at this time to shake themselves free from the accusation of being merely craftsmen, manual labour being considered in the society of the Renaissance as ignoble as it had been in the Middle Ages. The pride which artists took in not being involved in much manual labour appears in the contrasted description which Leonardo gives of the sculptor and the painter. The former

[1] Richter, op. cit. i, § 656.

[2] Bronzino, Pontormo, Cellini, Vasari, &c. For their letters cf. Bottari-Ticozzi, *Raccolta di Lettere sulla Pittura, Scultura ed Architettura*, Milan, 1822, i, pp. 17 ff.

PLATE 5

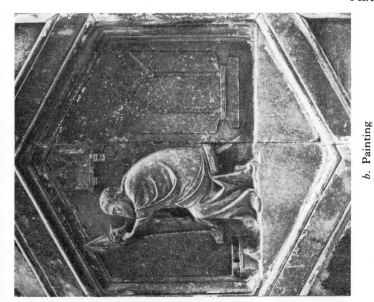

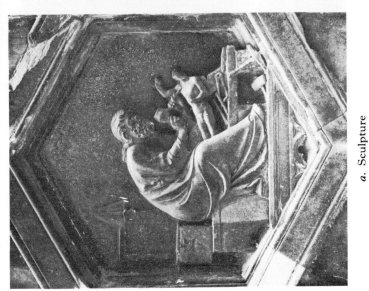

a. Sculpture

b. Painting

From the Campanile, Florence. 14th century

goes through an exhausting labour with hammer and chisel, is covered with dust and sweat so that he looks like a baker and not like an artist, whereas 'the painter sits in great comfort before his work, well dressed, and wields his light brush loaded with lovely colours. He can be dressed as well as he pleases, and his house can be clean and filled with beautiful paintings. He often works to the accompaniment of music, or listening to the reading of many fine works. And all this can be heard without being drowned with the sounds of hammering or other uproar.'[1] This gentlemanly kind of painting recalls the representations of the arts on the Campanile bas-reliefs in Florence in which the calm and dignity of every profession are the qualities which the artist seeks to render. (See Plates 5 a and b.)

The upshot of all these disputes was that the painter, sculptor, and architect obtained recognition as educated men, as members of Humanist society. Painting, sculpture, and architecture were accepted as liberal arts, and are now grouped together as activities closely allied to each other and all differing fundamentally from the manual crafts. The idea of the 'Fine Arts' comes into existence this way, though a single phrase is not attached to them till the middle of the sixteenth century, when they come to be known as the *Arti di disegno*. At the same time critics begin to have the idea of *a work of art* as something distinct from an object of practical utility, as something which is justified simply by its beauty and which is a luxury product.

The arguments about the liberal arts were, therefore, the theoretical side of the artists' struggle for a better position. The practical side of this was a struggle against the old organization of the guilds, by which artists felt themselves tied. By the end of the fifteenth century they had almost thrown off restraint, and the painter had become a

[1] Ludwig, op. cit., § 36.

free, educated individual co-operating with other men of learning.

In his new freedom the artist was no longer a purveyor of goods which every one needed and which could be ordered like any other material goods, but an individual facing a public. Both Alberti and Leonardo talk of the importance of pleasing the public. 'The painter in his work seeks to please the crowd (*tutta la moltitudine*)', says Alberti,[1] and Leonardo recommends the artist to take the advice of all his friends, who can at any rate judge of the likeness of the painting to nature.[2] Leonardo, however, still has in mind only an educated public, for in a passage already quoted he speaks scornfully of those painters who aim at pleasing the ignorant.[3] His view of the right of those who do not paint to judge painting is of only limited democracy. But by the beginning of the sixteenth century it became a generally accepted idea that the educated layman could give a useful opinion on the arts, and there was even a small outcrop of treatises on the arts written by laymen which will be referred to in a later chapter.[4]

The artist was now faced with a wide public consisting of educated people, not merely of Church officials and a few princes, which he attempted to attract by his art; and in this spirit of competition he began to carry out works other than those directly commissioned. We are here at the beginning of those modern ideas which make of the artist a creator who works for himself alone, but in the Cinquecento these views were only in their infancy. The artist was still closely tied to his public, and most of his work was commissioned. The days of exhibitions were yet a long way off.

But once the old organizations were abandoned as out of date, it became clear that artists needed some sort of institution for guarding their interests and training young artists.

[1] 'Della Pittura', p. 161.
[2] Ludwig, § 75. [3] Ibid., § 59. [4] See below, p. 82.

Consequently in the second half of the sixteenth century there began to grow up those academies which were later to form the whole structure of artistic education.[1] The earliest was the *Accademia del Disegno*, founded by Vasari in Florence in 1562, but this was soon followed in Rome, where the Guild of St. Luke was transformed into an academy in 1577. The essential difference between the guilds and the academies was that the latter treated the arts as scientific subjects to be taught theoretically as well as practically, whereas the guilds had mainly aimed at fixing a technical tradition. In the early days the academies allowed individual competition and did not crush every rival as the guilds had done, but later they in their turn became tyrannical.

The guilds were defeated, but there is one curious instance of their attempt to reassert their rights. As late as 1590 the Guild of Genoa tried to prevent Giovanni Battista Paggi from practising painting in the city because he had not gone through the regular training. Legally they were perfectly justified, but the decision went againt them, and this case became a sort of legal admission of the artist's new status and freedom.[2]

[1] For a full discussion of the origin and methods of the academies, cf. N. Pevsner's *Academies of Art Past and Present*, 1940.
[2] See Dresdner, *Kunstkritik*, p. 94.

Chapter V

MICHELANGELO

OUR sources of knowledge for Michelangelo's views on the Fine Arts are varied. Of his own writings, the letters contain almost nothing of interest from the point of view of theory, since they are nearly all personal or business notes to his family or his patrons. The poems, on the other hand, are of great importance, for though they contain few direct references to the arts, many of them are love poems from which it is possible to deduce in what terms Michelangelo conceived of beauty.

In addition to his own writings we have the evidence of three of his contemporaries. The first of these is the Portuguese painter Francisco de Hollanda, who came to Rome in 1538 and worked his way for a time into Michelangelo's circle. He was probably never very intimate with the latter, and his dialogues[1] were almost certainly written to glorify himself and to show how closely he associated with the master. But however great his conceit may have been, his evidence is of importance, since it deals with a period of Michelangelo's life on which we are not otherwise well informed by his biographers.[2]

The second contemporary source is the biography of Michelangelo in Vasari's *Lives*. It was first published in 1550, but was greatly enlarged and almost entirely rewritten for the second edition of 1568. It contains less material than might be expected, but it gives some account of his methods of working and records some of his opinions.

[1] Published in 1548 under the title, *Tractato de Pintura Antigua*.

[2] Hollanda's reliability has often and justifiably been challenged, e.g. by Tietze (cf. 'Francisco de Hollanda und Donato Giannottis Dialoge und Michelangelo', *Rep. für Kunstwissenschaft.*, 1905, xxviii, p. 295) and, more violently, by C. Aru (cf. 'I Dialoghi Romani di Francisco de Hollanda', *L'Arte*, 1928, xxxi, p. 117).

More important is the third authority, Ascanio Condivi, a pupil of Michelangelo, who published a biography of his master in 1553. The life seems to have been written to correct certain false statements made by Vasari; and, though Condivi was a somewhat naïve character, he is probably more reliable than either Hollanda or Vasari when he reports Michelangelo's own views and statements.

Michelangelo lived to a great age, and his views were constantly developing and changing, so that it is impossible to treat his theories as a single consistent whole. Born in 1475, he was trained under masters who still belonged to the Quattrocento. His earliest works in Rome represent the full blooming of the High Renaissance, but before he died in 1564 Mannerism was firmly established. It is impossible to divide his works or his ideas into sharply separate compartments, but for the present purpose they can be roughly grouped in three periods, if we ignore the very early years from which no documents survive.

In the first period, ending roughly in 1530, Michelangelo's view of the arts is that of High Renaissance Humanism. It is most clearly typified in the ceiling of the Sistine Chapel, the Pietà in St. Peter's (Plate 6 a), and the early love-poems. In these works the various elements which made up Michelangelo's early training are clearly visible. Like Leonardo he was heir to the scientific tradition of Florentine painting, but he was also affected by the atmosphere of Neoplatonism in which he grew up. His highest allegiance, however, was to beauty rather than to scientific truth; and although in his early years at least he felt that the attainment of beauty depended in large part on the knowledge of nature, he did not feel the urge to undertake the investigation of natural causes for their own sake. Consequently the observation of nature which he absorbed in the studio of Ghirlandaio could fairly easily be fused with the doctrines of beauty which he learnt from the circle of Lorenzo de' Medici. But there was another

factor which favoured Michelangelo in comparison with Leonardo. Neither Florence nor Milan could provide the latter with the atmosphere of buoyancy which alone can produce a great synthesis such as had been achieved in Florence in the early years of the fifteenth century. In Rome, on the other hand, Michelangelo found a city at the height of its wealth and politically in a leading position for the whole of Italy. In this atmosphere the artist felt at ease with the world, at which he could look out steadily, and which he could reflect directly in his works. A training in Neoplatonism led to a belief in the beauty of the visible universe, above all in human beauty, which was no longer coloured by the nostalgic mysticism of Florence. The grandeur of the figures on the Sistine ceiling depends on far more than the simple imitation of natural forms, but its idealization is based on a close knowledge and study of these forms. Whatever heroic quality is added, the foundation is a worship of the beauty of the human body.

In the field of thought the two apparently conflicting systems of Christianity and paganism are still perfectly fused in the Rome of the High Renaissance. The iconographical scheme of the Sistine ceiling frescoes is based on the most erudite theology, but the forms in which it is clothed are those of pagan gods. In Raphael's frescoes in the Stanza della Segnatura the four themes of Theology, Pagan Philosophy, Poetry, and Justice are intricately blended. The catalyst, however, is no longer the hard reason of the Florentines like Alberti, but rather the elaborate Neoplatonism of the later Quattrocento stripped of its more nostalgic elements. In Michelangelo the two faiths were both perfectly sincere. From the days when he was first influenced by the teaching of Savonarola he was a good member of the Catholic Church, though at first without that passionate self-abnegation which came into his faith in the last years of his life.

Michelangelo's belief in the beauty of the material world was very great. His early love-poems reflect this feeling in

PLATE 6

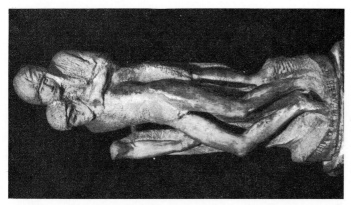

b. Michelangelo. Rondanini Pietà.
Palazzo Sanseverino, Rome

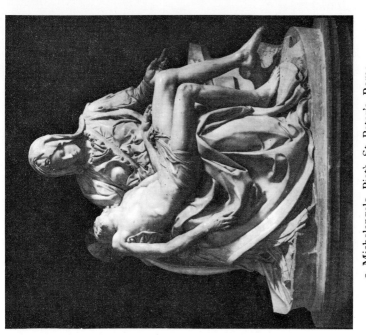

a. Michelangelo. Pietà. St. Peter's, Rome

their expression of strong emotional and often physical passion, directed as much towards visible beauty as towards the spiritual beauty of which the Neoplatonists spoke.[1] Moreover, Michelangelo's contemporaries tell us that he did not merely look at nature, but, throughout his life, studied it scientifically. Condivi speaks of his knowledge of perspective,[2] and both he and Vasari record the care which he devoted to anatomy, not merely learning it at second-hand but dissecting bodies himself.[3]

Michelangelo did not, however, believe in the exact imitation of nature. Vasari says that he made a pencil drawing of Tommaso de' Cavalieri 'and neither before nor afterwards did he take the portrait of anyone, because he abhorred executing a resemblance to the living subject, unless it were of extraordinary beauty'.[4] According to Hollanda his scorn for Flemish painting was based on the same idea: 'In Flanders they paint with a view to external exactness ... without reason or art, without symmetry or proportion, without skilful choice or boldness.'[5] This view that the artist must select from nature is in agreement with Alberti, though it is unlikely that the latter would have protested so vigorously against Flemish naturalism. His standards were not the same as those of Michelangelo. Alberti acted according to a strictly rational choice, and sought the typical. Michelangelo pursued the beautiful. Condivi describes his methods as follows, alluding to Zeuxis's painting of the Crotonian Venus:

'He loved not only human beauty but universally every beauti-

[1] Cf. Frey, *Die Dichtungen des Michelagniolo Buonarroti*, nos. v, vi; and Thode, *Michaelangelo und das Ende der Renaissance*, 1903, ii, pp. 138 ff.

[2] M. Holroyd, *Michael Angelo Buonarroti*, 2nd ed., p. 70.

[3] Ibid., p. 64; and Vasari, trans. de Vere, London, 1912–15, ix, p. 103.　　　[4] Vasari, op. cit., p. 106.

[5] Hollanda, *Four Dialogues of Painting*, trans. A. F. G. Bell, p. 15. It must be remembered, however, that in his youth in Florence, Michelangelo copied the work of a northern artist, Schongauer. He even planned a *Trattato di tutte le maniere de' moti umani, e apparenze, e dell' ossa.*

ful thing . . . choosing the beauty in nature, as the bees gather honey from the flowers using it afterwards in their works, as all those have done who have ever made a noise in painting. That old master who had to paint a Venus was not content to see one virgin only, but studied many, and taking from each her most beautiful and perfect feature gave them to his Venus.'[1]

For Michelangelo it is by means of the imagination that the artist attains to a beauty above that of nature, and in this he appears as a Neoplatonist compared with the rational Alberti. To him beauty is the reflection of the divine in the material world. In an early poem he speaks of God's revelation through beauty:

> Colui, che 'l tutto fe', fece ogni parte
> E poi del tutto la più bella scelse
> Per mostrar quivi le sue cose eccelse,
> Com' ha fatto or, con la sua divin' arte.[2]

And from another passage it is clear that the human figure is the particular form in which he finds this divine beauty most clearly manifested:

> Non posso or non veder dentr' a chi muore
> Tua luce eterna senza gran desio.[3]

In other cases he talks of the inward image which the beauty of the visible world arouses in his mind. The idea of beauty set up in this way is superior to material beauty, for the mind refines the images which it receives, and makes

[1] Condivi, op. cit., p. 74.

[2] Frey, iv, probably 1505–11: 'He who made the whole [universe] made every part; then from the whole chose what was most beautiful, to reveal on earth, as He has done here and now His own sublime perfections.' For this and the following translations of Michelangelo's poems I am indebted to the late Miss K. T. Butler.

[3] Ibid. xxx, c. 1526: 'I can never now perceive Thy eternal light within a mortal being without great longing.'

them approach more nearly the Ideas which exist in it by
direct infusion from God:

> Mentre ch'alla beltà, ch'i' viddi in prima
> Apresso l'alma, che per gli occhi vede,
> L'immagin dentro crescie, e quella cede
> Quasi vilmente e senza alcuna stima.[1]

But at this time Michelangelo still firmly believes that the
inward image is dependent on the existence of beauty in the
outside world which is transformed by the mind into some-
thing nobler. In an early sonnet, written in the form of a
dialogue, he asks Love:

> Dimmi di grazia, Amor, se gli occhi mei
> Veggon 'l ver della beltà, ch'aspiro,
> O s'io l'ho dentro, allor che, dov' io miro,
> Veggio scolpito el viso di costei.[2]

And Love answers:

> La beltà che tu vedi, è ben da quella,
> Ma crescie, poi ch'a miglior loco sale,
> Se per gli occhi mortali all' alma corre.
> Quivi si fa divina, onesta e bella,
> Com' a sè simil vuol cosa immortale.
> Questa e non quella a gli occhi tuoi precorre.[3]

These passages may be compared with Raphael's letters to
Castiglione, referring to his fresco of Galatea in the Farnesina,

[1] Ibid. xxxiv. 1530: 'As my soul, looking through the eyes, draws near
to beauty as I first saw it, the inner image grows, while the other recedes,
as though shrinkingly and of no account.'

[2] Ibid. xxxii. 1529–30: 'Tell me, Love, I beseech thee, if my eyes truly
see the beauty which is the breath of my being, or if it is only an inward
image I behold when, wherever I look, I see the carven image of her face.'

[3] Ibid.: 'The beauty you behold indeed emanates from her, but it
grows greater as it flows through mortal eyes to its nobler abode—the
soul. Here it becomes divine, pure, perfect to match the soul's immor-
tality. It is this beauty, not the other, which ever outruns your vision.'

in which he says: 'To paint a beauty I need to see many beauties, but since there is a dearth of beautiful women, I use a certain idea which comes into my mind.'[1]

Michelangelo's views, therefore, in his first period are still related to those of Alberti, but with a strong tinge of Neoplatonic idealism. For Alberti the artist is entirely dependent on nature in his work, and he can only improve on it by attempting to reach the types at which nature aims. For Michelangelo, on the other hand, the artist, though directly inspired by nature, must make what he sees in nature conform to an ideal standard in his own mind. Compared with Alberti this approach may seem already somewhat unrealistic, but compared with Michelangelo's later views it represents a close and direct connexion with nature.

By about 1530 the attempts of the Papacy to form a powerful secular State in Italy had failed. The Reformation had split the Church and incalculably weakened the position of the Pope. Financial disorders of every kind added to the confusion, and the greatest single blow of all had come with the Sack of Rome in 1527, which left Clement VII almost powerless. The whole social structure on which the Humanist art of High Renaissance Rome was based was swept away. Instead of a sense of security men felt the general disturbance of events, which seemed to threaten the existence of the Catholic Church and, with it, of the whole of Italian society.

This changed situation affected different generations in different ways. The older Humanists, men of Michelangelo's age, had felt that the Roman Church was in need of reform, and had anticipated many of the Pauline features in Luther's theology. The latter forms in some respects a parallel to Italian Humanism, for, if the Humanists asserted the rights of individual reason, Luther asserted those of individual conscience. The Italian Humanists were too closely involved

[1] Passavant, *Rafael*, 1839, i, p. 533.

PLATE 7

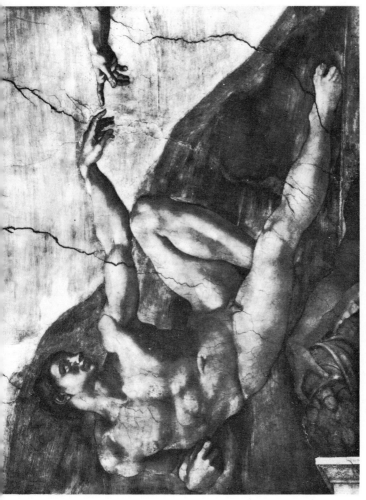

Michelangelo. Adam. From the *Creation of Adam*. Sistine Chapel

with the Church of Rome as an institution to follow Luther
when it became a question of schism in the Church, but, as
long as it appeared possible to combine the more moderate
doctrines of reform, particularly Justification by Faith, with
fidelity to Rome, many of them were in sympathy with the
demands of the German reformers. In this way there was
formed a party of Humanists who aimed at an internal
reform of the Roman Church and a compromise with the
Protestants. This party, which later received the official
support of Paul III, was led by men like Contarini, Pole, and
Sadoleto, with whom were associated as close followers
and supporters Vittoria Colonna and Michelangelo. The
religion of the latter now became fervent, and took on the
form of a serious but not fanatical piety, consonant with his
humanistic principles, but gradually modifying them. He
belongs, that is to say, to those who wanted to build up a new
and spiritualized Catholicism by means of such reforming
doctrines as did not destroy the basis of the Roman Church.

This change of outlook naturally affected Michelangelo's
art, and the change is most clearly shown in the great work
of this period, the fresco of the *Last Judgement* over the altar
of the Sistine Chapel, painted for Clement VII and Paul III
between 1534 and 1541. This fresco is the work of a man
shaken out of his secure position, no longer at ease with the
world, and unable to face it directly. Michelangelo does not
now deal directly with the visible beauty of the physical
world. When he made the *Adam* on the Sistine ceiling
(Plate 7) he was aiming at a rendering of what would in
actual life be a beautiful body, though it was idealized above
reality. In the *Last Judgement* his aim was different. Here
again nudes appear, but they are heavy and lumpish, with
thick limbs, lacking in grace (Plate 8). The truth is not,
as has sometimes been said, that Michelangelo's hand was
failing, but that he was no longer interested in physical
beauty for its own sake. Instead he used it as a means of

conveying an idea, or of revealing a spiritual state. Judged on the Humanist standard of 1510 the *Last Judgement* is a failure, and it is not surprising that the admirers of Raphael could not stomach it. But as the most profound expression of the spiritualized Catholicism which Michelangelo practised, it is a masterpiece of equal importance with the ceiling. The ideals of classic beauty which were relevant in the Sistine ceiling are no longer valid in the *Last Judgement*. Such classical features as there are, like the Charon and Minos group, are seen through the eyes of Dante and are given a new spiritual significance. The most fundamental principle of the High Renaissance seems here to have been neglected, for there is little reconstruction of the real world, no real space, no perspective, no typical proportions. The artist is intent only on conveying his particular kind of idea, though the means by which he conveys it is still the traditional Renaissance symbol, the human figure.

The new approach to life and to art which is to be found in the *Last Judgement* can also be traced in Michelangelo's writings. In the poems of the thirties and early forties a new attitude towards beauty and towards the problem of love is visible. At this time one of the poet's most frequent themes is that physical beauty passes away, so that love directed towards it cannot give complete satisfaction and is degrading to the mind:

> Condotto da molt' anni all' ultim' ore,
> Tardi conosco, o mondo, i tuo' diletti.
> La pace, che non ai, altrui prometti
> E quel riposo c'anzi al nascer muore.
> La vergogna e 'l timore
> Degli anni, c'or prescrive
> Il ciel, non mi rinnova
> Che 'l vecchio e dolce errore,
> Nel qual chi troppo vive
> L'anim' ancide e nulla al corpo giova.
> Il dico e so per pruova

PLATE 8

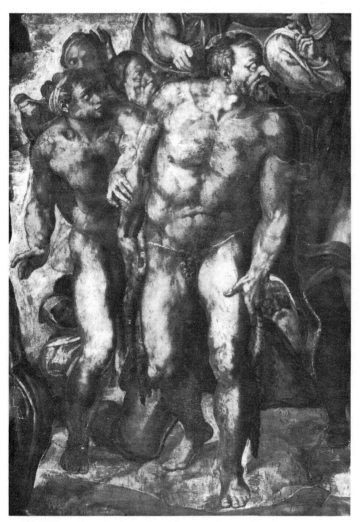

Michelangelo. St. John the Baptist. From the *Last Judgement*

Di me, che 'n ciel quel solo à miglior sorte
Ch'ebbe al suo parto più pressa la morte.[1]

But this element of bitterness and gloom is balanced by a
more optimistic Neoplatonic belief. Love of physical beauty
is a cheat, but the true love, that of spiritual beauty, gives
perfect satisfaction, does not fade with time, and elevates the
mind to the contemplation of the divine. This feeling is ex-
pressed most clearly in the poems to Tommaso de' Cavalieri,
who dominates Michelangelo's emotional life from 1532
onwards. The artist was evidently overwhelmed by the
physical beauty of the young man, but he regarded it as an
outward sign of spiritual and mental beauty, and the friend-
ship was built upon that basis, though the violence of
Michelangelo's passion was no less than in his earlier affec-
tions. This is summed up in a sonnet to Cavalieri:

Non vider gli occhi miei cosa mortale,
　Allor che ne' bei vostri intera pace
　Trovai, ma dentro, ov' ogni mal dispiace,
　Chi d'amor l'alma, a sè simil, m'assale:
E se creata a Dio non fusse eguale,
　Altro che 'l bel di fuor, ch'a gli occhi piace,
　Più non vorrìa; ma, perch'è sì fallace,
　Trascende nella forma universale.
Io dico ch'a chi vive quel che muore
　Quetar non può disir, nè par s'aspetti
　L'eterno al tempo, ove altri cangia il pelo.
Voglia sfrenata el senso è, non amore,
　Che l'alma uccide; e 'l nostro fa perfetti
　Gl'amici qui, ma più per morte in cielo.[2]

[1] Frey, cix. 34, 1536–46: 'Led by long years to my last hours, too late,
O world, I know your joys for what they are. You promise a peace which
is not yours to give and the repose that dies before it is born. The years
of fear and shame to which Heaven now sets a term, renew nothing in
me but the old sweet error in which, living overlong, a man kills his soul
with no gain to his body. I say and I know, having put it to the proof,
that he has the better part in Heaven whose death falls nearest his birth.'

[2] Ibid. lxxix, shortly after 1534. The same idea is expressed in xcii,

However, not only is love directed towards spiritual qualities, but it has also the effect of raising the lover's mind by means of beauty to a contemplation of the divine beauty and therefore to communion with God. In a sonnet to Cavalieri he ends up:

> A quel pietoso fonte, onde siam tutti,
>> S'assembra ogni beltà, che qua si vede,
>> Più ch'altra cosa alle persone accorte;
> Nè altro saggio abbiam nè altri frutti
>> Del cielo in terra; e chi v'ama con fede
>> Trascende a Dio e fa dolce la morte.[1]

But it must not be supposed that Michelangelo's view of beauty is wholly incorporeal and spiritualized. Visible beauty is still for him of the greatest significance, since it is the most effective symbol for the true spiritual beauty, and the beauty of man leads more easily than any other means to the contemplation of the divine. Love is stirred up most easily through the eye, which, according to the Neoplatonists, was the noblest of the senses:

> Tardi ama il cor quel che l'occhio non vede.[2]

cix. 66 and cix. 101, all probably written in the late thirties or early forties. 'It was no mortal thing I beheld when I found unbroken peace in your lovely eyes. But within where no ill thing can please, is One who assails me with love like His own. Had my soul not been created god-like, it would still seek no more than outward beauty, the delight of the eyes; but since this fades so fast, my soul soars beyond, to the eternal Form. Truly nothing mortal can still the desire of living man, nor can he, in reason, expect the Eternal from Time in which all things change and decay. Unbridled and sensual desire kills the soul, love does not. Such love as ours perfects friendship on earth and, in death, makes it yet more perfect in Heaven.

[1] Ibid. lxiv. 1533–4; cf. also cix. 99 and xci, both written in the thirties or early forties. 'The wise believe that all lovely things we see on earth approach more closely than anything else to that fount of mercy whence we all derive. Nor have we here below other foretaste or earnest of Heaven. My love for you makes me ascend to God with faith, turns death to sweetness.'

[2] Frey, cix. 104, c. 1545: 'The heart is slow to love what the eye cannot see.'

It is only through the eye that the artist is stimulated to creation and the spectator to contemplation of divine beauty:

> Per fido esemplo alla mia vocazione
>> Nel parto mi fu data la bellezza,
>> Che d'ambo l'arti m'è lucerna e specchio:
>> S'altro si pensa è falsa opinione.
>> Questo sol l'occhio porta a quella altezza,
>> Ch'a pingere e scolpir qui m'apparecchio.
> Se giudizii temerarii e sciocchi
>> Al senso tiran la beltà, che muove
>> E porta al cielo ogni intelletto sano,
>> Dal mortale al divin non vanno gli occhi
>> Infermi, e fermi sempre pur là, dove
>> Ascender senza grazia è pensier vano.[1]

And it is in the human body that divine beauty is most completely manifested:

> Nè Dio, sua grazia, mi si mostra altrove
>> Più che 'n alcun leggiadro e mortal velo;
>> E quel sol amo, perchè in lui si specchia.[2]

The same idea is expressed in the following madrigal by means of the familiar Neoplatonic doctrine that beauty is the light which streams from the face of God:

> Gli occhi mie' vaghi delle cose belle,
>> E l'alma insieme della sua salute
>> Non hanno altra virtute
>> Ch'ascienda al ciel che mirar tutte quelle.

[1] Ibid. xciv. 1541–4: 'As a sure guide to me in my vocation, the Idea of beauty, which is a mirror and a lamp to both my arts, was bestowed upon me at birth. Whosoever conceives otherwise is mistaken. This Idea alone lifts my eyes to those high visions which I set myself to paint and carve here below. If men of rash and foolish judgement drag sense-ward the beauty which moves and transports every right intelligence to Heaven, it is because weak and wavering eyes, and even eyes fixed steadily on things above, cannot pass from the mortal to the divine, for without grace it is a vain thought that one may rise thither.'

[2] Ibid. cix. 105, 'To Cavalieri', 1536–42: 'Nowhere does God, in his grace, reveal himself to me more clearly than in some lovely human form, which I love solely because it is a mirrored image of Himself.'

Dalle più alte stelle
Discende uno splendore,
Che 'l desir tira a quelle;
E qui si chiama amore.
Nè altro ha il gentil core
Che l'innamori e arda e che 'l consigli,
Ch'un volto che negli occhi lor somigli.[1]

At this period of his life, therefore, Michelangelo's poems
show strongly the influence of the more mystical elements of
Neoplatonism. The strong physical passion of the early love
poems has given place to doctrines which make of love the
contemplation of an incorporeal beauty. This is only another
manifestation of the same tendency which we have traced
in the paintings of the second period, such as the *Last Judge-
ment*. It is also the equivalent of the spiritualized form of
religion with which Michelangelo was associated in the
thirties and forties. In all branches of his art and thought
we feel a withdrawal from that direct contact with life which
characterized the early period.

It may be suggested that this tendency away from the
material and towards the things of the spirit can really be put
down to the fact that Michelangelo was growing old. No
doubt this provides a part of the explanation, but not the
whole of it. Not all old men become spiritually minded.
They only become so in certain circumstances, and Michel-
angelo's mysticism was a mode of escape from finding that
his own world had crumbled about him. Age played its part,
because had he been younger Michelangelo might have been
able to fit himself to the changed circumstances, and have been

[1] Frey, cix. 99, probably 1534–42: 'Neither my eyes in love with all that
is beautiful, nor my soul thirsting for salvation, possess any power that
can raise them to Heaven but the contemplation of beautiful things.
From the highest Heaven there streams down a splendour which draws
desire up towards the stars, and here on earth men call it love. And there
is nothing that can captivate, fire and give wisdom to a noble heart as can
a face lit with star-like eyes.'

drawn into the Counter-Reformation movement. But the general situation also played its part in breaking up the foundation on which his life was built.

In those passages of Michelangelo's poems which refer directly to the art of painting and sculpture we find a change corresponding to that in his ideas on beauty in the abstract.

In the first place Michelangelo is much more explicit about the religious function of the arts. Hollanda records a conversation in which Michelangelo explains his idea of the religious painter, who according to him must be skilful in his art and at the same time a man of pious life:

'In order to imitate in some degree the venerable image of Our Lord, it is not enough to be a painter, a great and skilful master; I believe that one must further be of blameless life, even if possible a saint, that the Holy Spirit may inspire one's understanding. . . . Often badly wrought images distract the attention and prevent devotion, at least with persons who have but little; while those which are divinely fashioned excite even those who have little devotion or sensibility to contemplation and tears, and by their austere beauty inspire them with great reverence and fear.'[1]

The view which he expresses here is curiously close to that of Savonarola on religious art.[2] We know from Condivi[3] that Savonarola was an important influence in his life, and it is quite likely that his conception of painting as an art devoted to the service of the Church was affected by the teaching of the Dominican.

In the more purely aesthetic part of Michelangelo's writings on the arts the dominant influence in this period is that of Neoplatonism, which affects his view of the relation of painting to the visible world. Painting is no longer talked of as an imitation of nature, and the artist's interest is diverted almost entirely towards the inward mental image,

[1] Op. cit., p. 65. [2] Cf. above, Ch. III. [3] Op. cit., p. 74.

which excels everything that can be found in the visible world:

> Amor, la tua beltà non è mortale;
> Nessun volto fra noi è che pareggi
> L'immagine del cor, che 'nfiammi e reggi
> Con altro foco e muovi con altr' ale.[1]

The idea in the mind of the artist is more beautiful than the final work, which is only a feeble reflection of it. According to Condivi Michelangelo 'has a most powerful imagination, whence it comes, chiefly, that he is little contented with his works and has always underrated them, his hand not appearing to carry out the ideas he has conceived in his mind.'[2]

At this time Michelangelo lays great stress on the divine inspiration of the artist. God is the source of all beauty:

> Ma quel divin, che in cielo alberga e stassi,
> Altri e sè più, col proprio andar fa bello.[3]

And art is a gift received by the artist from heaven:

> . . . la bell' arte, che, se dal ciel seco
> Ciascun la porta, vince la natura, . . .[4]

By means of this divine gift the artist can give life to the stone in which he carves his statue:

> Se ben concetto à la divina parte
> Il volto, e gli atti d'alcun, po' di quello
> Doppio valor con breve e vil modello
> Dà vita a' sassi. . . .[5]

[1] Frey, lxii. 1533–4: 'Love, thy beauty is not mortal. No face on earth can compare with the image awakened in the heart which you inflame and govern, sustaining it with strange fire, uplifting it on strange wings.'

[2] Condivi, p. 77; cf. Vasari, *Lives*, ix, p. 104.

[3] Frey, ci. 1547: 'The Divine Hammer [as opposed to the sculptor's] who dwells and abides in Heaven, not only shapes beauty in others but, by so doing, makes His own beauty greater still.'

[4] Ibid. cix. 94, shortly after 1534: '. . . Art which, if a man bring it with him from Heaven, subdues and surpasses Nature.'

[5] Ibid. cxxxiv, *c.* 1547: 'If a man's face and bearing have been well conceived by what is divine in the artist, then with twofold power [i.e. conception and execution] he will make the stone live, though he use but a small, mean model.'

And the stone itself, the material part of the work, is useless
and dead till the imagination has acted upon it:

> Si come nella penna e nell' inchiostro
> È l'alto e 'l basso e 'l mediocre stile,
> E ne' marmi l'immagin ricca e vile,
> Secondo che 'l sa trar l'ingegnio nostro. . . .[1]

Michelangelo's theory of sculpture can be deduced from
some of the poems, particularly the sonnet beginning:

> Non ha l'ottimo artista alcun concetto,
> Ch'un marmo solo in sè non circoscriva
> Col suo soverchio, e solo a quello arriva
> La man, che ubbidisce all' intelletto.[2]

The explanation of this idea is to be found in the fact that
when Michelangelo speaks of sculpture he always has in mind
sculpture in marble or stone and not modelling in clay. 'By
sculpture I mean the sort that is executed by cutting away
from the block: the sort that is executed by building up
resembles painting.'[3] For Michelangelo the essential charac-
teristic of sculpture is that the artist starts with a block of
stone or marble and cuts away from it till he reveals or dis-
covers the statue in it. This statue is the material equivalent
of the idea which the artist had in his own mind; and, since
the statue existed potentially in the block before the artist
began to work on it, it is in a sense true to say that the idea in
the artist's mind also existed potentially in the block, and
that all he has done in carving his statue is to discover this
idea.

In an early version of a sonnet which has been in part

[1] Ibid. lxv, referring to Cavalieri: 'Just as in pen and ink we find
elevated, plain and middle styles, and in marble noble or lowly forms
according as the sculptor's imagination is capable of drawing them forth
from the block. . . .'

[2] Ibid. lxxxiii. 1536–47: 'The greatest artist has no conception which
a single block of marble does not potentially contain within its mass, but
only a hand obedient to the mind can penetrate to this image.'

[3] Letter to Varchi, 1549.

quoted above, Michelangelo gives further indications about his methods:

> Da che concetto à l'arte intera e diva
> Le membra e gli atti d'alcun, poi di quello
> D'umil materia un semplice modello
> È 'l primo parto che da quel deriva.
> Po' nel secondo in pietra alpestra e viva
> S'arrogie le promesse del martello,
> E si rinasce tal concetto bello,
> Che 'l suo eterno non è chi 'l prescriva.[1]

This 'double birth' corresponds exactly to what we know of Michelangelo's methods as a sculptor. In general he did not make a full-size clay version for a marble statue, but worked instead from a small model, perhaps only a foot high, which kept before him the idea which he had in his mind.[2] Starting from this he attacked the block directly, literally uncovering the statue, so that an unfinished figure like the St. Matthew (Plate 9) gives the impression that it is all in the block and that one could just knock off the superfluous marble and reveal the complete statue.

Certain opinions of Michelangelo's which are recorded by his immediate followers show that he had almost consciously broken with the ideals of the earlier Humanists. He was opposed, for instance, to the mathematical methods which formed an important part of Alberti's or Leonardo's theory. Lomazzo records a saying of his that 'all the reasonings of geometry and arithmetic, and all the proofs of perspective

[1] Frey, p. 480, sonnet cxxxiv, version I, 1544–6: 'After divine and perfect art has conceived the form and attitudes of a human figure, the first-born of this conception is a simple clay model. The second, of rugged live stone, then claims that which the chisel promised, and the conception lives again in such beauty that none may confine its spirit.'

[2] Cellini in his *Trattato della Scultura* (ch. iv) records that Michelangelo in general worked without a full-scale model, but that in his later work he sometimes used one. He quotes as examples the statues for the New Sacristy of S. Lorenzo.

PLATE 9

Michelangelo. St. Matthew. Academy, Florence

were of no use to a man without the eye',[1] and Vasari attributes to him the saying that 'it was necessary to have the compasses in the eyes and not in the hand, because the hands work and the eyes judge'.[2] He disapproved further of the importance which Alberti and the early Renaissance artists attributed to rules in painting, and he seems not to have sympathized at all with their idea that nature was based on general rules and a general orderliness. He condemns Dürer's treatment of proportion in the human figure as too rigid, saying that this is a matter 'for which one cannot make fixed rules, making figures as regular as posts';[3] and, according to Vasari, 'he used to make his figures in the proportion of nine, ten, and even twelve faces,[4] seeking nought else but that in putting them all together there should be a certain harmony of grace in the whole, which nature does not present.'[5] These opinions all show how far Michelangelo in his later period relied on imagination and individual inspiration rather than on obedience to any fixed standards of beauty. The same is true of his attitude towards architecture, for Vasari writes that

'he departed not a little from the work regulated by measure, order and rule which other men did according to a common use and after Vitruvius and the antiquities, to which he would not conform . . . wherefore the craftsmen owe him an infinite and everlasting obligation, he having broken down the bonds and chains by reason of which they had always followed a beaten path in the execution of their works.'[6]

[1] Lomazzo, *Trattato*, bk. v, c. 7.
[2] Vasari, *Lives*, ix, p. 105. [3] Condivi, p. 69.
[4] Though Vasari writes *teste* here he must mean *faces*, for a figure of twelve *heads* would be too elongated even for a Mannerist.
[5] Vasari, *Lives*, ix, p. 104.
[6] Ibid., p. 44; cf. also Condivi, p. 69. Since Vasari's day the licences taken by Michelangelo with architecture have often been the subject of less favourable comment, as for instance by Teofilo Gallacini in his *Trattato sopra gli errori di architetti*, written in 1621 but only published in Venice in 1767.

This independence of all rule and the individualism that
accompanied it account for the opinion which was generally
held in the middle of the sixteenth century that Raphael was
the ideal balanced painter, universal in his talent, satisfying
all the absolute standards, and obeying all the rules which
were supposed to govern the arts, whereas Michelangelo was
the eccentric genius, more brilliant than any other artists in
his particular field, the drawing of the male nude, but un-
balanced and lacking in certain qualities, such as grace and
restraint, essential to the great artist. Those, like Dolce and
Aretino, who held this view were usually the survivors of
Renaissance Humanism, unable to follow Michelangelo as
he moved on into Mannerism. That this difference of aim
was apparent to Michelangelo himself is evident from his
remark recorded by Condivi that 'Raphael had not his art
by nature but acquired it by long study'.[1]

In the last fifteen or twenty years of his life we can trace
a further change in Michelangelo's art and ideas, though in
some ways this change consists in an intensification of the
characteristics of the art and ideas of the late thirties and
early forties.

After about 1545 the situation of the Papacy changed.
The schism with Protestantism had reached a more acute
stage, and since the Diet of Ratisbon it had become apparent
that any kind of compromise was impossible. Therefore the
position of the moderate party to which Michelangelo was
attached was steadily weakened. The Church could no
longer hope to save itself by their methods and was forced
to adopt a much more drastic policy. Even Paul III found
himself compelled in his last years to give up his attempts
at conciliation and to allow the more fanatical Counter-
Reformers to put their ideas into practice. At the Council
of Trent the survivors of the Contarini party were defeated,

[1] Condivi, p. 76.

and their rivals, the Jesuits and Caraffa, had their way,
gradually establishing their system of blind belief in authority,
strict obedience, and absolute rigidity of doctrine.

One result of this change was that the moderates found
themselves stranded. They could not sympathize with the
new and drastic policy, and yet their own methods seemed
useless. Their position was, in fact, hopeless, and for this
reason their mysticism gradually takes on a more introspec-
tive character.

Michelangelo's most representative work in this period
is the last group which he carved, the Rondanini *Pietà*
(Plate 6 *b*), left unfinished at his death, in which he seems
to have deprived his human symbols of all corporeal quality
and to succeed at last in conveying directly a purely spiritual
idea. Like most of the other works of this period, such as
the *Pietà* in the Cathedral of Florence, and the group of late
drawings, it is concerned with the central features of the
Christian faith, the events of the Passion. Michelangelo has
given up classical subjects, but even the religious themes
which he treats are no longer those which he preferred in his
younger days. Then he chose for his subjects either Old
Testament figures, like David, or themes from the New
Testament, like the Holy Family, which had a direct and
general human appeal. When he carved a *Pietà*, as in St.
Peter's, it was conceived as a human tragedy, without much
indication of the supernatural implications (Plate 6 *a*).
The *Pietà* of the last years is an expression of violent,
personal, mystical Christian faith, which appears with
equal intensity in the drawings for the Crucifixion of the
same period.

A corresponding change takes place in Michelangelo's
writings. Much of what has been said about his views in the
middle period of his life applies even more strongly to his last
years. His approach to the world and the arts becomes even
more spiritual, but at the same time more specifically

Christian. His religious feeling now combines the mystical conception of Neoplatonism with the intense belief in Justification by Faith which he learnt from Savonarola and the Contarini group. But he talks less of an abstract divine essence and more of a God whom he addresses personally. We may suppose that his comment on the paintings of Fra Angelico, which shows how much importance he attributed to Christian piety in an artist, was made about this time: 'This good man painted with his heart, so that he was able with his pencil to give outward expression to his inner devotion and piety, which I can never achieve, since I do not feel myself to have so well disposed a heart.'[1]

He wishes to abandon the whole world and to fix all his thoughts on God, but he feels that he can do nothing without God's grace:

> Gl'infiniti pensier mie', d'error pieni,
> Ne gl'ultim' anni della vita mia
> Ristringer si dovrien 'n un sol che sia
> Guida agli eterni suo' giorni sereni.
> Ma che poss' io, Signor, s'a me non vieni
> Coll' usata ineffabil cortesia?[2]

All mortal love must be given up. Michelangelo seems no longer to have faith in human beauty as a symbol of the divine. He rather fears it as a distraction from the pure things of the spirit:

> Deh, fammiti vedere in ogni loco!
> Se da mortal bellezza arder mi sento,
> Appresso al tuo mi sarà foco ispento,
> E io nel tuo sarò, com' ero, in foco.

[1] See Paleotti, *Archiepiscopale Bononiense*, Rome, 1594, p. 81.

[2] Frey, cxlviii, *c.* 1554–5: 'In these last years of my earthly life my endless thoughts, were they not full of error, should be contracting into one sole thought guiding me to the peace of eternal life. Lord, what shall I do, unless Thou wilt visit me with Thy wonted ineffable grace?'

Signior mio caro, i' te sol chiamo e 'nvoco
 Contra l'inutil mio cieco tormento:
 Tu sol puo' rinnovarmi fuora e drento
 Le voglie e 'l senno e 'l valor lento e poco;
Tu desti al tempo ancor quest' alma diva
 E 'n questa spoglia ancor fragil' e stanca
 L'incarcerasti e con fiero destino.
Che poss' io altro, che così non viva?
 Ogni ben senza te, Signior, mi manca;
 Il cangiar sorte è sol poter divino.[1]

He hates and fears the things of this world which he regards
as temptations, or, at best, as distractions from a higher duty.
In passionate repentance he writes:

Le favole del mondo m'ànno tolto
 Il tempo dato a contemplare Iddio,
 Nè sol le grazie sue poste in oblio,
 Ma con lor, più che senza, a peccar volto.
Quel ch'altri saggio me fa cieco e stolto
 E tardi a riconoscer l'error mio.
 Manca la speme, e pur cresce il desio
 Che, da te, sia dal proprio amor disciolto.
Ammezzami la strada, ch'al ciel sale,
 Signior mio caro, e, a quel mezzo solo
 Salir, m'è di bisognio la tua 'ita.
Mettimi in odio quanto 'l mondo vale
 E quante sue bellezze onoro e colo,
 Ch'anzi morte caparri eterna vita.[2]

[1] Ibid. cxxiii. 1547–50: 'Of Thy mercy, make me see Thee in all places.
If mortal beauty sets me aflame, my fire shall seem spent when brought
near to Thine. Yet in Thy flame shall I be once more on fire. On Thee
alone do I call, dear Lord, Thee alone do I invoke against my blind, vain
torment. Thou alone canst renew me within and without, renew my
desires, my judgement, my courage, slow and feeble. For Thou not only
gavest to Time my divine soul, but didst imprison it in this frail and weary
flesh, and didst hand it over to its cruel destiny. How can I escape living
thus? Without Thee, indeed, O Lord, I lack every good thing: it is
divine power alone which can change my lot.'
 [2] Ibid. cl, c. 1555: 'I have let the vanities of the world rob me of the
time I had for the contemplation of God. Not alone have these vanities

But most remarkable of all is the sonnet in which he turns
not only against the world and mortal beauty but against the
imagination itself and against the arts to which it has led him:

> Giunto è già 'l corso della vita mia
> Con tempestoso mar per fragil barca,
> Al comun porto, ov' a render si varca
> Conto e ragion d'ogni opra trista e pia.
> Onde l'affettuosa fantasia
> Che l'arte mi fece idol' e monarca
> Conosco or ben, com' era d'error carca
> E quel ch'a mal suo grado ogn' uom desia.
> Gli amorosi pensier, già vani e lieti,
> Che fien or s'a duo morte m'avvicino?
> D'una so 'l certo, e l'altra mi minaccia.
> Nè pinger nè scolpir fie più che quieti
> L'anima, volta a quell' amor divino,
> Ch'aperse, a prender noi, 'n croce le braccia.[1]

This sonnet is perhaps the supreme proof of the changes that
had come over Michelangelo since his youth. It is hard to
believe that the Humanist creator of the early Bacchus or

caused me to forget His blessings, but God's very blessings have turned
me into sinful paths. The things which make others wise make me blind
and stupid and slow in recognizing my fault. Hope fails me, yet my desire
grows that by Thee I may be freed from the love that possesses me. Dear
Lord, halve for me the road that mounts to Heaven, and if I am to climb
even this shortened road, my need of Thy help is great. Take from me
all liking for what the world holds dear and for such of its fair things as I
esteem and prize, so that, before death, I may have some earnest of eternal
life.'

[1] *Frey*, cxlvii, *c.* 1554: 'In a frail boat, through stormy seas, my life in
its course has now reached the harbour, the bar of which all men must
cross to render account of good and evil done. Thus I now know how
fraught with error was the fond imagination which made Art my idol and
my king, and how mistaken that earthly love which all men seek in their
own despite. What of those thoughts of love, once light and gay, if now
I approach a twofold death. I have certainty of the one and the other
menaces me. No brush, no chisel will quieten the soul, once it is turned
to the divine love of Him who, upon the Cross, outstretched His arms to
take us to Himself.'

even the painter of the Sistine ceiling would one day pray to renounce the arts from feelings of Christian piety.

In Michelangelo we have an example of that rare phenomenon, the great artist who is both able and willing to put in writing what he feels about his art. The value of these writings to us depends largely on the light which they throw on the artist's work in painting and sculpture. It is possible to enjoy and even to understand the frescoes on the Sistine roof without reading any of the sonnets, but the appreciation of both the poetry and the paintings can be increased by the comparison of the one with the other; and in the case of Michelangelo's latest works, like the Rondanini *Pietà*, the exposition in words in the late sonnets of the ideas expressed more obscurely, but not less completely, in the carved forms of the statue may provide a clue to the meaning of the latter, for which any one unacquainted with the poems might long search without success. We could deduce the changes traceable in Michelangelo's view of life from his paintings and sculpture, but the evidence of the written word is more compelling, because less liable to misinterpretation; and an hypothesis based on the former is more than doubled in strength when it is confirmed by the latter. The changes that have been traced above, however, are not merely those of a single individual. For Michelangelo was the type of those men who belonged to the Renaissance but lived on into the early stages of the Counter-Reformation. The development in his ideas, therefore, follows the change from one epoch to another, and prepares the way for the art and doctrines of Mannerism.

Chapter VI

THE MINOR WRITERS OF THE
HIGH RENAISSANCE

IN general the High Renaissance in Italy did not produce the outburst of theoretical works which might have been expected from it. The reason may be that in the early sixteenth century the arts were at a peak in their development when theory for a moment seemed unnecessary. In the Quattrocento the ideas which artists were working out were so new and exciting that they demanded theoretical treatment. In the early Cinquecento the newly discovered territory had been thoroughly absorbed. There was little to dispute in the field of the arts, since all were agreed on a more or less fixed set of doctrines worked out by the previous generation. Critics, therefore, could only go on copying down in palatable form a common stock of accepted ideas.[1]

More interesting than these popularizers is a small group of Venetian critics who wrote about the middle of the century. The *Disegno* of the Florentine Antonio Francesco Doni, published in Venice in 1549, provides nothing of theoretical interest, but from the works of three other writers we can form some idea of what the Venetians thought about painting in the middle of the Cinquecento. These writers are Paolo Pino, whose *Dialogo di Pittura* appeared in 1548; Michelangelo Biondo, who published his *Della Nobilissima Pittura* in the next year; and Lodovico Dolce, whose dialogue

[1] Among handbooks of this kind the following should be mentioned: Pomponius Gauricus, *De Sculptura*, Florence, 1504; Lancilotti, *Tractato de Pictura*, Rome, 1509. Castiglione's allusions to painting in the *Cortegiano*, and Equicola's in his *Instituzioni*, have already been mentioned in the last chapter. To these names may be added that of Paolo Giovio, who wrote short lives of Leonardo, Raphael, and Michelangelo.

L'Aretino, printed in 1557, will be chiefly discussed in the chapter on religious painting.

These treatises were written at the moment when Venetian painting was hovering on the edge between the Renaissance and the Mannerist periods. Titian, the great figure of the older generation, was slowly changing his style, abandoning his early sensuous manner, and turning towards a more dramatic, emotional, and religious style. Among the younger artists Tintoretto, Paris Bordone, and the Bassani were tending whole-heartedly towards Mannerism, while a few major figures such as Veronese continued in the earlier Venetian tradition.

We find the same division of feeling and the same hesitation among the critics. Much of what they say is simply the traditional matter of earlier Renaissance treatises. Pino, Dolce, and Biondo all three draw extensively on Alberti, Biondo even copying several chapters from him almost word for word, and the commonplaces from Pliny and other ancient writers fill a large part in each of the treatises.

Although his dialogue was the latest of the three in date, Dolce belongs more closely to the Renaissance than the other two critics. The theme of his dialogue is that Michelangelo is not so great a master as is generally supposed, and that Raphael and Titian at least are his superiors. It will be seen later that Dolce, who was largely acting as a mouthpiece for Aretino in this dialogue, had personal reasons for wishing to decry Michelangelo whom he certainly admired,[1] but probably he genuinely thought that Michelangelo was a one-sided artist in comparison with Raphael, and that in his later work, particularly in the *Last Judgement*, he was falling off from his earlier standard. It would be consistent with his strictly Renaissance view to regard the Mannerist idiosyncrasies of the *Last Judgement* as freaks and signs of decadence. To him Raphael was the perfect example of a balanced Humanist

[1] See his letter to Ballini in Bottari-Ticozzi, *Raccolta di Lettere*, Milan, 1822, v, p. 175.

artist, skilful in all the branches of his art, and not devoting himself to the pursuit of one quality only as Michelangelo concentrated, according to him, on the drawing of the nude. But even above Raphael he places Titian as the greatest painter of the period, a balanced artist, with supreme mastery of colour. In certain passages Dolce protests against practices which are particularly associated with Mannerism. He disapproves of the use of foreshortening when it is introduced irrelevantly only to display the skill of the artist;[1] also of the habit of making every figure affectedly elegant, a trick of the Mannerists who followed Parmigianino.[2] Dolce has great respect for the ancients,[3] and prefers the easy elegance of Raphael to the *terribiltà* of Michelangelo—a distinction which at this date is equivalent to the opposition of Renaissance to Mannerism. One point is discussed explicitly in Dolce which had only been indirectly dealt with by earlier writers, namely, the right of the layman who does not himself paint to judge in questions of art. Earlier writers of the Renaissance seem to have assumed that the educated layman was competent to judge everything except the technical part of a painting, but Dolce expresses this opinion clearly.[4] This view, based on the idea that painting is a learned pursuit and the sister of poetry, is again typical of Dolce's Humanist outlook.

Paolo Pino is more divided in his attitude. He has the proper Humanist feeling that the painter must be born with a natural talent for his art;[5] and in his attitude on the matter of facility, to which the Mannerists attributed such importance, he is still on the side of the Renaissance, maintaining that great speed and great slowness are both to be avoided.[6] On the other hand, he speaks more as a Mannerist when he demands that the artist shall display his virtuosity by in-

[1] *L'Aretino*, ed. 1735, p. 208. [2] Ibid., p. 192.
[3] Ibid., p. 190. [4] Ibid., p. 116.
[5] *Dialogo*, p. 21. [6] Ibid., p. 18.

genious foreshortenings in his paintings.[1] In another passage he hints at the theory of Eclecticism, when he says that if Titian and Michelangelo could have combined their talents they would have made the perfect artist.[2] This is an idea which constantly recurs in later Mannerist writings, and it is also reported as a maxim of Tintoretto.

Michelangelo Biondo is in general a mere plagiarist with no feeling for painting at all. All his ideas are borrowed from traditional Renaissance sources, but the treatise ends with the description of ten subjects for paintings, in the manner of Philostratus, in which the writer shows himself much closer to Mannerist ideals. The descriptions are a mixture of Neoplatonic imagery, freely interpreted mythology, and scholastic symbolism—in fact, just the elements which we shall later see brought together in the pure Mannerist writings on the arts.

[1] Ibid., p. 5. [2] Ibid., p. 24.

VASARI

THE political disturbances of the early sixteenth century affected different parts of Italy in different ways. Something has already been said of the chaos produced in Rome by the Sack of 1527. In Florence this episode was the signal for a new outburst of popular feeling. The Medici were driven out, and for a time a popular government ruled the city. But by 1531 the Medici were reinstated, and this time they took care to destroy even those traces of democracy which they had tolerated before 1527. The government of the city became undisguisedly autocratic, and nothing but the name remained of the old republic. During the pontificate of Clement VII and the early years of Paul III the connexion between Florence and Rome was strong, but when the Papacy, about 1545, launched out into the militant phase of the Counter-Reformation the tie grew steadily weaker. For several decades Florence was less affected than most Italian cities by the spirit which inspired reformers of the Caraffa type. Its government remained purely secular, and even the Inquisition was subject there to state control. There was never felt in Florence that bitter spiritual disillusionment which came over Michelangelo in Rome, nor the fighting Christian spirit personified in St. Ignatius.

The art of Florence in the mid-sixteenth century is therefore a pure court art. The constitution of the city was too autocratic for it to produce a Humanist art like that of Rome under Julius II, but it was also too secular to produce the spiritualized painting of Michelangelo in his later years, or of later Roman Mannerism. Florentine Mannerism, as represented in the painting of Vasari or Bronzino, has neither the rationalism of early Quattrocento Florentine painting, nor

the emotional intensity of Michelangelo's *Last Judgement*, nor the organized didacticism of Taddeo Zuccaro.

It is still a form of Renaissance art in the sense that many elements of classicism survive in it, but they are all transformed to suit the court tone which painting had assumed. The classical culture of the Florentine Mannerists has lost its aggressive quality. It is no longer progressively rational, but has become elegant and ingenious. Artists generally turn for their subjects either to the glorification of the Medici or to allegorical mythology, so involved that a volume is needed to explain a fresco cycle such as Vasari's in the Palazzo Vecchio. Religious subjects are treated in much the same way. Bronzino's frescoes in the chapel of Eleanor of Toledo in the Palazzo Vecchio are variations on the theme of the human figure, entirely freed from any spiritual significance; and Vasari's religious paintings are of the same kind.[1] The actual style grows elegant, sweet, and affected. Nothing survives from the real High Renaissance style except its skill and its worldliness. Its energy and rationalism have gone.

As is to be expected in the art produced in a court of this kind, it was only in portraiture that any real discoveries were made. Here Pontormo and still more Bronzino evolved a new style in which elegance was combined with a certain formalism of pose and minute naturalism of detail.

The equivalent in theory to Florentine painting of the mid-sixteenth century is provided by the writings of Vasari. There are other sources, such as Cellini's treatises on the goldsmith's and the sculptor's arts, or Benedetto Varchi's *Lezioni*, but these are too slight to be of use except in supplementing and confirming what we find in Vasari. Of Vasari's own works only the *Lives* are of serious interest from

[1] There were, of course, painters such as Rosso and Pontormo in his youth who worked in a different manner and produced paintings of passionate religious intensity in the earlier part of the century. But this style does not belong to the type of Mannerism reflected in Vasari, and for that reason it is not considered here.

the point of view of theory, since the *Ragionamenti* only
contain an exposition of the allegories in a single cycle of
paintings, and the letters are not in general illuminating.
From the *Lives*, on the other hand, it is possible to form
some idea of what Vasari thought about the arts.

The material, however, is not convenient to handle. The
Lives were first published in 1550 under the title *Le Vite de'
più eccellenti Architetti, Pittori et Scultori Italiani*, and were
reissued in 1568 in very much enlarged form. Apart from
the actual biographies, in which scattered comments on the
function of the arts can be found, there are certain sections
of the work devoted mainly to theoretical discussion. Of the
two prefaces the first contains the arguments about the
superiority of painting over sculpture, and the second a
history of art from the earliest times up to Cimabue. There
are also three introductions devoted to painting, sculpture,
and architecture respectively, in the main filled with technical
details, but containing also some general comments. Finally
there is a *proemio* to each of the three parts into which the
Lives are divided, and in these the general characteristics of
the period in question are discussed.

At first sight there seem to be many remains of High
Renaissance theory in Vasari, but when they come to be
examined it appears that all the elements surviving have been
altered and given a new meaning.

For Vasari, as for Alberti, the foundation of any theory of
painting is that this art consists in the imitation of nature.
One of his highest forms of praise for a painting is to say that
the figures are so natural that they seem alive, and in the pre-
face to the *Lives* he says: 'Our art is all imitation, of nature
for the most part, and then, because a man cannot by himself
rise so high, of those works that are executed by those whom
he judges to be better than himself.'[1] This quotation is
typical, for when Vasari says 'imitate nature' he nearly always

[1] Ed. cit. i, p. xliii.

qualifies it in such a way that in the end the reader is left
with the impression that there are many other things more
important for the artist to pursue than the rendering of
nature. It is at least as vital, for instance, that he should
learn from studying other painters, for, as Vasari says with
reference to Titian, whose style is too naturalistic for his
taste: 'He who has not drawn much nor studied the choicest
ancient and modern works cannot . . . improve the things
that he copies from life, giving them the grace and perfection in
which art goes beyond the scope of nature.'[1] This view that
art can excel nature is evidently one in which Vasari believed
firmly, for it is repeated in several contexts throughout the
Lives.[2] He is therefore far from agreeing with Leonardo that
the only hope of the artist lies in the greatest possible truth
to nature. In fact in the life of Domenico Puligo he implies
an actual contrast between beauty and naturalism:

'I have seen some heads portrayed from life by his hand, which,
although they have, for example, the nose crooked, one lip small
and the other large, and other such like deformities, nevertheless
resemble the life, through his having well caught the expression
of the subject; whereas, on the other hand, many excellent masters
have made pictures and portraits of absolute perfection with
regard to art, but with no resemblance whatever to those that they
are supposed to represent. And to tell the truth, he who executes
portraits must contrive, without thinking of what is looked for
in a perfect figure, to make them like those for whom they are
intended. When portraits are like and beautiful, then they may
be called rare works, and their authors truly excellent craftsmen.'[3]

[1] Ibid. ix, p. 171.
[2] e.g. with reference to Michelangelo, iv, p. 84, and to Raphael, iv,
p. 83. It is true that in the life of Mino da Fiesole he explicitly contradicts
this doctrine and says that the artist can by no means equal nature; but
in this case it is a piece of special pleading, for Vasari is reproving those
artists who only imitate the works of others without ever referring to
nature itself. This leads, of course, to mannerism, of which Vasari does
not in general disapprove when it is the mannerism of his own generation,
but which he condemns when it is a Quattrocento convention of non-
realism. [3] *Lives*, iv, p. 280.

Alberti admitted that exact imitation was not in itself enough to produce perfect beauty, but he would never have allowed the direct contrast between likeness and beauty made by Vasari.

The latter's attitude towards nature is illustrated by another small point. One of his principal reasons for recommending the careful study of nature is that it is the only means by which the artist can reach a stage where he can draw anything from memory with ease and without reference to the model.

'The best thing is to draw men and women from the nude and thus fix in the memory by constant exercise the muscles of the torso, back, legs, arms and knees, with the bones underneath. Then one may be sure that, through much study, attitudes in any position can be drawn by help of the imagination without one's having the living forms in view.'[1]

The study of nature is not therefore an end in itself, but a means to efficiency in drawing from memory.[2]

There are passages in the *Lives* which at first sight recall Alberti, particularly when Vasari is talking of the necessity of choosing from nature: 'Manner then attained to the greatest beauty from the practice which arose of constantly copying the most beautiful objects, and joining together these most beautiful things, hands, heads, bodies, and legs, so as to make a figure of the greatest possible beauty.'[3] But in reality the meaning of such a passage is different from that which Alberti would have given it. For the selection from nature is now to be made according to an entirely different principle from his. The artist is now no longer to choose the reasonable mean, the general and the typical; he is to choose according to his *judgement*. And with Vasari judgement is

[1] Introduction: Of painting, ch. i; *Vasari on Technique*, ed. L. S. Maclehose, p. 210.
[2] The same view is to be found in Cellini's fragmentary 'Discorso sopra . . . l'arte del disegno'.
[3] *Lives*, iv, p. 80.

not, as with Alberti, a rational faculty; it is rather an instinct, an irrational gift, allied to what we call taste, and residing not so much in the mind as in the eye.

It will be remembered that with Alberti the perfection of proportion in the human body was arrived at by a more or less mathematical computation, by averaging the measurements which were the foundation of all the proportions which he gave. Vasari draws a contrast between the results arrived at by measurement and those reached by judgement, which seems to work independently of any such rational mode of calculation. In talking of the artists of the Quattrocento he says: 'In proportion there was wanting a certain correctness of judgement, by means of which their figures, without having been measured, might have, in due relation to their dimensions, a grace exceeding measurement.'[1] And in the introduction on sculpture he makes the situation even clearer: 'But no better standard can be applied than the judgement of the eye; for even though a thing is perfectly measured, if the eye is still offended, it will not cease to censure it.'[2]

This final appeal to the eye is typical of Florentine Mannerist painting and of Vasari's outlook. For the group of artists which he represents, painting had ceased to be the intensely serious intellectual pursuit that it had been for the artists of the High Renaissance. It had become rather a game of skill, appealing to a love of ingenuity and leaving the rational faculties undisturbed.

Several characteristics in the main group of Florentine Mannerists and in Vasari bring out this lowering of the intellectual and emotional tone of art. For a painter like Bronzino or a theorist like Vasari painting consists primarily in the rendering of the naked human form, whereas an earlier Renaissance artist like Leonardo made human action and emotion his principal interest. To Michelangelo the naked

[1] Ibid. [2] *Vasari on Technique*, p. 146.

human body was certainly the first object for the artist's
consideration, but, as we have seen, he saw in it a reflection
of a spiritual and divine beauty, and in his later years he used
it to convey intensely tragic feelings. For Vasari the nude
was simply the unit in a jig-saw puzzle, to be twisted and
fitted into a decorative scheme. Of course the artist needed
some excuse for painting the nude, and therefore he became
ingenious in finding stories which could be supposed to
involve naked figures, but the imagination was allowed much
latitude in this. In a letter to Aretino, Vasari, speaking of
a painting he had executed, says: 'As you will see, I have
painted a group of naked figures fighting, first to show my
skill in art, and secondly to follow the story,'[1] and it appears
later that there is no reason at all to suppose from the story
that the characters were not fully dressed.

The drawing of the nude was, therefore, an object in itself,
and it is remarkable how Vasari's obsession with it obscures
his judgement of other artists' work. When he talks of
Michelangelo's *Last Judgement*, which he admires deeply,
he seems to be describing an academic exercise in trick draw-
ing. It is for him 'an exemplar in foreshortenings and all the
other difficulties of art'.[2] The point of the *Last Judgement* to
him is that it 'opened out the way to facility in this art in its
principal province, which is the human body'.[3] The expres-
sion of the passions is only mentioned by the way, and the
emotional significance of the painting is not spoken of at all.

But this dislike of any kind of emotion in art appears in
Vasari's comments on other artists as well. It is characteristic
that he strongly disapproves of Pontormo's Certosa frescoes,
in which is expressed the religious intensity of the early
attempts at reform in Florence.[4] The effect of tragedy, which
Pontormo could only convey in forms borrowed from northern
late Gothic art, was strongly distasteful to Vasari who pre-

[1] Bottari-Ticozzi, *Raccolta di Lettere*, Milan, 1822, iii, p. 32.
[2] *Lives*, ix, p. 130. [3] Ibid. ix, p. 56. [4] Ibid. vii, p. 164.

ferred his placid early works, painted under the influence of
Andrea del Sarto. For the same reasons he dislikes Becca-
fumi's later paintings in which, he maintains, the heads show
'an expression of terror by no means agreeable'.[1]

The crucial feature in the whole of Vasari's theory is the
appearance of the new quality of grace, *la grazia*. This word
had, of course, been applied to painting before Vasari's time,
but only in a sense vaguely interchangeable with beauty or
differing at most in degree from beauty.[2] With Vasari it
takes on a quite new function; it is distinguished from beauty
and even contrasted with it. It is never clearly defined in
the *Lives*, but by bringing together different passages we can
see that beauty is a rational quality dependent on rules,
whereas grace is an undefinable quality dependent on judge-
ment and therefore on the eye. It also very soon becomes
apparent that it is in grace and not in beauty that Vasari is
most genuinely interested. He speaks of 'delicacy, refine-
ment and supreme grace' as 'the qualities produced by the
perfection of art', and if these are lacking it is not enough in
a figure that 'the limbs as a whole are in accordance with the
antique and have a certain correct harmony in the propor-
tions'.[3] Correctness cannot produce grace.[4]

A passage quoted above in connexion with Vasari's use
of the word 'judgement' is so relevant to the meaning which
he attaches to grace that it must be referred to again. It is

[1] Ibid. vi, p. 249.

[2] Alberti, for instance, refers to 'quella gratia ne' corpi quale dicono
bellezza' ('Della Pittura', bk. ii, p. 109), and he adds that he knows of no
way of attaining it except by the close study of nature. The Neoplatonists
of the Quattrocento make a distinction between grace and beauty of the
same kind as Vasari, but they only apply it to corporal beauty, not to that
of the arts. [3] *Lives*, iv, p. 81.

[4] In his *Discorso della Bellezza e della Grazia* Benedetto Varchi makes
roughly the same distinction between beauty and grace as that made by
Vasari, though, as he is concerned mainly with the beauty and grace of
women, not of works of art, what he says only bears indirectly on the
point under discussion here.

his summing up on the masters of the Quattrocento: 'In proportion there was wanting a certain correctness of judgement, by means of which their figures, without having been measured, might have, in due relation to their dimensions, a grace exceeding measurement.'[1] The dependence of grace on judgement and therefore ultimately on the eye is established in this sentence; and in other passages Vasari gives a number of more revealing hints about the nature of grace.

Grace is, for instance, usually contrasted with the serious and the sublime. In comparing Leonardo and Raphael, Vasari says that though the latter could not equal Leonardo in 'a certain sublimity of ideas and grandeur of art', yet he approached near to him in sweetness, in facility, and in 'the grace of colouring'.[2] And elsewhere he speaks of 'those who, delighting little in the highest and most difficult flights of art, love things that are seemly, simple, gracious and sweet'.[3]

This connexion of grace with sweetness and softness is regular in Vasari. In the life of Masolino it is closely associated with *morbidezza* and *sfumato* effects;[4] a work of Giulio Romano is said to lack grace because of its dark and heavy colouring;[5] and the figures of Quattrocento artists are said not to show the muscles 'with that sweet and facile grace which hovers midway between the seen and the unseen'.[6] The same conclusion, that grace springs from sweetness and elegance, can be drawn from the list of artists whom Vasari particularly praises for this quality: Raphael, Parmigianino, and Perino del Vaga.

But what, in the last resort, gives the clearest idea of grace in the sense used by Vasari is its connexion with facility. Rapidity and ease of execution were not qualities pursued by Quattrocento artists for their own sake or recommended by the theorists of that period. On the contrary, care and exactness in working seem to be their first object, and speed

[1] *Lives*, iv, p. 80. [2] Ibid. iv, p. 242 f. [3] Ibid. v, p. 166.
[4] Ibid. ii, p. 167. [5] Ibid. vi, p. 149. [6] Ibid. iv, p. 80.

or slowness seems to be a matter of relative indifference to them. The Mannerists, however, prided themselves that they could establish records in covering wall-space. In his autobiography Vasari boasts that he executes his works 'not only with the greatest possible rapidity, but also with incredible facility and without effort',[1] and that this is no empty boast is proved by his performance in the Palazzo della Cancelleria in Rome, where he frescoed the big hall in a hundred days.[2]

Any trace of laboriousness, any evidence that the artist has sweated over his work will destroy the grace of a painting, and will give to it what in Vasari's judgement is the fatal quality of dryness. The whole Quattrocento is condemned by Vasari as *dry*. The artists of that day gave 'proof of diligent study' in finishing their paintings, but 'study when it is used in that way to obtain finish, gives dryness to the manner',[3] and it was only after Leonardo that painters were able to achieve that 'perfect grace, brought about by the disappearance of a certain dryness, hardness and sharpness of manner which had been left to our art by the excessive study of Piero della Francesca' and others.[4] Uccello is the artist most strongly reproved for his excessive industry, particularly in perspective, his obsession for which showed lack of judgement.[5]

The artist must therefore pursue 'the grace and facility that give most pleasure to the eye'. But facility will not only produce grace; it has other advantages, such as bringing with it boldness: 'Many painters . . . achieve in the first sketch of their work, as though guided by a sort of fire of inspiration, something of the good and a certain measure of boldness;

[1] Ibid. x, 187.

[2] Michelangelo, on being told by Vasari that he had executed the frescoes in this short time is said to have replied: 'So I see.' Annibale Caro also reproved the artist for his speed of work (see Bottari-Ticozzi, *Raccolta di Lettere*, Milan, 1822, ii, p. 17), and all the classical historians of the next century from Bellori to Félibien attack the Mannerists on the same score.

[3] *Lives*, iv, p. 81. [4] Ibid. iv, p. 82. [5] Ibid. ii, p. 131.

but afterwards, in finishing it, the boldness vanishes.'[1] Any undue effort or strain will destroy the effect of inspiration. It was disastrous, for instance, in the case of Uccello: 'for the spirit of genius must be driven into action only when the intellect wishes to work and when the fire of inspiration is kindled, since it is then that excellent and divine qualities and marvellous conceptions are seen to issue forth.'[2]

From what has already been said of Vasari's conception of grace and facility it will not be surprising to find that he makes them both derive from a natural gift which cannot be acquired by pains and study. 'Very great is the obligation that is owed to Heaven and to Nature by those who bring their works to birth without effort and with a certain grace which others cannot give to their creations either by study or by imitation.'[3] On the other hand, an artist is to be blamed if he does not take the trouble to cultivate his natural talent. Parmigianino, for instance, is taken to task by Vasari for this reason: 'If Francesco, who had from nature a spirit of great vivacity, with a beautiful and graceful manner, had persisted in working every day, little by little he would have made such proficiency in art, that, even as he gave a beautiful, gracious and most charming air to his heads, so he would have surpassed himself and the others in the solidity and perfect excellence of his drawing.'[4]

Vasari, therefore, approves of careful study and hard work in one way and disapproves of them in another. His solution to the problem of combining grace with the more solid excellence of draughtsmanship is as follows: 'As a result of the study and practice of many years the hand must be free and skilled in drawing and copying whatever nature has produced.'[5] That is to say, the artist must train himself by careful study and diligent copying to attain complete efficiency in drawing and painting natural objects. Over this he can

[1] *Lives*, v, p. 260. [2] Ibid. ii, p. 131. [3] Ibid. iii, p. 147.
[4] Ibid. v, p. 254. [5] Introduction: Of Painting, ch. i.

spend indefinite pains and care; but, when it comes to the actual execution of a particular work, he must act as rapidly as possible so that no traces of his effort may appear on the canvas. When he has reached perfect proficiency the artist will be able to draw whatever he wants from memory, without reference to the model at all.

Vasari was the first writer to elaborate the theory of grace in connexion with painting, but in itself it was no invention. For Vasari only applied to the arts the conception of grace as a necessary part of behaviour which had been evolved by the writers on manners, particularly by those of the Neoplatonic school, such as Castiglione. Indeed, the account of grace in its social sense in the *Cortegiano* is so close to Vasari's view of it applied to the arts, that we may conclude that he derived the idea directly from this source.

In the first book of the *Cortegiano* Castiglione gives instructions which the courtier must follow in his relations with other men. At the end of these one of the speakers in the dialogue says: 'The Courtier ought to accompany all his doings, gestures, demeaners, finally all his motions with a grace. And this, me thinke, ye put for a sauce to everie good thing, without which all his other properties and conditions were litle worth.'[1] Grace, therefore, is that extra quality which is added to the more solid 'properties' and 'conditions' which can be acquired by precept. Grace, on the other hand, cannot be learnt; it is a gift from heaven; and it comes from having a good judgement.[2] It will vanish if a man takes too much pains to attain it, or if he shows any effort in his actions. Nothing but complete ease can produce it.[3] And the only effort which should be expended in attaining it is an effort to conceal the skill on which it is based;[4] and it is from

[1] Hoby's translation, Everyman's Library, p. 43.

[2] Ibid., p. 43 ff. [3] Ibid., p. 46.

[4] Ibid. Castiglione makes the same point in connexion with women's make-up. He says that those only show grace who can make up so skilfully that no one can tell that they are made up at all. (Ibid., p. 66.)

sprezzatura, or *recklessness*, as Hoby translates it, that grace springs.[1] These are almost exactly the principles which Vasari lays down for the acquisition of grace in painting; and the parallel is completed by the comparison which Castiglione makes of the grace which he recommends and the methods of ancient painters: 'They say that also, it hath been a proverb among some most excellent painters of olde time, that Too much diligence is hurtfull, and that Apelles found fault with Protogenes, because he could not keepe his handes from the table (i.e. panel).'[2] The fact that Vasari's grace derives from a book of court manners shows the real significance of the idea in his works. With Humanists of the Quattrocento, painting had reached the position of being a learned art; with Vasari it was acquiring good manners.

Since, however, Vasari's main importance is not as a theorist but as an historian of art, something must be said of his historical approach. In its general lines his attitude is that traditional among Florentine historians from Villani and Ghiberti onwards. Art rose to its highest point in ancient Greece and Rome; it declined with the fall of the Roman Empire, sinking lower and lower during the period of barbarian domination; it made its first steps to recovery in Tuscany with Cimabue, and each of its successive advances was made by a Florentine artist—first by Giotto, then by Masaccio in painting, and Brunelleschi in architecture. Vasari merely carries on the line by putting another great Florentine, Michelangelo, as the peak to which the whole development of the arts led.

At moments Vasari's patriotism becomes childish, or, at least, disturbs his historical judgement. He tries, for instance, to persuade himself that the arts originated not in Chaldaea or in Egypt, as was generally maintained, but in his native Etruria.[3] In the life of Costa he admits rather grudgingly

[1] Hoby's translation, p. 48. [2] Ibid.
[3] Preface to the Lives, *Lives*, i, p. xli.

that there have been good artists who were not Tuscans,[1] but he rarely treats them with the respect which he allows to the men of his own country. Duccio, for instance, only gets two pages as against Giotto's twenty-five; and in writing of artists like Titian his prejudice constantly bursts out.

But in certain other ways he shows much greater balance in his judgement than would be expected. He realizes that an artist must be judged in connexion with his historical setting, and that it is foolish to condemn a painter of the Trecento for not being as realistic as one of the Cinquecento.[2] 'My intention has always been to praise not absolutely but, as the saying is, relatively, having regard to place, time and other similar circumstances.'[3] Therefore artists of the earlier period can receive due praise for their contribution towards the general movement of painting from the barbarism of the Middle Ages to the cultured naturalism of the Renaissance.[4]

Vasari's attitude, however, is not absolutely constant, and certain differences can be traced between the views expressed in the 1550 edition and those which appear in the much enlarged edition of 1568. In his treatment of history there is a tendency in the second edition for the author's patriotism to be a little less evident than in the first. The first is constructed solely to praise Florentine artists, with the life of Michelangelo as the climax. In the later edition non-Florentine artists are allowed more generous treatment, and though Michelangelo is still quite clearly the author's favourite, others are allowed to have approached, or even equalled him in certain respects. Raphael in particular, though he is not allowed to compete with Michelangelo in the field of drawing, is admitted to be a more balanced artist,

[1] Ibid. iii, p. 161. [2] Ibid. ii, p. 84. [3] Ibid. x, p. 221.

[4] For Vasari's appreciation of Gothic art, and the care which he took to give appropriate Gothic frames to Trecento drawings in his collection, cf. E. Panofsky, 'Das erste Blatt aus dem "Libro" Giorgio Vasaris', *Staedel-Jahrbuch*, vi, 1930, p. 25.

and even the Venetians whose main interest was in colour are more kindly treated in 1568 than in 1550.

In the matter of theory there is one important passage added in the second edition to the chapter on painting in the introduction. This passage is the only one in which Vasari attempts anything approaching a general and abstract definition, and, though the result is not at all clear, the passage is of interest. He tries to define drawing, and he says of it that

'proceeding from the intellect it extracts from many things a universal judgement, like a form or idea of all the things in nature. . . . From this knowledge there proceeds a certain idea or judgement, which is formed in the mind, and this idea to which expression is given by the hands is called drawing. It can therefore be concluded, that this drawing is simply a visible expression and manifestation of the idea which exists in our mind, and which others have formed in their mind and created in their imagination.'

Vasari is ill at ease among these abstract terms, but it is significant that he attempts to give some theoretical foundation to the arts. This account is based on Aristotelian ideas, and forms a prelude to the revival of abstract aesthetics among the later Mannerists. The prominence given to the *Idea* prepares us for the theories of Lomazzo and more particularly of Federico Zuccaro, whose version of Aristotelian doctrines will be discussed in a later chapter.[1]

[1] The fact that this passage stands out from the general line of Vasari's thought is explained by its being a direct borrowing from another writer. Scoti-Bertinelli discovered a page of manuscript by Vincenzo Borghini containing a draft of this passage (see *Giorgio Vasari, Scrittore*, p. 82). Vasari was certainly indebted to many of his friends for information and ideas used in the *Lives*, but the difficulties of distinguishing the different contributions are so great that I have thought it better to treat the *Lives* as a homogeneous work. In this case the ideas expressed by Vasari may well have been common property among the circle in which he moved in Florence. His definition of drawing can be paralleled in Varchi's exposition of the meaning of *concetto* in his *Lezione* on Michelangelo's sonnet beginning: 'Non ha l'ottimo artista alcun concetto'.

The tradition of criticism which Vasari had inaugurated in Florence was carried on by a small group of followers. None of these has anything of great originality to contribute to aesthetics, but they are just worthy of mention. The most important is Raffaello Borghini, whose long treatise, *Il Riposo*, published in 1584, is the best source for the biographies of the later Florentine Mannerists. From the theoretical point of view it is less interesting, for Borghini takes his ideas almost word for word from Vasari.[1] The one point worth noting about the book is that Borghini is writing not only for artists but also for those who, without actually painting themselves, yet want to be in a position to judge works of art.[2] No writer of a full-dress treatise on painting before Borghini had set out with this intention.

Even Vasari always addresses himself to his fellow artists, and the same is true of all earlier critics, except those like Equicola who only write of painting incidentally. In other ways Borghini continues along the lines laid down by Vasari. He talks little of the imitation of nature, and much of the importance of such qualities as grace. His formula for achieving this is in exact agreement with the practice of most Florentine Mannerists: give your figures small heads and long limbs, and they will have the required elegance.[3]

Vincenzo Danti was a Perugian by birth, but his devotion to the manner of Michelangelo attaches him to the Florentine group. Of the fifteen books in which he composed his treatise on proportion only one was published, in 1567. The sole purpose of the writer seems to have been to expound the ideas of Michelangelo, whose authority is quoted on every page, and whose works are the foundation for every law that is laid down. The third member of the group is Francesco

[1] e.g. all his arguments on the quarrel between the sculptors and painters are taken from Vasari's *Proemio*, and his definition and analysis of drawing from the introduction on painting.

[2] *Il Riposo*, p. 127. [3] Ibid., p. 153.

Bocchi, who wrote one of the earliest guide-books to Florence, and also published a short work entitled *Eccellenza della statua di S. Giorgio di Donatello*. This pamphlet contains little that is new or interesting, but it is typical of Florentine Mannerism in the stress which it lays on movement as the greatest source of beauty in the human figure.

Chapter VIII

THE COUNCIL OF TRENT AND
RELIGIOUS ART

THE kinds of painting which are commonly grouped to-
gether under the term 'Mannerism' are far from being
uniform. Different parts of Italy, being at different stages
of development and affected in different ways by the political
disasters of the sixteenth century, produced styles as varied
as those which they evolved in the early Renaissance. In
Michelangelo's later work we saw the tragic mystical form of
Mannerism; Vasari represents the aristocratic version of the
style suited to the court of the Medici. In this section we
shall consider the official style of religious art, which came
into existence under the influence of Rome and Trent, and
the theories which accompanied it. The various forms of
Mannerism differ in many ways among themselves, but,
compared with the art of the High Renaissance, they have
much in common with each other; for they were all produced
against the common background of the political and religious
reaction which the alliance of the Papacy with Spain made
possible after 1530. It will therefore be necessary before
going further to consider this historical situation out of which
Mannerism arose.

Paradoxically, the ultimate results of the events centring
round the Sack of Rome was to strengthen rather than to
weaken the power of the Papacy in Italy. Clement, almost more
frightened by the revolution in Florence than by the Sack
itself, realized that resistance to Charles was useless, and that
his only hope lay in an alliance with Spain. The old founda-
tions on which Italian greatness was built were gone. The
great merchant republics, like Florence and Venice, had been
doomed since the fall of Constantinople and the discovery

of America had destroyed the command of the Mediterranean over the most important trade-routes, and Rome itself was ruined by the schism in the Church. If Italy was to keep any position in Europe it would clearly have to be by new means, and the alliance with Spain seemed to offer just the right opportunity.

After 1530 the Papacy was still the most powerful single State in Italy, but it was a changed Papacy, for its policy was now dominated by its new ally. Now, compared with the Italian republics or with the States of north-western Europe, Spain was socially and politically behind the times. It was still more than half feudal, and was only just emerging as a modern State. Therefore by its change of policy about 1530 the Papacy moved from a leading place among the progressive States of Italy to one of reaction. It still aimed at dominating the whole peninsula, but it was going to do so with the support, not of the merchants and bankers, but of a foreign power with almost feudal ideas and methods.

The aim of Papal policy in the second half of the sixteenth century was not to strengthen the State of which the Popes of the High Renaissance had laid the foundations, but to establish ecclesiastical absolutism as far as possible in Italy; and to achieve this aim it was prepared to use any means, gentle or forcible. In its ultimate results the most fatal action of the Papacy at this time was probably the introduction of the suicidal Spanish system of taxation, for it hurried on the economic collapse which must in any case soon have overtaken Italy. But from the more general point of view the essential characteristic of the earlier stage of the Counter-Reformation is that it is an attempt to return to the ecclesiastical domination which the Church had held during the Middle Ages.

In the intellectual field this meant that the movement was opposed to all the achievements of Renaissance Humanism. The individual rationalism of Humanism had played

a considerable part in the development of the Reformation, and Humanism was therefore anathema to the Counter-Reformers. It was their aim to undo all that the Renaissance had achieved, and to get back to a feudal and medieval state of affairs. The movement was just as much a Counter-Renaissance as a Counter-Reformation, and it set itself to destroy the human scale of values in which the Humanists believed and to replace it once again with a theological scale such as had been maintained during the Middle Ages.

One of the first objects of the Counter-Reformers was to abolish the right of the individual to settle all problems of thought or conscience according to the judgement of his own personal reason. They wished instead to set up the acceptance of authority, which was exactly the principle that the Humanists had succeeded in destroying. Their attitude can best be seen from the weapons which they used to enforce their ideas. Of these the most powerful were the Inquisition and the Society of Jesus. The assumption underlying the former was that no latitude could be allowed in matters of dogma, in which the decisions of the Church were to be blindly followed. The latter was built up like a military organization on the basis of absolute, unquestioning obedience. The effect of institutions like this and of the spirit that lay behind them was the destruction of individual thought. As has been said, 'the sacrifice of the intellect was demanded, not its dedication', and therefore those few thinkers who were courageous enough to go on with their speculations either took to purely innocuous and abstract fields, or like Bruno, came into conflict with the authorities.

This is, of course, only the negative side of the Counter-Reformation, of which the positive is provided by the intense desire of men like Caraffa to reform the Church, and by the passionate and unselfish devotion of the Jesuits to the spreading of what they believed to be the truth.

On the arts the effect of the Counter-Reformation was the

same as in other branches of culture and thought. After about 1530 the Humanist school of painting which had flourished in Rome at the beginning of the century gradually falls into decay. Artists no longer make new discoveries about the outside world. Their work is largely controlled by the Church, and, even when they are allowed a certain freedom, they seem to have lost their interest in what lies around them. Their preoccupation is no longer with the reconstruction of the visible universe, but with developing new methods of drawing and composition. They are not breaking new ground, but rather exploiting what their predecessors had discovered for them and turning their discoveries to new purposes. They abandon the Renaissance ideals of convincing space and normal proportions, and make almost as free use as a medieval artist of arbitrary construction and deliberate elongation. For the restrained and realistic colouring of the Renaissance they substitute tones which appeal directly to the emotions rather than to the mind. In fact, in many ways the Mannerists are nearer to the artists of the Middle Ages than to their immediate predecessors. And this is true not only of matters of technique but also of the subjects which artists seem to choose for preference. At the time of the High Renaissance artists preferred those which had a wide appeal. Even when they painted religious subjects, they were able to find those, such as the Holy Family, which could be treated almost as secular themes with all the emphasis on the human significance. The Mannerists, on the other hand, prefer subjects in which they can emphasize the theological or supernatural aspects.

In the following sections we shall constantly come upon features of Mannerist painting or theory which are only intelligible if we bear in mind the reaction which was going on during the second half of the sixteenth century to the ideas of the Renaissance in religion and politics—for the two cannot be separated and the reaction in the Church was only

another manifestation of the social and political movement which accompanied it.

In their attempts to purge the Church of abuses the Protestants come near to denying altogether the value of any kind of religious art. Images and paintings smelt of idolatry, while the decoration of churches and the impressive ritual of the Mass were examples of that worldliness into which Satan had lured the Catholic Church. As soon, therefore, as the Roman Church gave up its attempt at compromise with the Protestants, and followed the course of strengthening traditional doctrines and methods in defiance of Luther and Calvin, it became necessary for theologians to underpin the foundations on which religious art was built, and to prove that, far from being idolatrous, sacred images were an incitement to piety and a means of salvation. So the first works on the arts produced by the Counter-Reformation are a series of treatises in which all the arguments used by earlier theologians in the Iconoclastic struggles are revived and turned against the Protestants.[1]

Old phrases, like Gregory's description of religious painting as 'the Bible of the Illiterate', reappear and occur in every writer on the arts during the later sixteenth century, and before the end of the Council of Trent art was not only saved for religion but was acknowledged as one of its most valuable weapons in propaganda.

When in its last session in December 1563 the Council discussed the problem of religious art its conclusions were as follows:

'That the images of Christ, of the Virgin Mother of God, and of the other Saints, are to be had and retained, particularly in

[1] The most important of these are: Ambrosius Catharinus, *De certa gloria invocatione ac veneratione sanctorum*, Lyons, 1542; Conradus Brunus, *De Imaginibus*, Augsburg, 1548; Nicholas Hartsfield, *Dialogi Sex*, 1566; Nicholas Sanders, *De typica et honoraria sacrarum imaginum adoratione*, Louvain, 1569. Their arguments are repeated by all the later writers on religious art in general, such as Paleotti or Molanus.

churches, and that due honour and veneration are to be given them; not that any divinity, or virtue is believed to be in them on account of which they are to be worshipped; or that anything is to be asked of them; or that trust is to be reposed in images, as was done of old by the Gentiles who placed their hope in idols; but because the honour which is shown them is referred to the prototypes which those images represent; so that by the images which we kiss and before which we uncover our heads and prostrate ourselves we adore Christ, and we venerate the Saints whose likeness they bear; as by the decrees of Councils, and especially of the second Synod of Nicaea, has been defined against the opponents of images.

'And the bishops shall carefully teach this: that, by means of the stories of the mysteries of our Redemption, portrayed by paintings or other representations, the people are instructed and confirmed in the habit of remembering, and continually revolving in mind the articles of faith; as also that great profit is derived from all sacred images, not only because the people are thereby admonished of the benefits and gifts bestowed upon them by Christ, but also because the miracles which God has performed by means of the Saints and their salutary examples are set before the eyes of the faithful; that they may give God thanks for those things, may order their own lives and manners in imitation of the Saints; and may be excited to adore and love God and to cultivate piety.'[1]

But, having decided that images were to be retained and having justified them against the charges of idolatry, the Church had to take care that only the right kinds of religious paintings and statues were allowed and that nothing should be found painted or carved which might either mislead Catholics or give the Protestants a weapon against the Church of Rome. Great trouble was therefore taken to keep churches clear of any heretical or secular paintings, or of any which might be open to the charge of profanity or indecency.

The attitude of the Church towards heretical paintings varied at different periods, but was in general surprisingly

[1] *Canons and Decrees of the Council of Trent*, Session xxv, Tit. 2.

broadminded before the Counter-Reformation. In the Middle Ages the Church was so powerful that it could afford to be lax. Rather than risk excluding people from its body, it preferred to allow popular aspirations to express themselves in the broad humour of the Miracle plays and in the imaginative freedom of Gothic sculpture. It allowed stories to be acted or depicted, even if they were legendary or invented, provided that they did not directly go against any ecclesiastical practice or doctrine. During the Renaissance the same broad-mindedness prevailed. Pagan doctrines and symbols were incorporated into Christianity, and the revival of classical ideals was not only tolerated but actively furthered by most of the Popes from Nicholas V to Clement VII. So close was the fusion of Classical and Christian ideas that it surprised no one that Raphael should paint the ancient poets and the ancient philosophers opposite the Christian theologians in decorating one of the central rooms of the Vatican.

During the fifteenth and early sixteenth centuries only one case is known in which official action was taken against heretical painting. The painting in question was Botticini's *Assumption*, now in the National Gallery, which was based on the ideas of Matteo Palmieri and was supposed to contain certain heresies derived from Origen and repeated in Palmieri's *Città di Vita*. The ecclesiastical authorities ordered the painting to be covered, apparently between 1485 and 1500, and the chapel in which it hung was still under an interdict in the middle of the eighteenth century.[1]

Such cases, however, must have been very rare at the time of the Renaissance, and it was not till the middle of the sixteenth century that the Church decided to see that all religious paintings were strictly orthodox. The tightening up of doctrine and of discipline which was one of the prin-

[1] For a full account of this episode see the introduction to Margaret Rooke's edition of the *Città di Vita* (Smith College Studies in Modern Languages, vol. viii).

cipal results of the Council of Trent applied in this field as much as in any other, and in the Acts of the Council we read: 'No image shall be set up which is suggestive of false doctrine or which may furnish an occasion of dangerous error to the uneducated.'[1] It is typical of the firm control which the Church intended to exercise at this time that the Act adds later: 'That these things may be the more faithfully observed the Holy Synod decrees that no one be allowed to place or cause to be placed any unusual image in any place or church . . . unless it has been approved by the Bishop.'[2]

This decree, like most of those dealing with religious art, was repeated and expanded by that group of writers who made it their business to publish the decisions of the Council. St. Charles Borromeo will have nothing which disagrees with Holy Scripture or the tradition of the Church.[3] Cardinal Gabriele Paleotti, Archbishop of Bologna, bans anything 'superstitious, apocryphal, false, idle, new, unusual'.[4] The Fleming Molanus demands that even pictures or representations of heretics should be destroyed.[5]

But it was not enough for the artist to avoid incorporating established heresies into his paintings; he was constrained further to keep very closely to the Biblical or traditional story which he was treating and not let his imagination add ornaments to it for the sake of making it more attractive. The picturesque or familiar details with which Gothic painters filled their works, and the impressive accompaniments in which the Venetians set their Biblical scenes, were equally condemned. The painter must concentrate his attention on depicting the story in the clearest and most accurate manner possible. With this view may be compared the attitude of the Council of Trent towards religious music, from

[1] Loc. cit.　　　　　　　　[2] Ibid.
[3] *Instructiones Fabricae et Supellectilis Ecclesiasticae*, bk. i, ch. 17.
[4] *Archiepiscopale Bononiense*, Rome, 1594, p. 230.
[5] *De Historia SS. Imaginum*, 1619, bk. ii, ch. 58.

which were swept away the elaborate counterpoint, the improvisations and diminutions which obscured the words of the Mass and made of the music a jig-saw puzzle of sound. The aim of Church music should be not to produce 'a vain delight for the ears', but to provide such a setting 'that the words may be heard by everyone'. The same demand for clarity appears in connexion with painting in the importance attached to certain external details by which the figures could be represented. Angels must have wings; saints must have haloes and their particular attributes, or if they are really obscure, it may even be necessary to write their names below them to avoid any confusion.[1] If allegory is used it must be simple and intelligible, for, as Gilio da Fabriano says: 'A thing is beautiful in proportion as it is clear and evident.'[2]

All the direct exponents of the decrees of Trent already mentioned emphasize the need for accuracy in the representation of religious subjects, and they are joined by others whose primary interest is in painting but who show how far the influence of the Council spread during the later sixteenth century. Raffaello Borghini, for instance, in the *Riposo*, published in 1584, wishes the artist to 'paint subjects derived from Holy Scripture simply and purely',[3] and others write in the same spirit. These authors are all forced to admit that the artist cannot confine himself absolutely to the Biblical story, that there may be gaps which he is compelled to fill and details which he must add to make the story comprehensible. But they are unanimous in urging him always to consider whether any detail which he adds is suitable and essential to his theme,[4] and when they come to define the liberties which they are prepared to allow they are seen to be small enough. Gilio da Fabriano, for instance, in his dialogue *Degli Errori*

[1] Borromeo, *Instructiones*, bk. i, ch. 17.

[2] *Due Dialogi*, p. 115. [3] p. 77.

[4] Cf. Molanus, op. cit., bk. ii, ch. 19; Borromeo, *Instructiones*, bk. i, ch. 17.

de' Pittori admits that it would not be wrong to make the number of Pharisees present at a given scene greater or smaller than it really was, or to make the servants of Pilate or Herod handsomer or better dressed than they may actually have been.[1] This kind of licence does not leave the artist's hands very free; and we shall see later that in many cases he was not allowed to wander as far as this from the path of accuracy. Certain other concessions are, however, made. Molanus and Gilio agree that the artist may introduce into his paintings *probable* facts or ideas, that is to say, those which are based on the authority of 'wise and learned men'.[2] In general, also, artists were allowed the use of allegory, but only provided that the truth which it conveyed was strictly in accordance with the beliefs of the Church.[3]

The extraordinary attention which critics and theologians paid to details in religious paintings can best be seen in the censures of Gilio da Fabriano on Michelangelo's *Last Judgement* or in Borghini's comments on Florentine Mannerist paintings, particularly on Pontormo's frescoes in S. Lorenzo. Gilio's criticisms go farther towards the ludicrous than Borghini's, for he was a priest and a professional theologian and took purely doctrinal errors intensely to heart, but Borghini comes very close to him and proves that laymen and not only priests were profoundly influenced by the Tridentine reforms. A few of Gilio's objections to the *Last Judgement* are perhaps worth quoting in detail to give the tone of his dialogue. Michelangelo, he says, has represented the angels without wings. Certain of the figures have draperies blown about by the wind, in spite of the fact that at the Day of Judgement wind and storm will have ceased. The trumpeting angels are shown all standing together,

[1] p. 80.

[2] Gilio, op. cit., p. 88; and cf. Molanus, op. cit., bk. ii, ch. 30.

[3] Molanus, op. cit., bk. ii, chs. 20 and 21; Possevino, *Tractatio de Poesi et Pictura*, ch. 25.

whereas it is written that they shall be sent into the four corners of the earth. Among the dead rising from the earth some are still bare skeletons, while others are already clothed with flesh, though according to the Biblical version the general Resurrection will take place instantaneously. (In the dialogue this view is elaborately disputed, but is finally admitted.)[1] Gilio also protests against the fact that Christ is shown standing, instead of seated upon His throne of glory. One of the speakers justifies this on the grounds that it is symbolical, but his defence is disallowed by the leader of the argument in a sentence which sums up the whole feeling of the dialogue: 'Your opinion may be right, that he intended to interpret the words of the Gospel mystically and allegorically; but first of all the literal meaning should be taken, whenever this can properly be done, and then the others, keeping to the letter as often as possible.'[2]

This represents not only the attitude of Gilio to Michelangelo but that of his whole generation to the great figures of thirty years before. Caraffa turned against the liberal Reformers, like Contarini and Pole, who attempted to bring a new spirit into the Church without bothering about the letter of dogma; and the supporters of the Council of Trent turned against Michelangelo, who evolved a new spiritualized art and sometimes preferred a moral allegory to the letter of Biblical accuracy. In the face of the Protestant menace, both Pole and Michelangelo might have provided a weapon against the Church of Rome and therefore could not be tolerated.

The Counter-Reformers, however, were not only concerned to clear religious art of theological inaccuracies; it was at least as important to eliminate from it everything secular or pagan. Again, their action in connexion with painting and sculpture is parallel with their purge of Church music. In the early sixteenth century it was a regular custom to sing parts of the Mass to the tunes of popular songs, and it some-

[1] Op. cit., pp. 96–121. [2] Ibid., p. 103.

times happened, even in the Papal choir, that one of the voices was allowed to sing the words ordinarily associated with the tune while the others sang the words of the Mass. The reforms enjoined by the Council of Trent and by the Commission of Cardinals which dealt with Church music in 1564 forbade all these practices and insisted that words and music should be entirely religious. In the same way the Church insisted that paintings in churches should be entirely free from secular elements, particularly from traces of Greek or Roman paganism.

The reasons which the Counter-Reformers had to fear the worship of classical antiquity have already been explained, and it is not therefore surprising to find Gilio da Fabriano objecting to Michelangelo's introduction of Charon into the *Last Judgement*.[1] It is agreed in the dialogue that Michelangelo was here acting on the authority of Dante, but this defence is not allowed to stand, and it is typical of the change of spirit in the Church that what would not have been challenged in the time of Dante could not be risked in 1560.

The most austere moralists go farther and would not allow the preservation of pagan images and paintings even in their own houses. According to Possevino the sight of pagan images is abhorrent to the saints in heaven, and Pius V and Sixtus V were therefore right in their attempts to remove and destroy ancient statues or convert them to Christian uses.[2] Molanus takes the line that pagan statues should not please Christians, but that those which teach a good moral lesson in accordance with Christian ethics may usefully be preserved.[3]

It is, however, clear that these extreme views were not universally accepted and that the Church was ready to make

[1] Gilio, op. cit., p. 108.

[2] Op. cit., ch. 27. Sixtus V adapted the two columns of Trajan and Marcus Aurelius to Christian purposes by crowning them with figures of St. Peter and St. Paul.

[3] Op. cit., bk. ii, chs. 57 and 60.

some concessions. Classical antiquity had passed into the habits of thought of the Italians so deeply that nothing could have eradicated it completely. The Church, therefore, set itself to eliminate only the more dangerous forms of classical influence and to devise adequate excuses for allowing the rest. St. Charles Borromeo, for instance, in his instruction for the building of churches, permits the use of the classical orders 'for the sake of structural durability'.[1] In general, however, the Church decided that the innocuous part of classicism was its mythology. It was frightened of the philosophical systems of antiquity which might lead to serious conflict with Christian principles, but mythology was a harmless enough means of satisfying the Italians' romantic feeling for antiquity.

In the later sixteenth century, therefore, fresco cycles of mythological themes are common, but they are no longer treated in the spirit in which Raphael painted them. The classicism survives in the stories and symbolism, but the Humanist seriousness which accompanied them at the time of the High Renaissance has gone. This rationalism, which was combined to perfection with classicism in the *School of Athens*, was the real bugbear of the Church since it led to Protestant reforms or free thought; and, once separated from this, once derationalized, classicism was harmless. Even so severe a critic as Gilio does not altogether ban mythological painting, for he divides painters into three kinds—historical, poetical, and mixed[2]—and under the poetical class he evidently intends to include those who treat mythological scenes, since he refers to Raphael's decoration of the Farnesina.

In religious painting the Church did not limit its attention to the exclusion of classical or pagan elements. It disapproved of the introduction of the secular in any form. We are lucky enough to have the full details of one incident in which it took action against an artist in this matter, and the account

[1] *Instructiones*, bk. i, ch. 34.
[2] Op. cit., p. 75. Borghini follows his view (op. cit., p. 53).

is worth quoting at some length, since it throws light on the official view and on the state of mind of a certain group of artists. In July 1573 Paul Veronese was summoned before the Tribunal of the Inquisition to defend his painting of the 'Feast in the House of Levi', executed for the refectory of SS. Giovanni e Paolo, and now in the Academy in Venice.[1] The main objections made by the Inquisitors to the painting were that Veronese had introduced into it dogs, dwarfs, a fool with a parrot, men armed in the German manner, and a servant whose nose is bleeding—all details which are not mentioned in the Biblical story and are not suitable to a religious painting. Veronese at first argues ingeniously that Levi was a rich man and no doubt had servants, soldiers and dwarfs about him, but he is rapidly forced to his real explanation. When he was asked whom he supposed to have been actually present at this feast, he answered: 'I believe that Christ and the apostles were there. But, if in a painting there is space left over, I fill it with figures from my imagination.' And again: 'My commission was to make this picture beautiful according to my judgement, and it seemed to me that it was big and capable of holding many figures.' His explanations were not accepted and he was ordered to make certain alterations in detail, which he duly carried out. It is typical of the methods of the Counter-Reformation that the Inquisition in this case was satisfied with certain changes of detail which left the painting exactly as worldly in feeling as it was before. But the replies of Veronese are even more instructive. His ideas are entirely those of the Renaissance. He thinks in terms of beauty not of spiritual truth, and his object was to produce a magnificent pageant painting, not to illustrate a religious story. The explanation is that, compared with most other parts of Italy, Venice was little affected by the Tridentine phase of the Counter-Reformation. The

[1] The *Processo Verbale* has been published by Pietro Caliari in *Paolo Veronese*, Rome, 1888, pp. 102 ff.

Jesuits were never firmly established there and the Inquisition was subject to State control. Certain painters, like Tintoretto, absorbed the new ideas and their paintings are filled with the turbulent spirituality of the Counter-Reformers, but they were in a minority, and it was still possible in the later sixteenth century for artists like Veronese or Palladio to work on principles which are fundamentally those of the Renaissance.

The last problem connected with religious painting with which the Church was concerned was that of decency. Before the Council of Trent this question had never been of any great moment. In the Middle Ages the Church allowed as much freedom to popular humour as to popular legends, and both expressed themselves within the range of religious art. In the fifteenth and early sixteenth centuries there are cases of objections being made to works of art on the grounds of decency. Jean Gerson, Chancellor of Paris University at the beginning of the fifteenth century, protested against the effects of naked figures in church decoration,[1] and in Italy Savonarola caused all the voluptuous paintings that he could lay hands on to be burnt, though, as we have seen, he did not disapprove of the arts in general provided they were directed according to the principles of religion. Vasari records that a St. Sebastian by Fra Bartolommeo had to be moved from a church because it had inspired impure thoughts in certain members of the congregation,[2] and he also tells how Sodoma got into trouble, but only after he had deliberately painted an indecent scene to irritate the monks for whom he was working.[3]

But these cases are isolated, and it is clear from the frequent occurrence of nudes in religious paintings till the middle of the sixteenth century that before the Counter-Reformation the Church was not prepared to take any steps beyond seeing

[1] See Schnell, *Baierischer Barock*, p. 6.
[2] *Lives*, iv, p. 158. [3] Ibid. vii, p. 247.

that nothing grossly indecent was introduced into church decoration. But after the Council of Trent the situation was entirely changed, and the decency of religious paintings was watched as carefully as their orthodoxy. The Tridentine decree on this subject is very general: 'Finally all lasciviousness must be avoided; so that figures shall not be painted or adorned with a beauty inciting to lust.'[1] But this was made the text of long and detailed expositions by the propagators of the reforms. Borromeo and Paleotti merely expand the theme, adding to it only the view that indecency must be avoided not only in churches but in the decoration of private houses also.[2] Gilio da Fabriano considers in some detail the question of nudity, and decides that even when from the Biblical narrative it is clear that the figures should be naked, the artist must at least equip them with loin-cloths.[3] Molanus is shocked by the representation of the Infant Christ naked,[4] and Possevino is horrified at the idea of any nude appearing in any painting anywhere, since 'if a man has any decency in his heart, he will hardly dare to look at himself naked'.[5]

As in the disputes over heresy, so in those over decency, Michelangelo's *Last Judgement* came in for the most violent attacks. Its position in the Sistine Chapel gave it an importance which made it a good test case, and in the question of nudity it provided ample material for discussion. It was not only exposed to written attacks, but on several occasions was in danger of complete destruction and only escaped with serious mutilation. Even before it was finished, the master of the ceremonies to Paul III, Biagio da Cesena, protested against it; but the Pope stood by the artist, who took an easy revenge by painting his opponent as Minos in Hell. Paul IV

[1] *Canons*, Session xxv, Tit. 2.

[2] Borromeo, *Acta Ecclesiae Mediolanensis*, ed. Brescia, 1603, ii, p. 496; Paleotti, op. cit., bk. iii.　　[3] Op. cit., p. 104.

[4] Op. cit., bk. ii, ch. 42.　　[5] Op. cit., ch. 27.

PLATE 10

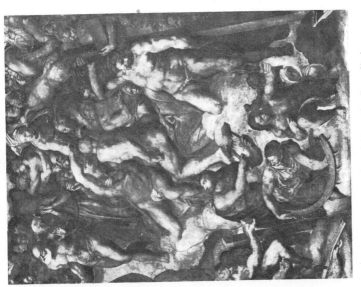

a. Michelangelo. Detail from the *Last Judgement*; original condition

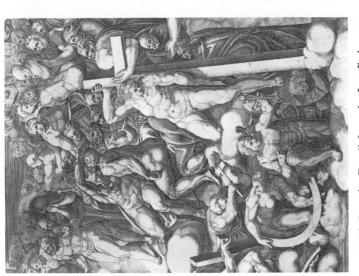

b. Michelangelo. Detail from the *Last Judgement*; present condition

threatened to destroy the whole fresco and finally ordered Daniele da Volterra to paint draperies over some of the figures. Pius IV was still dissatisfied and had the draperies increased in number, while Clement VIII was only prevented from completely destroying the painting by the appeals of the Academy of St. Luke.[1] The violence which Michelangelo's work aroused is shown by a Florentine criticism, quoted by Symonds, in which the artist is described as 'that inventor of filthiness'.[2] The official ecclesiastical writers were less forcible in their language, and, as will appear later, the only other critics to speak without any restraint were not disinterested in their attacks (Plates 10 *a* and *b*).

The Church exerted much the same control over literature as over painting, but even more systematically. In the fifteenth century the Papacy was cautious but broad-minded. Sixtus IV forbade the publication of any book till it had been licensed by the ecclesiastical authorities, but little more was done till the last years of Paul III when, owing to the influence of Caraffa, it was made a criminal offence to print, sell, or own any forbidden book. The first official list of such books was published, in harmony with the Tridentine decrees, at Rome in 1564. The rules laid down in this *Index Expurgatorius*, and in later editions of the work, were close to those which the Council had imposed on painting: prohibition of all heresy, profanity, indecency, and of anything attacking Papal supremacy. As in the case of painting, the ecclesiastical authorities paid more attention to the letter than to the spirit; and they were compelled to make some concessions over the Classics. They were also far fiercer against anti-clerical than

[1] Pius V also had some figures repainted; and it was on this occasion that El Greco offered to replace the whole fresco with one 'modest and decent, and no less well painted than the other' (quoted from Mancini by Willumsen, *La Jeunesse du Peintre El Greco*, i, p. 424). Clement XIII had yet more draperies added in 1762, and rumours were current in 1936 that Pius XI intended to continue the work.

[2] See Gaye, *Carteggio Inedito*, Florence, 1839–40, ii, p. 500.

against immoral writers, as can be seen from the so-called expurgated editions, approved by the congregation, of authors like Bandello and Folengo. The Papal authorities, therefore, showed the same curious mixture of piety and policy with regard to literature as over painting, and the development of the movement leading to the *Index* runs parallel with the tightening of control over religious art.

So far almost all the authorities quoted in connexion with the reforms in religious art have been either priests or men directly dependent on ecclesiastical control. But there is no question that, whether or not they really approved of the decisions of Trent, the artists of the later sixteenth century were affected by them and forced in general to follow them. For instance, when Durante Alberti was elected President of the Roman Academy of St. Luke in 1598, he brought with him to the first meeting a Jesuit, who exhorted the Academicians to paint 'decent and praiseworthy subjects, and to avoid everything lascivious or improper'.[1] The unworldliness of some Mannerist painting has already been discussed, and even in works which are not entirely spiritual in feeling the external laws of decency were observed by painters in the later sixteenth century. Nudes are practically never found in religious art in this period and even figures only partially draped are considerably rarer. There is, indeed, one case of an artist showing as strong a horror of the nude as any of the ecclesiastical critics. This is the sculptor Bartolommeo Ammanati, who in 1582 wrote a letter to the members of the Academy of Drawing in Florence in which he laments all the statues of naked men and women which he had made in earlier years, and, since he cannot destroy these works, wishes to make public confession of his repentance for having carved them. Finally, he urges his brother artists to paint and carve fully draped figures, which, he says, are just as beautiful and

[1] Romano Alberti, *Origine e Progresso dell' Accademia*, p. 79.

just as good a test of the artist's skill.[1] Later he wrote to the Grand Duke Ferdinand asking for permission to alter all the naked statues which he had made for the Duke's father by draping them or by transforming them into illustrations of Christian allegories.[2] A conversion of such intensity was, no doubt, exceptional, but to a certain extent most artists of the time were affected by the atmosphere of the Counter-Reformation.[3]

The attitude of the critics of the Mannerist period towards the problem of the nude in painting is relevant to the whole relation of Mannerism to the Renaissance. The more puritanical of the Counter-Reformers seem to have been simply insensible to the serious qualities of Renaissance art, but with critics like Gilio da Fabriano the case is different. He not only admits the merits of Michelangelo but enthusiastically praises them. Michelangelo, he says, has restored painting to splendour in its externals; he, Gilio, wishes to restore it in its treatment of religious subjects.[4] And of the *Last Judgement* he writes that in it Michelangelo 'has shown all that art can achieve'. He admits, therefore, that on standards of purely artistic achievement Michelangelo is incomparable. But Gilio admits a still higher standard according to which, he maintains, Michelangelo must be condemned, because he 'has taken more delight in art, to show of what kind and how great it was, than in the truth of the subject'.[5] For 'I consider an artist who fits his art to the truth of the subject far wiser than one who adapts the purity of the subject to the beauty of art'.[6] To Gilio, therefore, Michelangelo is to be censured for not treating his subject with sufficient seriousness, and he quite unjustly classes him with those of his Mannerist followers against whom it was a common accusa-

[1] Bottari-Ticozzi, *Raccolta di Lettere*, Milan, 1822, iii, pp. 532 ff.

[2] Gaye, *Carteggio Inedito d'Artisti*, Florence, 1839–40, iii, p. 578.

[3] Palestrina seems to have had the same feelings of regret about his earlier madrigals. Cf. Bernier, *St. Robert Bellarmin*, p. 65.

[4] Op. cit., p. 69. [5] Ibid., p. 94. [6] Ibid., p. 86.

tion that they introduced as many nudes as possible into their paintings simply in order to show their skill in drawing.[1] We cannot accuse critics like Gilio of failing to recognize the technical and formal ability in Michelangelo's work; we can only regret their blindness to the intense seriousness which inspired it, but which to men of their generation was concealed by the existence of theological errors of detail, of quite minor importance to a Renaissance Humanist mind.

The critics involved in the disputes about religious art do not always base their views on a direct appeal to morality or to ecclesiastical authority. They sometimes make use of a doctrine invented for quite different purposes, namely, the theory of decorum. We have already come across this theory in the writings of Leonardo, for whom it forms a necessary part of the realistic presentation of a scene. In the sixteenth century it is applied in a more complex manner. It demands that everything in a painting should be suitable both to the scene depicted and to the place for which it is painted. That is to say, the figures must be dressed suitably to their standing and character, their gestures must be appropriate, the setting must be rightly chosen, and the artist must always consider whether he is executing a work for a church or a palace, a State apartment or a private study.

In religious painting the theory provides another reason for demanding accuracy in detail, but on some occasions it even seems to form a higher test than literal exactness. It is used, for instance, by Gilio to justify his condemnation of the figure of Christ in Michelangelo's fresco of the *Conversion of St. Paul* in the Cappella Paolina. One of the speakers in the dialogue argues that this figure, rushing down from heaven, symbolizes the irresistible and sudden force of grace, but Gilio answers that this is unimportant compared with the fact that the figure of Christ is lacking in the dignity suitable to him.[2]

[1] e.g. Pontormo in his frescoes in S. Lorenzo, now destroyed.
[2] Op. cit., p. 89.

The theory of decorum, however, is most extensively applied in the one contemporary attack on Michelangelo which remains to be considered. I have left it till this point because it must be carefully distinguished from all the criticism inspired by the Council of Trent. The attack in question was launched by Aretino and carried on in his name by his friend, Lodovico Dolce. It was inspired by purely personal motives and was in no way connected with the serious and religious criticisms of the *Last Judgement*, though later Gilio da Fabriano seems to have borrowed arguments from Dolce's work. The story of Aretino's relations with Michelangelo has been told at length by various writers,[1] and need only be summarized here. Aretino, who greatly admired Michelangelo, did everything to gain the latter's good graces. But his flattering letters, in which he begged for a drawing, received no reply, and his attempt to dictate to the artist how he should paint the *Last Judgement* was met with insulting evasion. For ten years Aretino persisted, but in 1545 his patience gave way, and he wrote to Michelangelo that letter on the *Last Judgement* which is now famous as an example of insincere prudishness. From a man of Aretino's character it seems strange to hear passionate horror at the indecencies of the *Last Judgement*, but they pour out with far more violence than from Gilio or any seriously minded priest. Dolce's dialogue, *L'Aretino*, which was published in 1557, repeats all Aretino's arguments with the same intensity, and, since the authors were close friends, there is no doubt that they were working in collaboration. We need not examine their accusations in detail, since they are largely the same as those made by Gilio, but what is important is the fact that Aretino and Dolce base their charges on different premises from those of Gilio. The latter attacks in the name of morality; the former do so when it suits them, but more often it is to the theory of decorum that they appeal. They

[1] e.g. by Gauthiez in *L'Arétin*, Paris, 1895.

are shocked not so much at Michelangelo's painting an in-
decent picture as at his painting it in such an important place
as the Sistine Chapel: 'Who will dare to assert that it is right
that, in the church of St. Peter, prince of the apostles, in
Rome where all the world meets together, in the chapel of
the Pope, who, as Bembo truly says, is like a god on earth,
there should be seen painted so many naked figures, shame-
lessly uncovered both before and behind.'[1]

This theme of the unsuitability of the painting to its posi-
tion recurs in Dolce, and makes us suspect that his feelings
are not based only on morality. This suspicion is confirmed
by one extraordinary passage in the dialogue. Fabrini, the
second speaker, complains of the indecency of a set of Marc'
Antonio's engravings after Giulio Romano for which Aretino
himself had written a series of sonnets in his most licentious
manner. Aretino, however, shifts the blame from Giulio to
the engraver, saying that the former never intended to pub-
lish them, and adds: 'It is not wrong for the painter some-
times to produce such works for his own amusement; just
as certain ancient poets joked freely about the image of
Priapus, to please Maecenas and to celebrate his gardens.
But in public . . . one must always behave with decency.'[2]
This defence of what has always been considered a series of
calculatedly pornographic engravings, coming immediately
after Aretino's prudish horror at the nudes in the *Last Judge-
ment*, leaves no doubt that the writer was inspired by personal
anger and not by any high moral feelings. The whole of
Aretino's and Dolce's attack is, in fact, irrelevant to the theme
of religious art at the time of the Counter-Reformation, but
since the latter's dialogue was widely read, and was particu-
larly used by French writers of the following century,
it cannot be altogether ignored.[3]

[1] *L'Aretino*, p. 236. [2] Ibid., p. 240.
[3] It is sometimes suggested (e.g. by Mary Pittaluga, cf. *L'Arte*, xx,
p. 240) that Dolce's dialogue represents the common opinion held of

We have already come across one survivor of the Renaissance involved in the quarrel over religious art, namely Veronese. Another almost equally out of sympathy with the reform of Trent was Vasari, though he was aware of what was taking place and in general avoided committing himself too far. In the matter of heretical paintings he is a little disingenuous. Referring to Botticini's *Assumption* he says that people complained that it contained heretical ideas, and adds: 'As to whether this is true or false, I cannot be expected to judge; it is enough that the figures painted therein . . . are entirely worthy of praise . . . all varied in diverse ways, the whole being executed with good design.'[1] This is as much as to say that he is not interested in the religious details which he leaves to the theologians. Over decency in painting he is more explicit. He is, of course, enthusiastic about the *Last Judgement* and in general he is quite free from prudishness, though he condemns the engravings by Marc' Antonio which Aretino defends. In the life of Fra Angelico he makes a complete statement of his views, saying that 'those who work at religious and holy subjects should be religious men', and blaming those who regard 'the rude and inept as holy, and the beautiful and excellent as licentious', since the saints should be 'as much more beautiful than mortal men as Heaven is superior to earthly beauty'. He even accuses those who are hypersensitive about decency in painting of revealing 'the unsoundness and corruption of their own minds by drawing

Michelangelo in Venice. Apart from the fact that nothing but personal spite could account for the tone of Dolce's attack, there is evidence that in general Michelangelo was admired in Venice at this time. Biondo and Pino both praise him highly in their dialogues; Doni, writing to Aretino in 1549, does the same (*Disegno*, p. 60); and there is even a letter from Dolce himself to Gaspero Ballini, in which Michelangelo is described as *divine* and is said to have raised the arts to the level they attained in antiquity (Bottari-Ticozzi, op. cit., v, p. 175). In proof of his influence on Venetian artists it is enough to recall Tintoretto's motto: 'Il disegno di Michelangelo, e il colorito di Tiziano.'

[1] *Lives*, iii, p. 249.

evil and impure desires out of works from which, if they were lovers of purity, as they seek by their misguided zeal to prove themselves to be, they would gain a desire to attain to Heaven'.[1] This all occurs in the 1550 edition and is entirely Renaissance in feeling. But when the second edition was published in 1568 the quarrel over the *Last Judgement* had reached a more acute stage, and though Vasari leaves the passages quoted above, and in fact adds to them in the same sense, he also puts in a defensive paragraph in which he covers himself by an appeal to the theory of decorum: 'However I would not have any believe that I approve of those figures that are painted in churches in a state of almost complete nudity, for in these cases it is seen that the painter has not shown the consideration that was due to the place.'[2] It is hard to tell how sincere this passage is, but in any case it is clear that Vasari had not fundamentally changed his attitude towards religious art.

So far the effects of the Council of Trent on the arts which we have considered have been mainly negative, and since the Counter-Reformation was at first a purging movement, it is to be expected that the positive stimulus given by it to painting and architecture should be less direct than its restraining influence. But traces of positive instruction can be found in the propagandists of the Council of Trent.

The decrees of the Council itself emphasize the value of painted and carved images as incitements to piety, and this theme is developed by Paleotti, who argues that visible representations appeal more vividly to the minds of many than the spoken word,[3] and by the Lateran Canon Gregorio Comanini, who points out that paintings in a church may catch the eye of even an idle and inattentive person.[4] As has already been said, Gilio da Fabriano and other writers consider it more important that the artist should represent the

[1] *Lives*, iii, p. 33. [2] Ibid.
[3] *Archiepiscopale Bononiense*, p. 567. [4] *Il Figino*, p. 139.

truth of his subject than its external and physical beauty. Therefore, in the representation of martyrdoms or of the sufferings of Christ and the saints, which are subjects capable of arousing piety, the artist must not turn the scene into one of calm, statuesque beauty with naked bodies in their physical perfection; he must on the contrary show the full grimness and horror of the scene. If he is painting the Flagellation he must not make it a study in eurhythmics as Sebastiano del Piombo did in his fresco for S. Pietro in Montorio of which the Counter-Reformers strongly disapproved. He must show Christ as 'afflicted, bleeding, spat upon, with his skin torn, wounded, deformed, pale and unsightly'.[1] If he wants to show a calmer beauty he must choose a calmer subject such as the Baptism, or a more sublime theme like the Transfiguration. In these cases outward beauty is to be encouraged since it is appropriate.

In general the positive as well as the negative advice of the followers of Trent is conspicuous for its minuteness rather than for any generalized emotional argument such as this opinion of Possevino. This is particularly true of Molanus, who devotes the last two books of his treatise to exact instructions for the painting of any figure or scene from religious history. Every detail is considered—what persons should be present, how they should be dressed, how placed, what attitude they should be given—so that under his guidance the painter cannot make a mistake. It will be seen later that Mannerist critics applied just the same method to classical and mythological scenes as to religious subjects.

No less precise is St. Charles Borromeo, who is the only author to apply the Tridentine decree to the problem of architecture. His *Instructiones Fabricae et Supellectilis Ecclesiasticae*, composed soon after 1572, dealt with extraordinary care with all the problems concerning church building. The book centres round one idea which is typical

[1] Gilio, op. cit., p. 86.

of the Counter-Reformation and which was to be of even greater significance in the seventeenth century: that the Church itself and the services held in it must be as dignified and as impressive as possible, so that their splendour and their religious character may force themselves even on the casual spectator. The fact that the Protestants, reacting against the worldliness of Roman ceremonies, went to the opposite extreme of denying any importance to outward show in church services must have provided one reason for the Counter-Reformers to make their own services more and more splendid, but they must also have realized the emotional effect which a big religious ceremony can exert on a congregation. In his prologue to the *Instructiones* Borromeo praises the ancient tradition of ecclesiastical splendour, and demands that priests and architects shall combine to keep it up.

He begins by recommending that the Church should be built in a prominent position, if possible on a slight hill and in any case with steps leading up to it, so that it may dominate its neighbourhood.[1] Its façade must be decorated with figures of saints and with 'serious and decent ornament'.[2] Internally great attention is to be paid to the High Altar, which must be raised on steps[3] and stand in a chancel spacious enough for the priest to be able to officiate with dignity.[4] The sacristy should lead into the main body of the Church, not directly into the chancel, so that the priest can make an effective procession to the High Altar.[5] The transepts may be converted into chapels with further big altars for particular masses.[6] Rich vestments add dignity to a service,[7] and, since the whole ceremony must be properly lit, the windows of the church must in general be filled with white glass.[8]

But all this effect must be obtained by proper means. There must be no vain show, and above all nothing secular

[1] *Instructiones*, bk. i, ch. i. [2] Ibid., ch. 3. [3] Ibid., ch. 10.
[4] Ibid., ch. 11. [5] Ibid., ch. 28.
[6] Ibid., ch. 2. [7] Ibid., bk. ii. [8] Ibid., bk. i, ch. 8.

or pagan.[1] Everything must be strictly in the Christian tradi-
tion. The church should be in the shape of a cross, not in
the form of a circle which is a pagan practice.[2] Incidentally
Borromeo recommends the Latin rather than the Greek
cross, and thereby eliminates the favourite Renaissance form.
No doubt he had in mind the new type of Latin-cross plan
which had already been evolved by Vignola for the Gesù and
was ideally suited to the Counter-Reformation desire for
spectacular effects. Even in matters of detail the appeal to
ancient Christian tradition is final; doors, for instance, must
be square-headed and not arched, because the former kind
is found in early Christian basilicas, whereas the latter is a
pagan design.[3] In every case ecclesiastical reasons pre-
dominate, and purely artistic considerations are only allowed
in questions which are ecclesiastically indifferent. Borromeo's
attention to detail hardly needs further emphasis, but it is
illuminating that he devotes a whole pamphlet to the cleaning
of church decoration and furniture.[4]

To understand the significance of Borromeo's instructions
for the building of churches it may be useful to compare
them with those of architects in whom the ideas of the High
Renaissance survived in the middle of the sixteenth century.
The forms of Church plan which the latter evolved were also
based on religious principles, but their theology was of
another kind. Borromeo condemned circular churches be-
cause they were pagan. Palladio recommends them because
the circle is the most perfect form and is therefore suitable
to the house of God.[5] Moreover, the circle is symbolical of
the unity of God, His infinite essence, His uniformity, and
His justice.[6] After the circle the most perfect form and there-

[1] Ibid., ch. 34. [2] Ibid., ch. 2. [3] Ibid., ch. 7.
[4] *De Nitore et Munditia Ecclesiarum.*
[5] *I Quattro Libri dell' Architettura*, bk. iv, c. 2.
[6] Alberti was in favour of circular churches because the circle is a form
loved by nature (*De Re Aed.*, bk. vii, ch. 4). The theological reason is hardly
mentioned by him.

fore the most suitable plan is the square. Finally comes the
cross, which is appropriate because it symbolizes the cruci-
fixion. Borromeo would have approved of this argument,
though he would have been shocked at the low place which
Palladio allows to the cruciform church. He would have been
even more shocked at Palladio's advice in a later chapter that
the rules for building churches are those for the construction
of temples, with a few modifications to allow for the introduc-
tion of a sacristy and a belfry.[1]

Cataneo, in his *Quattro Primi Libri di Architettura*, pub-
lished in Venice in 1554, argues in a slightly different way
about church building. He maintains that the principal
church in a city should be cruciform, because the cross is the
symbol of redemption.[2] The proportions of the cross should
be those of a perfect human body, because they should be
based on those of the body of Christ, which was more perfect
than that of any other man. Cataneo also adds a very curious
and characteristic argument about the decoration of churches.
The interior, he says, should be richer than the exterior,
because the interior symbolizes the soul of Christ and the
exterior the body, and the soul is more beautiful than the
body.[3] Therefore the exterior should be built in a plain
order like the Doric and the interior in a more ornamental
such as the Ionic. The symbolism of the orders was evidently
widespread and is referred to by Serlio. He wishes the orders
to be chosen according to the kind of saint to whom the
church is dedicated: Doric for those dedicated to Christ,
St. Peter, St. Paul, and the more virile saints; Ionic for
the gentler male saints and the more matronly female;
Corinthian for maiden saints.[4] (Plates 11 *a* and *b*.)

All these arguments about church building are typical of
the way of thought of the High Renaissance. Since beauty
was a divine quality, the proper offering to God was a build-

[1] Op. cit., bk. iv, ch. 5. [2] Bk. iii, fol. 35ᵛ.
[3] Ibid., fol. 38. [4] *L'Architettura*, bk. iv, chs. 6, 7, 8.

PLATE 11

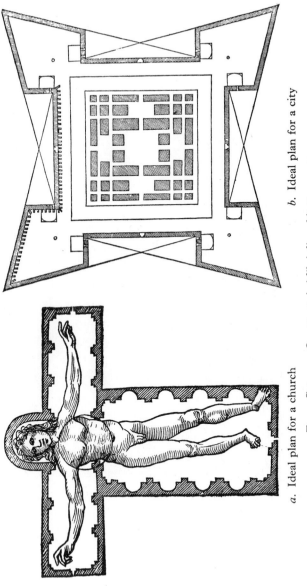

a. Ideal plan for a church

b. Ideal plan for a city

From Cataneo, *Quattro primi libri di architettura*, 1554

ing of great beauty. Combined with this was a strong feeling for the symbolism of certain forms and ornaments. The minute demands of ecclesiastical usage, which for Borromeo weighed above all else, were not yet taken into consideration.

Throughout his *Instructiones* Borromeo emphasizes the importance of collaboration between priests and artists. This principle had been laid down by the Council of Trent, and we know that in painting at any rate it was generally put into practice. The themes of most Mannerist fresco-cycles are so obscure that they can only have been chosen by a trained theologian, and in some cases we know the names of those who planned the programme. The subjects for the decoration of the Pauline Chapel in S. Maria Maggiore, for instance, were selected by two members of the Oratory.[1] The same method was generally used in mythological and historical paintings, as, for instance, in the decoration at Caprarola, which were planned by Annibale Caro.[2] But from this dictation of ecclesiastical authorities to artists we see that art had, in the most literal sense, returned to its medieval position and had become once more the handmaid of religion.

This alteration in the position of the arts is brought out by Paleotti, who says that 'The art of making images is among the noblest arts if it is directed by Christian discipline'.[3] But the question is more fully discussed by Comanini in his dialogue, *Il Figino*, published in 1591. The speakers are Ascanio Martinengo, Abbot of S. Salvatore, Brescia; Stefano Guazzo, a literary and artistic patron; and Ambrogio Figino,

[1] Mâle, *L'Art religieux après le Concile de Trente*, p. 36.

[2] Caro's instructions to Taddeo Zuccaro for these paintings are given in full by Vasari (*Lives*, viii, p. 245). They are worth studying to see how far painters at this time were prepared to have everything dictated to them. The tone is set by Caro's opening remarks: 'It is not enough for them to be explained by word of mouth, because, besides the invention, we must look to the disposition of the figures, the attitudes, the colour, and a number of other considerations, all in accordance with the descriptions that I find of the subjects which seem to me suitable.'

[3] *De Imaginibus Sacris*, bk. i, ch. 7.

a Milanese painter. In the first part of the dialogue Guazzo argues that the aim of painting is simply to produce pleasure, and maintains an art-for-art's-sake theory. Martinengo, the priest, opposes him and says that though painting produces pleasure by means of imitation, yet it is subject to moral philosophy, and its real end is utility not pleasure. Art, he maintains, has always been controlled by the State, as in Egypt, Greece, and Rome, and has been directed by the State towards good ends. In Christian times the control of art as a useful activity belongs to the Church, which generally has directed it and always should direct it towards the support of religion. In the end Guazzo gives in and admits that the primary end of painting is utility and that the pleasure which it produces is only of secondary importance. The speakers then turn to other matters and Figino maintains that painting is capable of more perfect imitation than poetry, and is therefore more useful than poetry. But the main theme remains clear: painting should aim at moral improvement by means of instruction according to the principles of the Church, not at pleasure by means of aesthetic stimulus. In this thesis is summed up the whole view of the Counter-Reformation on the position and function of the Fine Arts.

The theories so far discussed in this section are those of the most austere Counter-Reformers on the arts. They would have been endorsed by the ascetic Popes Paul IV or Pius V and by the great saints of the spiritual regeneration like St. Charles Borromeo. But these were not the only figures involved in the Counter-Reformation, and in both the religious and artistic development of the period there were other movements and other individuals of a quite different temper.

The aim of the severe reformers just mentioned was to recapture a medieval purity of doctrine and a monastic simplicity of life. Their ideas were drawn from the past in which they saw many good features which the men of

their own day might profitably imitate. In the curing of abuses their work was of great value, but in some ways they were out of touch with modern conditions and towards the end of the sixteenth century it became clear that their re-actionary reforms would not give the Church that vigour which it needed if it was to re-establish its power after the attacks of Protestantism. Gradually, therefore, there grew up, parallel with the harsher institutions of reform, bodies which aimed at adapting the Catholic Faith to the needs of modern life. The principal agents of this transforma-tion were the Jesuits, but other organizations such as the Oratory contributed their share, and Popes like Pius IV and Clement VIII, more worldly in their outlook than a Paul IV or a Sixtus V, encouraged the movement. The principle on which these new missionaries worked was that religion must not be made so grim in its appearance and so discouraging in its unattainable ideals that ordinary people would be frightened away altogether from the Church. So they set about making religion more accessible, not by giving it a more rational foundation as the Protestants had done, but by making it appeal to the emotions.

It is hardly necessary to prove in detail how much the Jesuits relied on an appeal through the senses for the excite-ment of religious emotion. The *Exercises* of St. Ignatius are evidence enough. In them the neophyte is urged to use all his five senses to realize, almost to re-enact, the scenes of the Passion, the torments of Hell, or the bliss of Heaven. He is not only to acknowledge these things with the mind, he is to feel them with the heart through the senses. The Jesuits, however, were by no means alone in using these methods. St. Philip Neri attached much value to music as a means of heightening the appeal of pious words, and the music which he preferred for performance at the Oratory was neither the old frivolous music of the Renaissance, nor the simple setting of the words which the Tridentine decrees demanded, but the

work of Palestrina, who was in charge of the music at the Oratory from 1571 till his death in 1594. By the extreme purity of his later style he attained the rare position of satisfying not only the Oratorians but so severe a reformer as Pope Paul IV.

The quarrel between the old and the new in the Counter-Reformation came to a head in the dispute between the Jesuits and the Dominicans which occupied the last ten years of Clement VIII's pontificate and was only silenced, not settled, by Paul V. The Dominicans considered themselves the heirs of St. Thomas Aquinas, whose system they strove to maintain in every detail. The Jesuits, on the other hand, found the rigidity of these doctrines a handicap in their proselytizing work, and in particular considered that the gloomy Thomistic theory of grace and free will was a hindrance to many potentially good Catholics. Through two of their official spokesmen, Aquaviva and Molina, they began to enunciate a more optimistic belief according to which man's will is freer than St. Thomas admitted, so that he can to some extent work out his own salvation. The dispute which arose out of this difference was in effect the conflict between the supporters of a medieval doctrine and those who wished to modify this doctrine in order to make of it a more efficient weapon in propagating the Faith. As has already been said, Paul V cut the dispute short without making any decision; but this was practically a victory for the Jesuits, for they were the challengers and had avoided condemnation. They only had to wait till the accession of Gregory XV in 1621 for their views to be fully accepted, at least in practice. One of this Pope's first acts was the canonization of St. Ignatius and St. Francis Xavier, and this may be taken as typical of the policy of submission to Jesuit control which he and his successor Urban VIII consistently followed.

This worldly, emotional, anti-intellectual kind of religion produced its equivalent in the arts. In the seventeenth century the whole Baroque movement must be closely associated

with the Jesuits, but even before that time there was a branch of Mannerist painting in which many of the same qualities could be found as in the methods and writings of Jesuits and members of the Oratory. Parallel with the academic and aristocratic Mannerism of Florence, and with the didactic style which flourished under the more severe Popes and is perhaps best shown in the frescoes of Sixtus V's library in the Vatican, there was a current of emotional and ecstatic painting, particularly associated with the name of Barocci, but including a whole group of artists in Rome and elsewhere. In Barocci the ecstatic subject is common; it is rendered with a whirl of floating figures and sweeping draperies which anticipate Bernini, and in intense colours which appeal directly to the eye and not to the mind. This irrational use of colour recalls the frescoes of Pontormo in the Certosa. Now, however, the colours are applied not to grim, gothicizing, spiritualized forms, but to fleshy figures which smile only too sweetly, or express their emotions of terror in gestures which appeal to the senses like the coy movements of Greuze's virtuous girls. It is typical of the connexion between this kind of art and bodies like the Jesuits and the Oratory that St. Philip Neri had a particular predilection for the painting of Barocci, and was on one occasion found in an ecstasy in front of his altar-piece of the Visitation in S. Maria in Vallicella. It was for Pius IV, the supporter of the Jesuits, that Barocci first worked in Rome, where he decorated for him the Casino in the Vatican gardens. Further, almost all the artists employed in the original decoration of the central church of the Jesuits, the Gesù, such as Giovanni de' Vecchi, Salimbeni, and Muziano, belong to that group of Mannerists in whom anticipations of the Baroque are most evident.

This new emotional kind of painting was not of a sort to produce much theorizing. Artists so consciously opposed to the intellect and relying so little on rational appeal would be

unlikely to evolve any systematic doctrine about their art, and the only equivalent to this painting is to be found in details of certain expositions of the Tridentine decrees. For instance, the advice of Gilio da Fabriano to the painter that he must show to the full the horrors of any scene of martyrdom which he may have to depict corresponds to the desire of these fore-runners of the Baroque to make their appeal as direct and unavoidable as possible. More remarkable, however, is the addition which the Jesuit Possevino makes to this idea, when he says that the painter must himself feel these horrors if he is to convey them to the spectator.[1] This seems an almost direct application of the methods of the *Exercises* to the practice of the arts.

[1] Op. cit., ch. 26.

Chapter IX

THE LATER MANNERISTS

AT the end of the sixteenth century Mannerism gradually ceases to be the dominant style in Italian painting, and its place is taken by the Eclecticism of the Carracci and the Bolognese Academy. It is generally said that the Carracci mark a sharp reaction against the Mannerists with all of whose ideas and methods they disagreed. It is true that there is little in common between the Carracci and Mannerists of the Florentine tradition or those of the Beccafumi type, but there is one group of artists, always described as Mannerists, whose doctrines anticipate the methods of the Eclectics so accurately that one is tempted to regard the Bolognese Academy as the realization in practice of ideas evolved by those very Mannerists which the Academy officially condemned.

Compared with the aristocratic and emotional kinds of Mannerists so far considered the group now referred to may be described as academic and eclectic—the two adjectives usually reserved for the Carracci and their school. These Mannerists were deeply conscious of the decline which had come over Italian art since the days of Leo X, and they hoped like the Carracci to stop this decline not by new discoveries but by the intelligent imitation of the works which the masters of the Renaissance had left behind. For them, as for the Bolognese, painting was a science which could be taught according to fixed rules, and these rules could be discovered by studying the example of good masters.

These academic Mannerists can be considered in two main groups. One centred round the Academy of Drawing in Rome, and the most important member of it was Federico Zuccaro, who was elected president in 1593. The other, a

Milanese group, was less important in painting but more significant in theory since it produced the treatises of Lomazzo, in which the doctrines of later Mannerism are set out at full length.

Of the practice of these two schools it is not necessary to say much. In spite of differences due to the local traditions out of which they sprang, Lomazzo and Federico Zuccaro in his later period belong to the same stage of painting. Both were highly self-conscious in their outlook and calculating in their methods. Both learnt more from other painters than from the study of nature, and each combined in himself stylistic elements taken from many different sources: Zuccaro drawing mainly on the Roman and Venetian traditions, Lomazzo borrowing directly from Leonardo, Raphael, and Michelangelo, and, through his master Gaudenzio Ferrari, deriving qualities from Mantegna and Pontormo. Both artists avoided the almost caricatural extreme of Mannerism which some of their immediate predecessors had reached, and made some return towards the principles of classical composition and drawing practised by Raphael and his contemporaries. But, though it is necessary to emphasize these new qualities in their art, it remains nevertheless true that these two artists are fundamentally Mannerists. Compared with the paintings of Vasari's Florentine followers their work may seem simple and unaffected, but, put side by side with any panel of the Farnese Gallery, their use of *repoussoir* figures, of double *contraposto*, and of obscure allegorical allusions reminds us that they were still deeply involved in the habits of the later sixteenth century. They belong, in fact, to that transitional stage from Mannerism to the seventeenth century which is best represented in the frescoes of the Cavaliere d'Arpino, an artist who, deriving from Mannerism and working independently of the Carracci, yet developed many of the characteristics of the latter's style.

Something must be said of the individual writers whose

theories will be discussed. With the Roman group two names are to be associated—Federico Zuccaro and Giovanni Battista Armenini. The former published a number of small treatises of which much the most important is the *Idea de' Pittori, Scultori e Architetti*, printed in 1607. A shorter expression of his views is to be found in Romano Alberti's *Origine e Progresso dell' Academia del Disegno*, published in 1604. This nominally contains the minutes of Academy discussion for the years 1593-4, but since no one but Federico Zuccaro seems to have been allowed to speak, the book is simply a sort of preliminary to the *Idea*. Armenini was a native of Faenza whose views on the arts, however, were entirely coloured by his six years' training in Rome between 1550 and 1556. It is significant that he seems to have been more impressed with the works of Raphael's followers, Polidoro da Caravaggio and Perino del Vaga, than with the newly painted cycles of full Mannerism like Vasari's Sala de' Cento Giorni in the Palazzo della Cancelleria, or Salviati's paintings in the same palace and in the Oratory of S. Giovanni Decollato. On leaving Rome in 1556 Armenini travelled through Italy studying the masters of every school —Giulio Romano at Mantua, Correggio at Parma, Perino del Vaga at Genoa, Titian in Venice. In later life he became a priest. He published his only work on painting in 1586[1] and called it *Dei Veri Precetti della Pittura*—a title which already reveals the academic outlook of its author.

The interest of the Milanese group centres entirely round Lomazzo. He was born in 1538 and was trained mainly under Gaudenzio Ferrari. He went blind in 1571 and was therefore forced to give up painting and take instead to the theory of the arts. He evidently fancied himself a master in every intellectual field and was proud of being president of a local

[1] All the authorities give 1587 as the date of publication for this book, but the British Museum has a copy with the date 1586, of which the 1587 edition seems to be an exact reprint.

organization, the Accademia della Valle di Bregno. Apart from his poems, some of them in dialect, and his autobiography in verse, he published two major works on the arts. The first was entitled *Trattato dell' Arte della Pittura, Scultura, et Architettura* and was printed in 1584. The second, which appeared six years later, was called *Idea del Tempio della Pittura*. The *Trattato*, which will be described in detail later, is an exhaustive volume, of which the *Idea* is a sort of summary, containing less detailed advice and more abstract aesthetics.

In the theories of the late Mannerists the same division is visible as in their paintings. They are half in sympathy with earlier Mannerism and half in reaction against it. At one moment they speak like Vasari; at the next they seem nearer to the classical critics of the seventeenth century. In general they are novel in their practical teaching, but still fully Mannerist when they write of aesthetic questions and of beauty in the abstract. It will therefore be convenient to treat these two sections of their writings separately.

It has already been said that just as the Counter-Reformation in its earlier stages was a reaction towards feudalism, so Mannerism was in many respects a return towards Medievalism in art. The direct effect of this in connexion with religious art was discussed in the last chapter. In Lomazzo and his contemporaries the influence of the Middle Ages was no less important, but it appears in a different form. They all agree with the officials of the Church that art must be subservient to religion, but this is not a matter to which they devote much space, and it is in their abstract discussions of aesthetics that their anti-classical tendencies appear most clearly.

Lomazzo and Zuccaro differ in many details of their aesthetic views, but one important feature is common to both, their systems. Whereas for the writers of the Early and High Renaissance nature was the source from which all beauty was

ultimately derived, however much it might be transformed by the artist's imagination, for these Mannerists beauty was something which was directly infused into the mind of man from the mind of God, and existed there independent of any sense-impressions. The idea in the artist's mind was the source of all the beauty in the works which he created, and his ability to give a picture of the outside world was of no importance, except in so far as it helped him to give visible expression to his idea. The relation of the artist to nature, which was immediate in the Early Renaissance and important, though not so dominant, in the case of Michelangelo, has here been almost broken off. Lomazzo and Zuccaro both perfunctorily define painting as the imitation of nature, but neither refers to the matter at any length, and both had in mind more particularly the Scholastic idea that art works according to the same principles as nature, rather than the view that painting copies the individual works of nature.[1] That is to say, they mean that both painting and nature are controlled by intellect—in the one case human and in the other divine intellect—that both obey certain laws of order, and so on. Zuccaro attacks the view that painting copies nature in one of his lectures to the Roman Academy,[2] and when Armenini comes to define painting nature is not mentioned at all.[3] In both cases the emphasis is on the idea in the artist's mind, which is the proper object of imitation.

For Zuccaro ideas exist in three different stages: first in the mind of God, secondly in the mind of angels, and thirdly in the mind of man. Since he is writing for artists, he chooses to avoid the word *idea*, and prefers to it the phrase *disegno interno*. By this device he is able to argue that everything

[1] Cf. Zuccaro, *Idea*, ch. 10; and particularly *La Dimora di Parma*, ch. 10, where drawing is described in the same breath as *scimia della Natura* and *scimia di Dio*.

[2] Cf. Romano Alberti, *Origine e Progresso dell' Accademia*, p. 24.

[3] *Veri Precetti*, bk. i, ch. 2.

derives ultimately from *disegno interno*, and that drawing is
the foundation of all intellectual pursuits. *Disegno interno* is
entirely without substance and is a reflection of the divine
in us.[1] This scheme and the account which Zuccaro gives of
the workings of the intellect are exactly in accordance with
Scholastic doctrines, and in many cases are explained in
passages copied directly from St. Thomas.[2] Many of the
ideas which Zuccaro expresses are Aristotelian in origin, but
they are combined with elements of Christian doctrine to
form a typically medieval Scholastic blend.[3]

With Lomazzo the scheme is in many ways similar, but
flavoured with a strong addition of Neoplatonism.[4] Whereas
Zuccaro is more concerned with the intellectual idea, in
Lomazzo the concept of beauty plays a far greater part. For
to the Neoplatonist beauty is a visible manifestation of the
good. According to Lomazzo beauty is a spiritual grace,
'una certa grazia vivace e spiritale', which springs from God
and appears in three ways; in angels, where it forms ideas;
in the human soul, where it is called reason or knowledge
(*ragione* or *notizie*); in matter, where it creates images or
forms (*imagini* or *forme*). The means by which beauty is
infused into matter or into the human soul are not logically
explained, but the process is compared with that of light

[1] He describes it as *scintilla della divinità* (*Idea*, bk. i, ch. 7). To
emphasize this point he makes a characteristically Mannerist pun,
deriving the word *disegno* as *segno di Dio* (*di-segn-o*).

[2] This has been noticed by E. Panofsky (cf. *Idea, Ein Beitrag zur
Begriffsgeschichte der älteren Kunsttheorie*, Studien der Bibliothek War-
burg, 1924, pp. 39 ff), who gives a full analysis of Zuccaro's and Lomazzo's
views on the nature of beauty.

[3] Zuccaro used his theory of *disegno* as the basis for a series of decora-
tions in his own house in Rome (cf. Körte, 'Der Palazzo Zuccari in Rom',
Römische Forschungen der Biblioteca Hertziana, 1935, pp. 35 ff.). The
central panel of the ceiling is reproduced on Plate 12.

[4] Zuccaro is at times inclined towards Neoplatonism, but only rarely.
He gives Plato himself as the source for his theory of Ideas, though it is
more exactly Neoplatonic (*Idea*, bk. i, ch. 5), and he talks of light in a
Neoplatonic manner towards the end of the *Idea* (bk. ii, ch. 15).

PLATE 12

Federico Zuccaro. Allegory of Drawing. Palazzo Zuccaro, Rome

streaming from the face of God and absorbed by spiritual and material beings.[1]

Although Zuccaro and Lomazzo differ about the general problems of aesthetics, it appears that they have in common certain important qualities: both are strongly anti-rationalist and mystical, and in both the scientific spirit characteristic of Renaissance thought is entirely absent. In both the idea from which the work of art is copied derives from God and not from the outside world. Both writers have their eyes turned inward, not outward, and they would have sympathized with the feelings of another Mannerist, El Greco, as recorded in a story, perhaps apocryphal, told of him by Giulio Clovio. Clovio went to see him on a summer day and discovered El Greco sitting, inactive, in a room with the curtains drawn, because he found the darkness more conducive to thought than the light of day, which disturbed his inner light.[2]

Further, the ideas of both Zuccaro and Lomazzo discussed above are all strongly medieval. The Neoplatonist Christianity of the latter and the Scholasticism of the former are both signs of the tendency in the Mannerist period for theorists as well as artists to give up the rational ideals which had dominated the Renaissance in its pure manifestations and to return to the non-humanist theological values of medieval Catholicism. In the case of Lomazzo the Gothic effect is greatly increased by the form in which he expresses his ideas. His fondness for astrology led him to use a complicated system of symbolism, according to which every quality in painting and every division of the mental faculties are placed under

[1] *Tempio della Pittura*, ch. 26. The greater part of this passage is a verbatim borrowing from Ficino (see Panofsky, *Idea*, Appendix I). In the *Trattato* Lomazzo constantly refers to Ficino or to earlier Neoplatonists like the Pseudo-Dionysius for ideas (e.g. in bk. iv, ch. 3).

[2] Cf. Panofsky, *Idea*, p. 56. As another example of the Mannerist love of darkness the studiolo of Francesco de' Medici in the Palazzo Vecchio may be quoted. It is a small room, completely shut in, with no windows, so that it can only be lit up artificially.

the protection of a particular planet. The types of proportion in the human body and the different emotions which the painter must depict are divided into seven planetary groups, and the painters chosen as Governors of the Temple of Painting are each connected with a heavenly body—Raphael with Venus, Leonardo with the Sun, and so on. There is also considerable play in Lomazzo with the symbolism of numbers, with the seven circles of heaven, and with all the apparatus of medieval astrology. Even Zuccaro, who is in general clear of this particular lumber, when he compares drawing with the sun as the source of all light, cannot resist dragging in Mercury, Jupiter, and the rest to complete the picture,[1] and some of Vincenzo Borghini's letters about painting are obscured with the same symbolism.[2] His namesake, Raffaello Borghini, however, avoids this method and is able to satisfy his urge for complicated comparisons in Christian and mythological terms. It is not surprising that this medieval tendency appears more strongly in Lomazzo than in the other writers, for Milan had never been as fully conquered by the Renaissance as the towns of central Italy. There was always a certain connexion kept up between Lombardy and the countries north of the Alps, and throughout the sixteenth century the influence of Gothic painting was strong in Milan, even in Leonardo's immediate followers, but more particularly in Lomazzo's master Gaudenzio Ferrari.

The almost mystical doctrines held by the later Mannerists about the nature of beauty and the foundations of art were accompanied by many other anti-rational features, of which perhaps the most important is the new attitude towards the relation of painting to mathematics. Lomazzo admits that proportion and perspective are based on actual measurement and on the certain methods of mathematics,[3] but he reminds

[1] *Idea*, bk. ii, ch. 15.
[2] See letters 43 and 44 in *Carteggio artistico inedito di Vincenzo Borghini*, Florence, 1912. [3] *Trattato*, bk. i, ch. 4.

the artist that this is only a foundation, and that in the last resort he must rely on his eye and not on his compasses.[1] Zuccaro goes much further and denies the connexion with mathematics altogether:

'But I say—and I know that I speak the truth—that the art of painting does not derive from the mathematical sciences, nor has it any need to resort to them to learn rules or means for its own art, nor even in order to reason abstractly about this art: for painting is not the daughter of mathematics but of Nature and of Drawing.'[2]

So mathematics, which had been to the early Humanist artists one of the chief weapons in the scientific study of the outside world, is in the Mannerist period almost driven out of painting. The certainty of scientific observation has given place to a conviction directly inspired by God: reason has given way to faith.

Certain writers of this period go farther and deny not only the validity of mathematics as a foundation for painting but the possibility of the arts being based on any certain rules at all. Giordano Bruno says that poetry does not spring from rules, but rules from poetry, and that there are therefore as many different kinds of rule as there are different kinds of poets.[3] Zuccaro writes that the mind of the artist 'must be not only clear but free, and his invention unfettered and not compelled to the mechanical slavery of such rules; for this noble profession demands judgement and skilful execution which are its rules and standards of working.[4] And for Zuccaro judgement is no longer a rational and intellectual faculty but the weapon which 'chooses that which is most pleasing to the eye'.[5]

It has already been said in connexion with Vasari that the

[1] Ibid., bk. v, ch. 1, and *Tempio della Pittura*, ch. 11. His authority for this view is Michelangelo.
[2] *Idea*, bk. ii, ch. 6.　　[3] See Panofsky, *Idea*, p. 38.
[4] *Idea*, bk. ii, ch. 6.　　[5] Ibid., bk. ii, ch. 4.

rising importance which attached to the quality of grace in
the sixteenth century was a sign of an anti-rational attitude
towards the arts. In the later Mannerists this quality plays
a great part. It is in general treated by Lomazzo in the same
way as by Vasari: it appeals to the eye and cannot be attained
by mere study.[1] Zuccaro is even more explicit: 'Grace is . . .
a soft and sweet accompaniment which attracts the eye and
contents the taste . . .; it depends entirely on good judgement
and good taste.'[2] This coupling of grace with taste (*gusto*) is
another sign that it is a sensuous and not an intellectual
quality, a fact which is brought out even more clearly in a
passage where it is put with *spirito* and *sapore* as the vital
qualities which a too great subservience to the rules of
mathematics will destroy.

So far the ideas of Lomazzo and his contemporaries con-
sidered in this chapter have been those which are generally
in agreement with Mannerist principles. It is not till we
leave their explanations of the nature of beauty and the
function of the arts and come to the methods which they
recommend for the training of artists and for the actual practice
of painting that the new features in their theories appear.

It has been said above that these later Mannerists were
aware of the decline which had taken place in Italian art since
the generation of Raphael, Michelangelo, and Titian, and the
feelings which this decline aroused in them receive clear
expression in their writings. Armenini speaks of the horror
which these masters would feel if they could come back and
see the works of their followers.[3] Lomazzo attributes the
decay of the arts to the fact that artists will not think out their
works with enough care in advance,[4] nor take enough trouble
in making themselves perfect in their art.[5] Zuccaro makes

[1] *Tempio della Pittura*, ch. 12.
[2] Cf. Romano Alberti, *Origine e Progresso dell' Accademia*, p. 59.
[3] Op. cit., bk. ii, ch. 11. [4] *Trattato*, bk. vi, ch. 64.
[5] *Tempio della Pittura*, ch. 3.

the poor state of the arts his main theme in the *Lamento della Pittura*.[1] Painters wish only to please the eye and neglect all the intellectual side of their art. Their principal qualities are *capriccio*, *frenesia*, *furore*, and *bizzaria*, whereas they should display *disegno*, *grazia*, *decoro*, *maestà*, *concetti*, and *arte*. These demands seem not to be entirely in agreement with Zuccaro's belief in the importance of *gusto*, but contradictions like this are common in the writers of this group, and only bring out more clearly the transitional position which they held.

The hope of the later Mannerists was to save the arts from falling to a yet lower point by academic methods. They were academic in both the particular and general senses of the word. In the particular sense, they actually used the existing academies as weapons for attaining their ends, and they show particular pride at being members of different academies, even when the latter had nothing in particular to do with their own professions. Lomazzo, for instance, was president of the Accademia della Valle di Bregno, the main business of which was to preserve a local dialect; and Zuccaro was not only President of the Academy of Drawing in Rome, but also a member of the Accademia Insensata at Perugia and of the Innominata at Parma, and he tried to found other academies in Venice and elsewhere. These academies of drawing, which had been founded as a demonstration of the fact that painting was a liberal art, were gradually changing their character in the later sixteenth century. They were no longer simply meeting-places where those interested could discuss the general problems of the arts, but they had become institutions in which every detail of instruction was supervised and fixed by rule.

But the late Mannerists were also academic in the wider

[1] The *Lamento*, published at Mantua in 1605, was in part an imitation from Francesco Lancilotti's *Tractato di Pictura* (Rome, 1509), in which the author laments the small respect in which painting was held in his time.

sense of the word. Their doctrine was exclusive. They scorned the idea of making a wide or popular appeal and deliberately directed their work towards a select, educated public[1] of men who could understand the subtleties of painting and would not be taken in by technical brilliance like the ignorant crowd.[2] Even in appreciating human beauty training and a knowledge of painting are necessary if one is not to judge it like an animal.[3] If knowledge and learning are important in the spectator, it follows that they are even more necessary in the painter himself, who must be learned in all the sciences connected with his art—and in many, such as astrology or philosophy, which do not to us seem directly relevant to it.[4]

The demand for knowledge in the painter is a manifestation of one of the fundamental tenets of the late Mannerist system, namely, a belief that the arts can be taught by precept. This assumption runs all through the *Trattato* of Lomazzo, which is a Handbook to Painting in a much more thorough sense than any of the earlier treatises. Armenini is quite explicit on the point. The title of his book, *De' Veri Precetti della Pittura*, is in itself evidence of his faith, but he leaves no doubt when, in the concluding reflections of the work, he speaks of those who maintain that painting 'is so difficult that it cannot be taught by the written word except in certain confused, feeble, and poor principles, and they add that it is a virtue and a grace poured from heaven into human bodies which cannot be acquired by other means'. Armenini comments on this: 'How stupid are those who have got into their heads the idea that this is one of those speculative or occult sciences which are only revealed and comprehensible to the deepest and most acute minds.' Rules are for him 'the unchangeable foundations of the art'.[5]

The Mannerists do not, of course, maintain that the whole

[1] Lomazzo, *Tempio della Pittura*, ch. 9. [2] Ibid., ch. 31.
[3] Ibid., ch. 7. [4] Ibid., ch. 8. [5] Op. cit., Proemio.

of painting can be taught, and they frequently refer to the fact that the painter must be born with a natural genius if he is to achieve any good at all.[1] But having said this, they devote all their attention to the minutiae of his training.

It is no new doctrine to maintain that much useful advice could be given to the painter by means of the written word. Alberti and Leonardo had both put down their views in writing for the benefit of other artists and many had profited by them. But the Mannerists approached the matter in a different spirit. The theorists of the Early Renaissance believed that a student could be helped to learn the art of painting by the application of reasonable methods; the Mannerists wished him to learn it by absolute rules.

At first sight reason seems to play quite an important part in the theories of Lomazzo and Armenini. Painting, says the former, does not appeal to the eye, but to the reason.[2] However, his argument in favour of this view reveals what he really means; for he argues that beauty must appeal to the reason and not the eye, because no one would deny that beauty exists in angels and, since they are invisible to the eye, their beauty must be recognizable by other means—according to him, by reason. This explanation makes clear the gulf which exists between the reason of Alberti and the reason of Lomazzo. For the latter is, in effect, only repeating the view of St. Thomas that beauty appeals to the mind and not to the senses, and he is going no farther than Armenini, who makes painting appeal to 'the eye of the understanding' (*l'occhio dell' intelletto*).[3] Neither the reason of Lomazzo nor the understanding of Armenini has anything in common with the reason of the early Humanists which was a weapon for studying the real world, and the foundation of the scientific method.

When analysed, Lomazzo's idea of reason comes down

[1] Lomazzo, *Tempio della Pittura*, ch. 8.
[2] Ibid., ch. 26. [3] Op. cit., bk. i, ch. 2.

roughly to the knowledge and observance of certain fixed rules. Moreover, these rules are based on authority, not on experience. With Alberti, and even more particularly with Leonardo, the scientific approach led to observation of actual facts about painting or about natural beauty. From these observations were deduced the rules which made up the treatises of these writers. The rules were put down only in a tentative way, to be abandoned if a new experimental test went against them. They were a means by which one artist could hand on to another the practical knowledge which he had gained at first hand. With the Mannerists all this is changed. Rules are laid down as final, and the reason that they are final is not that they are the outcome of the writer's own observations but that they have been deduced from his study of some other master's work. The argument now is that such and such a method is to be followed because it was followed by such and such an artist. In the conclusion to his work Armenini explains that he travelled all round Italy to study the work of all the best artists so that he might draw up his rules of study; and we shall see later that the whole method of instruction suggested by Lomazzo in his *Idea del Tempio della Pittura* is based on the same doctrine.

This return to the principle of authority appears in one curious form, in connexion with ancient art. Although in general the Counter-Reformation and Mannerism were movements opposed to the influence of classical antiquity, yet the ancients are quoted as authorities whose example must be followed, particularly by Armenini, whose connexion with Rome brought him into close contact with ancient remains. The explanation is connected with a point which has already been discussed in connexion with religious art. The Church was only opposed to the philosophical systems of the ancients and was prepared to allow the use of classical themes and classical forms as long as they were divorced from that element of individual rationalism which gave them their

point in the Early Renaissance. This appears in the art of
the period, for instance in fresco-cycles like Zucchi's decora-
tion in the Palazzo Ruspoli in Rome, in which the themes and
apparatus are all classical but the spirit and forms in every
way anti-rational and Mannerist.[1] Another example is the
Mannerist fondness for grotesques—a fantastic and therefore
harmless form of ancient art—which were developed with
great originality by the Mannerists in their decoration.

As students of antiquity concentrated more and more on
the details of classical antiquity and less on the recovery of
its spirit, respect for the authority of the ancients increased
and became almost servile. Alberti admires classical antiquity
and uses it constantly, but only when it suits him. He is
never tied by it and he advises the young artist to break away
from its limits if he can. In the later sixteenth century it is
accepted as a final authority in all matter of detail. In archi-
tecture, for instance, the only matter in dispute was the rela-
tive importance of Vitruvius and of surviving buildings as
means of deciding what was right and what was wrong.
Palladio, for instance, a great practising architect, whose
methods still had much in common with the classical archi-
tects of the beginning of the sixteenth century, relied
more on his study of the buildings themselves than on the
rules of Vitruvius;[2] Serlio, on the other hand, who was
primarily a theorist, pins all his faith on the latter. His belief
in him is so great that he is ready to admit that other Roman
architects sinned when they did not follow his precepts. For
instance, speaking of the theatre of Marcellus, he says:

'it does not seem to me that on the basis of one or other of the
ancient buildings a modern architect is justified in sinning (and
by *sinning* I mean breaking the rules of Vitruvius). . . . Besides,

[1] For a full discussion of the treatment of classical themes in these
frescoes cf. Saxl, *Antike Götter in der Spätrenaissance*, Studien der
Bibliothek Warburg, 1927.
[2] *I Quattro Libri dell' Architettura*, bk. i, ch. 12.

if this ancient architect was licentious that is no reason why we should be so: for, unless reason tells us to the contrary, we must always follow the teaching of Vitruvius as an infallible rule and guide.'[1]

Vignola harmonized the models provided by the surviving works of antiquity with the rules of Vitruvius, and produced for the first time a set of absolute proportions for the Five Orders, based solely on the authority of the ancients.[2]

At the same time Armenini took an important step in the same direction in the theory of painting. When he comes to give the correct proportions for the human figure he does not base his measurements entirely on the most beautiful specimens in life, but he checks the results arrived at in this way by 'the most perfect statues in Rome'.[3] No doubt Alberti and his contemporaries had been influenced in their choice of natural beauty by their taste for Roman sculpture, but this is the first occasion on which a writer actually makes ancient statues the final test for natural beauty.

In the system of the later Mannerists, therefore, the individual reason, which was the foundation of all Renaissance progress, was replaced by an acceptance of authority, exactly as the individual conscience had been crushed in religion by the Counter-Reformation.

This servility and the study of the great masters to which it led produced the intricate scheme of rules which is most fully developed by Lomazzo in his *Trattato*. In this book, which contains some seven hundred crowded pages, every possible problem which may confront the painter is discussed and settled. The treatise is divided into seven books dealing respectively with Proportion, Motion, Colour, Light, Perspective, Practice, and History. Each book is systematically subdivided so that nothing escapes analysis. In the book on

[1] *Tutte l'Opere d'Architettura et Prospettiva*, bk. iii, ch. 4.

[2] In the *Regole de' Cinque Ordini*, first published in Venice in 1562.

[3] Op. cit., bk. xii, ch. 5.

Proportion, for instance, details are given for drawing figures of men and women of seven, eight, nine, and ten heads in height. The proportions of children and horses are also added. In the book on Motion, which includes Expression, all the possible human emotions are classified, the gestures and facial movements which they produce are described, and episodes are mentioned which illustrate the effects of each. In the last book, of History, Lomazzo describes the Forms of all the gods, of the elements, and of everything that the painter may want to depict. It is interesting in this context to notice that he uses the word 'Form' in its medieval and Scholastic sense, meaning that which gives any particular thing its being, that which distinguishes it from other things.[1] For him, therefore, the form is not simply the outward shape of a thing; it is the sum of its distinguishing characteristics. The form of Jupiter, for instance, includes his eagle and his thunderbolts. In the case of a saint it includes his traditional attributes. So that the last book of the treatise contains a complete handbook to Christian and Classical iconography. To paint Mars or the Archangel Michael the artist need not use his imagination; he need only turn up the relevant passage in the *Trattato*.

This method is carried to its extreme point by Lomazzo,[2] but it is also used in a milder way by the other late Mannerists, particularly Armenini. The latter covers a smaller range than Lomazzo, but within it he is no less final in his statements and no less dictatorial in his tone. In the first book of the *Veri Precetti* his treatment is rather general, but in the second, in which he discusses the different parts of painting —proportion, colour, light, and shade—his approach is just like that of Lomazzo, and in the last book, devoted to the

[1] In his pamphlet, *Della Forma delle Muse*, he says: 'La forma è quella che dona l'essere alle cose tutte.'

[2] In architecture the equivalent handbook is Scamozzi's *Idea della Architettura Universale*, Venice, 1615.

kind of decoration required in different buildings, his instructions recall those of St. Charles Borromeo, though the authorities appealed to here are the masters of the Renaissance, not the early Christian Fathers.

Enough has been said to show in what sense the later Mannerists were academic, and it remains to consider their Eclecticism. According to Lomazzo the process of artistic production could be divided into two parts: the formation of the idea in the mind of the artist, and the expression of this idea in material form in paint, marble, or line. The first of these stages was the business of the mind and the imagination. For the second it was essential to acquire a 'good manner'; and it is in the acquisition of a good manner that the method of Eclecticism becomes important.

First of all it is important to see approximately what Armenini means by 'manner'. Vasari often talks of the *maniera*, and it is from this word that the whole school of the late-sixteenth-century Italian painting now takes its name. It is therefore a quality of considerable importance, but it is not easy to isolate its meaning. Vasari usually qualifies the word, and talks of *maniera secca*, or *gran' maniera*. Raffaello Borghini appears to be the first critic to say simply that a painter possesses or lacks 'manner'. When he does so he seems to understand by 'manner' what Vasari meant by *gran' maniera*, which is connected with the *terribiltà* for which Michelangelo was famous and with our idea of the sublime. At any rate he contrasts it with *cose finite e delicate*.[1] Armenini is more explicit. His conception of the *maniera* depends on the distinction which he draws between exact imitation and good drawing.[2] There was nothing new in making such a distinction, for all the critics of the earlier Renaissance, except Leonardo, the supreme naturalist, had made it. But Alberti has quite different reasons from Armenini for distinguishing these aspects of painting. For Alberti good drawing is one

[1] *Il Riposo*, p. 159. [2] Op. cit., bk. iii, ch. 11.

stage beyond exact imitation, since to arrive at the former the artist has to go through the process of selecting and combining the best elements in natural beauty. Armenini conceives of another stage beyond this, for he tells the story of Zeuxis choosing the most beautiful features of five Crotonian girls to paint his Venus—the anecdote always chosen by earlier critics to illustrate Alberti's selection process—and then adds: 'If Zeuxis . . . had not possessed a particular manner (*singolar maniera*), he would never have harmonized the different features which he had chosen for their beauty from the several girls.'[1]

Now Michelangelo also went a stage beyond Alberti's selection, but with him the further process was a transmutation of the selected material by means of the imagination. Armenini's method is different. His final stage consists not of a transmutation but of an addition—the addition of *maniera*.

A first approximation to a translation of *maniera* in this context might be *style*. There is, of course, nothing unusual in the idea of an artist's having style. All artists have style, naturalism itself being a style as much as Gothic or Baroque. But, in general, naturalistic artists do not talk about style; they talk more in terms of what they are interested in painting, or of the accuracy with which they think they can paint it. It is a characteristic of non-naturalistic, mannerist periods of art that people talk explicitly about style. In this way Armenini is typical of his time. He evidently thinks that there is one and only one style; for when he discusses the painters of the Quattrocento he does not say, like Vasari, that they have a *maniera secca*, but simply that they lack *la bella maniera*, as if it was something discovered by his contemporaries.[2] It is this confidence in the absolute rightness of their particular style, and the undue importance which they attribute to it as an end in itself, that justify the name of Mannerists, as opposed to Stylists, for the painters and

[1] Ibid., bk. ii, ch. 3. [2] Ibid., bk. ii, ch. 10.

theorists under consideration, and bring us to the more obvious translation *manner* as the closer approximation to the meaning of *maniera*.

In training himself to acquire a good manner, the first essential is that the artist should decide in what direction his natural talent draws him.[1] Lomazzo is quite clear about this point, and frequently reminds the artist of the disasters which will come upon him if he imitates other painters slavishly, without stopping to consider whether they are the right kind of painter for him personally to imitate, or if he tries to force his style into a certain line because he has been told that it is the right line. This basic proposition distinguishes Lomazzo's Eclecticism from the rigid system of borrowing usually connected, though not quite fairly, with the Carracci. Once the artist has decided in what direction he is naturally drawn, there are two methods by which he can develop his talent: by sheer study and effort, or by the imitation of other artists. The former is a serious way of advancing, but it has one disadvantage, that too concentrated work leads to dryness of manner and consequently prevents the artist from displaying grace in his work. Since the loss of grace is of the greatest importance the second method is the better, and Lomazzo explains it at length. His Temple of Painting is controlled by seven Governors, each of whom represents a particular kind of perfection in painting. They form a curious list to our eyes. First the four great names of the High Renaissance: Leonardo, Raphael, Michelangelo, and Titian; then Lomazzo's master, Gaudenzio Ferrari; and finally Polidoro da Caravaggio, presumably as the continuer of the Raphael-esque tradition, and Mantegna, who perhaps owes his position in the list to the influence which he seems to have exerted on Gaudenzio. The particular achievements of these seven Governors are then analysed under the seven parts of paint-

[1] The whole of the theory that follows is expounded in ch. 2 of Lomazzo's *Idea del Tempio della Pittura*.

ing (proportion, motion, colour, &c.) in a confusion of
astrological symbolism.[1] The young painter has, therefore,
simply to decide which elements he finds congenial in each
of these painters and, by carefully studying them, to nourish
his own talent. By this method he will be saved the excessive
fatigue which will overcome him if he tries to work out every-
thing for himself and he will make the best use of the work
of his predecessors.

This scheme represents, in effect, a full system of Eclecti-
cism, which is summed up in the description which Lomazzo
gives of his ideal painting. It was to consist of two panels;
on the first Adam drawn by Michelangelo and painted by
Titian, using the proportions of Raphael; on the other, Eve
drawn by Raphael and painted by Correggio.[2] But in spite
of passages like this, it must be remembered that Lomazzo
tempered his Eclecticism by his constant warning against
mere plagiarism and by his advice to the artist only to imitate
those masters for whom he feels a natural sympathy.[3]

The method recommended by Armenini is similar in its
general lines, but rather less complicated. He agrees with
Lomazzo that it is vital for the artist to possess a good
manner, more precisely *una bella e dotta maniera*.[4] This can
only be acquired if the artist has a natural gift as a painter, but
this gift must be cultivated by study.[5] The first stage of study
is to consist simply of copying progressively more difficult
models: first drawings and engravings, then paintings, in
chiaroscuro and in colour, and finally ancient sculpture and
Michelangelo's *Last Judgement*.[6] The student is then offered
two alternative methods: either to follow one master, or to
draw what he needs from the study of many different masters.
Armenini does not finally decide which is the better of these

[1] *Tempio della Pittura*, chs. 11–17. [2] Ibid., ch. 17.

[3] e.g. in *Trattato*, bk. vi, ch. 64.

[4] Op. cit., Proemio, and bk. i, ch. 8.

[5] Ibid., bk. i, ch. 7. [6] Ibid., bk. i, ch. 8.

two methods, but he evidently favours the latter, since he quotes Michelangelo's remark that a man who always follows another never overtakes him, and laments the bad effect which the universal imitation of even so great an artist as Michelangelo has had on painting.

However, the important difference between the schemes of Lomazzo and Armenini lies in the position which the latter gives to ancient sculpture as a model for the artist. His admiration for antiquity thrusts itself even into his definition of painting. For in this, after saying that the painter must first conceive an idea in his mind, he goes on to talk of the manner which the painter must adopt to express it, and this manner he calls not *maniera buona* but *maniera antica*.[1] His feeling for the ancients has already been mentioned in con-nexion with his treatment of proportion, but it appears throughout his discussion of the artist's training. Ancient sculpture is quoted as the best possible model, and nature, which is only to be imitated at all after the painter has acquired his good manner, is said to be beautiful in pro-portion as it approaches the works of antiquity.[2] It is, how-ever, to be expected that the Roman-trained Armenini should show a greater enthusiasm for ancient sculpture than the Milanese Lomazzo.

Lomazzo and Armenini are, therefore, academic and eclectic in their method, but they could not free themselves from Mannerist views even in their practical advice to the painter. For though they favour this very elaborate training and urge the artist always to work out carefully in his head and on paper what he intends to do before he actually sets to work on a painting, yet they accept Vasari's compromise that in the execution itself he should be as rapid as possible so that he may not destroy the grace of his painting by over-elaboration.[3]

[1] Op. cit., bk. i, ch. 2. [2] Ibid., bk. i, ch. 8.
[3] Lomazzo, *Tempio della Pittura*, ch. 2, and Armenini, op. cit., bk. i, ch. 9.

However, in the practical advice which these theorists give to the painter these few Mannerist features are more than counterbalanced by those which they have in common with the Carracci.[1] Some of these common features also go back to the earlier forms of Mannerist practice. The Eclecticism advocated by Lomazzo, and by the Carracci, for instance, was the common habit of many painters in the middle of the sixteenth century, and even sometimes received conscious formulation, as, for instance, by Tintoretto, who aimed at combining the colour of Titian and the drawing of Michelangelo, or by Tibaldi, who wished to harmonize the *terribiltà* of Michelangelo with the elegance of Raphael.[2]

It in no way lessens the importance of the Carracci in the development of the arts in Italy to say that in their method of teaching they applied many of the methods worked out by their Mannerist predecessors. It means only that the name of 'Eclectic' usually applied to them is not an adequate description of their achievement. Their Eclecticism was not new, but in many other ways their teaching revolutionized Italian painting. As all their biographers in the seventeenth century agree, their great work was that they brought painting back to the imitation of nature after the wanderings of the Mannerists. In our view their naturalism is so mild, particularly in comparison with that of Caravaggio, that it is hard to think of them as anything but academic. But in their day they seemed to be getting back to a simple and direct rendering of nature, after a period of almost abstract stylization.

[1] It is worth noticing that both Armenini and Federigo Zuccaro were in personal contact with Lodovico Carracci (cf. a letter from Zuccaro to Carracci, Bottari-Ticozzi, op. cit. viii, p. 516). But the two Mannerists were of an altogether older generation than Lodovico Carracci, and what influence there was must have gone from the theorists to the painter.

[2] Niccolò dell' Abbate's eclecticism, as celebrated in the famous sonnet attributed to Agostino Carracci, may be rather a construction of the later author than the conscious intention of the master himself.

BIBLIOGRAPHY

A full bibliography of the whole subject is to be found in J. Schlosser, *La Litteratura artistica*, 3rd edition, ed. O. Kurz, Florence–Vienna, 1964. A number of the early texts listed below have been reprinted in facsimile. Others have been reprinted in Paola Barocchi, *Trattati del Cinquecento fra Manierismo e Contrariforma*, Bari, 1960–2 (referred to as Barocchi, *Trattati*, below). An extensive and well-chosen selection of texts from the principal treatises is to be found in the same author's *Scritti d'arte del Cinquecento*, Milan–Naples, 1971. Other texts, in not always reliable translations, are printed in E. G. Holt, *Literary Sources of Art History*, Princeton, 1947.

GENERAL

A. DRESDNER, *Die Kunstkritik, ihre Geschichte und Theorie*. Munich, 1915.

L. VENTURI, *History of Art Criticism*. New York, 1936.

N. PEVSNER, *Academies of Art Past and Present*. Cambridge, 1940.

K. BIRCH-HIRSCHFELD, *Die Lehre von der Malerei im Cinquecento*. Rome, 1912.

K. BORINSKI, *Die Antike in Poetik und Kunsttheorie vom Ausgang des klassischen Altertums bis auf Goethe und Wilhelm von Humboldt*. Leipzig, 1914–24.

R. W. LEE, 'Ut pictura poesis': *The humanist Theory of Painting*. New York, 1947.

R. WITTKOWER, *Architectural Principles of Humanism*. London, 1952.

E. PANOFSKY, *Idea: A Concept of Art History*. Columbia, 1968.

J. SHEARMAN, *Mannerism*. Harmondsworth, 1967.

CHAPTER I. ALBERTI

ALBERTI, *De re aedificatoria*. Florence, 1485. Italian translation illustrated with woodcuts, Florence, 1550. Latin text with Italian translation, ed. G. Orlandi and P. Portoghesi. Milan, 1966.

——*Della Pittura libri tres* and *De Statua*. Italian texts and German translation. In *Leon Battista Albertis kleinere kunsttheoretische*

Schriften. Ed. H. Janitschek, in Eitalberger's *Quellenchriften.*
für Kunstgeschichte. Vienna, 1877. Also in Leon Battista
Alberti, *Trattati d'arte, Opere volgari,* ed. C. Grayson, iii, Bari,
1973.

C. GRAYSON, *Leon Battista Alberti On Painting and On Sculpture.*
Latin texts and English translations. London, 1972.

G. MANCINI, *Vita di L. B. Alberti,* 2nd edition, Florence, 1911.

I. BEHN, *Leone Battista Alberti als Kunstphilosoph.* Strasbourg,
1911.

F. BORSI, *Leon Battista Alberti.* Oxford, 1977.

A. MANETTI, *Vita di Filippo Brunelleschi,* ed. D. De Robertis and
G. Tarturli, Milan, 1976.

VITRUVIUS POLLIO, *On architecture.* Text and translation by F.
Granger (Loeb Classical Library). London, 1931–4. Italian
translation by Fabro Calvo Ravennate with marginal notes by
Raphael, ed. V. Fontana and P. Morachiello, Rome, 1975.

L. GHIBERTI, *I Commentarii,* ed. J. Schlosser, Berlin, 1912.

R. KRAUTHEIMER and T. KRAUTHEIMER-HESS, *Lorenzo Ghiberti.*
Princeton, 1956.

PIERO DELLA FRANCESCA, *De Prospettiva Pingendi.* Ed. G. N. Fasola,
Florence, 1942.

CHAPTER II. LEONARDO DA VINCI

For publication of manuscripts see above, p. 23.

J. WOLFF, *Lionardo da Vinci als Ästhetiker.* Jena, 1901.

L. VENTURI, *La critica e l'arte di Leonardo da Vinci.* Bologna, 1919.

E. PANOFSKY, *The Codex Huygens and Leonardo da Vinci's Art
Theory.* London, 1940.

K. CLARK, *Leonardo da Vinci.* Cambridge, 1952.

L. H. HEYDENREICH, *Leonardo da Vinci.* English translation,
London–New York–Basle, 1954.

C. PEDRETTI, *Leonardo da Vinci. A lost book (Libro A) reassembled
from the Codex Vaticanus Urbinas 1270 and the Codex Leicester.*
London, 1965.

CHAPTER III. COLONNA: FILARETE: SAVONAROLA

F. COLONNA, *Hyperotomachia Poliphili.* Venice, 1499. Ed. G.
Pozzi and L. A. Ciapponi. Padua, 1964.

M. T. CASELLA and G. POZZI, *Francesco Colonna. Biografia e opere.*
Padua, 1959.

A. FILARETE, *Trattati d'architettura.* Ed. A. M. Finola and L.

Grassi. Milan, 1971. English translation (not wholly reliable) by J. R. Spencer. New Haven, 1965.

FRANCESCO DI GIORGIO, *Trattati d'architettura ingegnieria e arte militare*, ed. C. Maltese. Milan, 1967.

G. GRUYER, *Les Illustrations des écrits de Jérôme Savonarole*. Paris, 1879.

E. WIND, 'Sante Pagnini and Michelangelo. A study of the succession of Savonarola', *Gazette des Beaux-Arts*, 1944, ii. 211.

D. WEINSTEIN, *Savonarola and Florence*. Princeton, 1970.

R. M. STEINBERG, *Fra Girolamo Savonarola, Florentine Art, and Renaissance Historiography*. Athens (Ohio), 1977.

CHAPTER IV. THE SOCIAL POSITION OF THE ARTIST

B. VARCHI, *Due Lezzioni*. Florence, 1549, and Barocchi, *Trattati*, i. 7.

M. EQUICOLA, *Instituzioni . . . con un eruditissimo discorso della pittura*. Milan, 1541.

BALDASSARE DA CASTIGLIONE, *Il libro del Cortegiano*. Venice, 1528. English translation by Sir Thomas Hoty, Everyman Library.

CHAPTER V. MICHELANGELO

MICHELANGIOLO BUONARROTI, *Rime*. Ed. E. M. Girardi, Bari, 1960. Free translations of selected poems by J. A. Symonds, London, 1878.

A. CONDIVI, *Vita di Michelangelo*. Rome, 1553. English translation in C. Holroyd, *Michael Angelo Buonarroti*. London, 1903.

F. DE HOLLANDA, *Tractato de Pintura antigua*. Lisbon, 1548. English translation by A. F. G. Bell. London, 1928.

J. A. SYMONDS, *The Life of Michelangelo Buonarroti*. London, 1893.

H. THODE, *Michelangelo und das Ende der Renaissance*. Berlin, 1902–13.

C. DE TOLNAY, *Michelangelo. Sculptor, painter, architect*. Princeton, 1975.

CHAPTER VI.

THE MINOR WRITERS OF THE HIGH RENAISSANCE

P. CAURICUS, *De sculptura*. Florence, 1504. French translation, ed. A. Chastel and R. Klein, Geneva, 1969.

A. F. DONI, *Disegno*. Venice, 1549.

P. Pino, *Dialogo della Pittura*. Venice, 1548, in Barocchi, *Trattati*, i. 93, and ed. P. Nicodemi, Milan, 1945.

M. A. Biondo, *Della nobilissima pittura*. Venice, 1549. German translation in Eitelberger's *Quellenschriften für Kunstgeschichte*, vol. v. Vienna, 1879.

L. Dolce, *Dialogo della pittura . . . intitolato l'Aretino*. Venice, 1557, and Barocchi, *Trattati*, i. 141. English translation, London, 1770.

M. Roskill, *Dolce, Aretino and Venetian Art Theory of the Cinquecento*. New York, 1968.

G. Sorte, *Osservazioni nella Pittura*. Venice, 1580, and Barocchi, i. 271.

P. Aretino, *Lettere sull'arte*. Ed. F. Pertile and E. Camesasca, Milan, 1957–60.

CHAPTER VII. VASARI

Le vite de' più eccelenti architetti, pittori, et scultori italiani. Florence, 1550. Second and enlarged edition, Florence, 1568. Best modern editions: ed. G. Milanesi, Florence, 1878–81, and P. Barocchi, Florence, 1966– (in progress). English translation by Gaston du C. de Vere, London, 1912–15.

Vasari on Technique. Ed. L. S. Maclehose. London, 1907.

W. Kallab, *Vasaristudien*. Vienna–Leipzig, 1908.

W. von Obernitz, *Vasaris allgemeine Kunstanschauungen auf dem Gebiete der Malerei*. Strasbourg, 1897.

Il Vasari storiografo e artista. *Atti del Congresso internazionale nel IV centenario della Morte* (Arezzo, 1974). Florence, 1976.

V. Danti, *Il primo libro del trattato delle perfette proporzioni*. Florence, 1567, and Barocchi, *Trattati*, i. 207.

F. Bocchi, *Le Bellezze della città di Firenze*. Florence, 1591, and in Barocchi, *Trattati*, iii. 125.

B. Cellini, *Opere*. Turin, 1959. *The Treatises on Goldsmithing and Sculpture*. English translation by C. R. Ashbee, New York, 1967.

CHAPTER VIII.
THE COUNCIL OF TRENT AND RELIGIOUS ART

Carlo Borromeo, *Acta ecclesiae Mediolanensis*. Brescia, 1603; and Barocchi, *Trattati*, iii. 1.

Gabriele Paleotti, *Archiepiscopale Bononiense*. Rome, 1594. *De*

Imaginibus Sacris. Ingolstadt, 1594, and Barocchi, *Trattati*, ii. 117.

MOLANUS, *De picturis et imaginibus sacris.* Louvain, 1570. Enlarged edition under the title *De historia SS. imaginum et picturarum*, Louvain, 1594.

G. A. GILIO DA FABRIANO, *Due Dialoghi.* Camerino, 1564, and Barocchi, *Trattati*, ii. 1.

POSSEVINO, *Tractatio de poesi et pictura.* Lyons, 1595.

G. COMANINI, *Il Figino.* Mantua, 1591, and Barocchi, *Trattati*, iii. 237.

R. BORGHINI, *Il Riposo.* Florence, 1584, and ed. M. Rossi, Milan, 1967.

FEDERICO BORROMEO, *De pictura sacra libri duo.* Milan, 1624, and ed. C. Castiglioni and G. Nicodemi, Camastro, 1932.

B. AMMANATI, *Lettera scritta agli Accademici del Disegno.* Florence, 1582, and Barocchi, *Trattati*, iii. 15.

C. DEJOB, *De l'influence du Concile de Trente sur la littérature et les beaux-arts chez les peuples catholiques.* Paris–Toulouse, 1884.

E. MÂLE, *L'Art religieux après le Concile de Trente.* Paris, 1932.

E. S. BARELLI, *Teorici e scrittori d'arte fra Manierismo e Barocco.* Milan, 1966.

G. SCAVIZZI, 'Le Teologia Cattolica e le immagini durante il XVI Secolo', *Storia dell'Arte*, xxi, 1974, p. 171.

CHAPTER IX. THE LATER MANNERISTS

G. P. LOMAZZO, *Trattato dell'arte della pittura, scultura et architettura.* Milan, 1584. Reprinted in Lomazzo, *Scritti sull'Arte*, ed. R. P. Ciardi, Florence, 1973. English translation by R. Haydocke: *A tracte containing the artes of curious paintinge, carvinge, buildinge.* Oxford, 1598.

——*Idea del tempio della pittura.* Milan, 1590. Reprinted with notes by R. Klein, Florence, 1974.

G. B. ARMENINI, *De' Veri Precetti della pittura.* Ravenna, 1586.

F. ZUCCARI, *Lettera a principi . . . con un lamento della Pittura.* Mantua, 1605.

——*L'Idea de' Pittori, scultori et architetti.* Turin, 1607. Both reprinted in *Scritti d'arte di Federico Zuccaro*, ed. D. Heikamp, Florence, 1961.

——'La Dimora di Parma' in *Passagio per Italia.* Bologna, 1608.

ROMANO ALBERTI, *Origine e Progresso dell'Accademia del Disegno.* Rome, 1604; and in Barocchi, *Trattati*, iii. 195.

ANDREA PALLADIO, *I quattro libri dell'architettura*. Venice, 1570.

S. SERLIO, *Tutte l'opere d'architettura et prospettiva*. The separate books published between 1537 and 1575; the first complete edition, Venice, 1584. The sixth book was published from the Munich manuscript by A. M. Brizio, Milan, n.d.

VIGNOLA, *Regole de' cinque ordini*. Venice, 1562.

VINCENZO SCAMOZZI, *Idea della architettura universale*. Venice, 1615.

V. SCAMOZZI, *Taccuino di Viaggio da Parigi a Venezia*. Ed. F. Barbieri. Venice, 1959.

INDEX

The principal references are in bold type